Archaeological Displays
and the Public

Lacock
Chippenham

ARCHAEOLOGICAL DISPLAYS
AND
THE PUBLIC

Muscology and Interpretation

edited by

Paulette M. McManus

Second Edition

Archetype Publications

First published 1996 by the Institute of Archaeology, University College London
This second edition published 2000 by Archetype Publications Ltd.

Archetype Publications Ltd.
6 Fitzroy Square
London W1T 5HJ

www.archetype.co.uk

Tel: 44(207) 380 0800
Fax: 44(207) 380 0500

© 2000 Editors and authors

ISBN 1-873132-67-0

Printed and bound in Great Britain by Henry Ling Ltd, The Dorset Press, Dorchester

iv

Contents

List of Contributors

Brian Bath is a project designer working for The Visual Connection, London. At the time of writing he was Head of Design and Interpretation at English Heritage with responsibility for all aspects of site presentation. In his time at English Heritage six awards for outstanding interpretive practice were given to projects he supervised.

Glyn Coppack is a senior Inspector of Ancient Monuments with English Heritage whose conservation projects over the past twenty years have included Lulworth Castle, Fountains Abbey, Mount Grace Priory, and Wigmore Castle. When not working on major conservation projects he is also an authority on the archaeology and planning of monastic sites.

Jenny Hall is Roman Curator in the Department of Early London History and Collections at the Museum of London. A classicist by degree, she has worked for the museum for over 25 years. She is responsible for the Roman collections and for the Roman London Gallery, refurbished in 1996. She played a major role in the museum's temporary exhibition, High Street Londinium, where archaeological evidence had to be translated into full-scale reconstructions of Roman buildings. She has gained considerable experience of interpreting Roman London to a wide audience, the school Roman box scheme being one facet of public accessibility.

Sally MacDonald is manager of the Petrie Museum of Egyptian Archaeology, University College London. Since 1980 she has worked in regional and community museums in England, mostly with social history and decorative art collections. She set up and ran the museum and heritage service in Croydon, which opened to the public in 1995. She sits on the Heritage Lottery Fund's Expert Panel for museums, libraries and archives, on the Registration Committee for Resource, and on the Museums Association's Professional Development Committee. Her current research interests include public attitudes to Ancient Egypt and the role of object handling in stimulating learning.

Carolyn MacLulich B.Ed (Hons), M.Litt (Mus Studies) is Head of the Division of Education at the Australian Museum in Sydney, Australia. She is principally involved with exhibition and program policy and development. Carolyn has been at the Museum since 1986. She has tertiary qualifications in education and anthropology, and a master's degree in museum studies, focusing on public program accessibility and exhibition text production. Carolyn has been Vice President of Museums Australia NSW, a Board member for the Museum Studies course at University of Sydney, and a member of the Museums Advisory Committee to the NSW Minister for the Arts.

Paulette McManus has worked as a consultant specialising in the interface between visitors and museums and heritage sites since 1983. She has worked for many national and municipal museums and sites in Britain and abroad. Since 1994, she has also been a part-time lecturer at the Institute of Archaeology, University College London, where she teaches Museum Communication and Heritage & Site Interpretation to post graduate students and supervises doctoral research into museum and heritage issues.

Jordi Pardo is the Chief Executive of IKONOS CULTURAL SL., Barcelona – a company that designs and develops heritage projects. At the time of writing he was the Managing Director of

the Centre for the Contemporary Culture of Barcelona. He wrote of his recent experience as the Director of the Organisme Autonom Conjunt Monumentes d'Empuries (OACME). An archaeologist by training he also has postgraduate business school qualifications in Public Administration and Management. Throughout his career he has also been a lecturer in Museum Studies at the Universities of Gerona and Barcelona.

Greg Richards obtained a PhD in geography from University College London. He founded the European Association for Tourism and Leisure Education (ATLAS) in 1991. With ATLAS he has led many EU-funded projects in the fields of tourism education, cultural tourism, sustainable tourism, tourism employment and ICT in tourism. He is currently a lecturer in leisure studies at Tilburg University in the Netherlands. His main research interest is cultural tourism, and he has edited volumes on *Cultural Tourism in Europe* (1996) and *European Tourism and Cultural Attractions* (2001).

Elaine Sansom is the Director of South East Museums Service, the museum and gallery development agency for the south east of England. She is currently the Secretary of ICOM UK and is the external examiner for the University of Newcastle Museum Studies course. With a degree in archaeology and postgraduate qualifications in museum studies and management, she has worked in field archaeology in the UK and Sri Lanka, in the local authority museum sector in the UK – most recently as Director of Watford Museum and Art Gallery, and as a lecturer at the Institute of Archaeology.

Carol Scott is Manager of Evaluation and Audience Research at the Powerhouse Museum in Sydney Australia. She is President of the Evaluation and Visitor Research Special Interest Group and also a member of the Museums Australia National Council.

David Simmons is Director of Visitor Services and Senior Archaeologist at Old Sturbridge Village, where he has worked since 1982. He assists in the direction of ongoing archaeological fieldwork and directs the museum's program of audience research. He holds a BA in Anthropology and History from Duke University, and an MA in American Civilization from the University of Pennsylvania, where he is also a doctoral candidate in Historical Archaeology.

Jim Specht MA, PhD, FAHA, head of the Division of Anthropology, joined the Australian Museum in 1971. Since then his interests have been primarily focused on the Pacific Islands, both as an archaeologist working in Papua New Guinea, and in cultural heritage matters more generally. Between 1974 and 1983 he was a member of the advisory committee to the Minister for Foreign Affairs on cultural assistance programs in the Pacific Islands. Jim has also served on the Australian National Commission for UNESCO, and is a fellow of the Australian Academy of Humanities.

Hedley Swain is Head of Early London History and Collections at the Museum of London. He was previously Finds Manager with the Museum of London Archaeology Service. He has done much work on archaeological archives and providing public access to them.

Foreword

Peter Ucko

Many illustrious academic archaeologists have stressed the importance of the principle of communicating to the wider public lessons gained from archaeological investigations. In practice, however, few of them have tried to do so themselves, except as part of their normal university teaching activities, or occasionally within an adult or continuing education lecture. In fact, communicating archaeological results to non-archaeologists is a complex matter, often raising some fundamental questions about the very nature of archaeological enquiry. After all, it often turns out that it is even difficult to decide what exactly the messages are which should be widely disseminated.

Like any healthy discipline, archaeology is also continuously engaged in re-examining its own disciplinary assumptions and methodologies; currently in a world-wide context it is debating whether the ongoing emphasis on a culture-historical framework for interpreting the past is really the most suitable one. In the choice of what is to be presented in museum displays or highlighted in site signage and tourist guides, culture-history retains its domination almost everywhere. Since many of the attempts to gain a wider audience – to inform the public about the past – are often tied to activities aimed at preserving the physical remains of the past, such attempts are often overtly based on appeals to a public's claimed pedigree, whether in terms of overt nationalism, regionalism or ethnic identity. Site and museum visits, therefore, often have an inbuilt tendency to reinforce culture-historical preconceptions and stereotypes.

Furthermore, it is frequently an impossibly complex and daunting task first to attempt to identify, and then to attempt to remove from any archaeological messages, all the encumbrances of gender bias, racial or ethnic preconception, and subjective evaluation based on assumed degrees of technological progress, which have, relatively recently, come to be recognised as some of the pitfalls of past archaeological interpretations. It is vital, however, that these issues are tackled, even though archaeology is at a particularly difficult moment in its development. In fact, the current difficulties facing archaeological interpretation emerge particularly clearly in the context of discussions about the exact nature of the archaeologists' responsibility to the wider public, whether that public be the adult, free to enjoy a vacation and to visit museums and archaeological sites, or the captive child, forced to study the past and take examinations about it. The real problem lies not only in deciding what messages about the past should be communicated, but also how 'meaning' should be 'explained' to others.

No wonder that archaeology itself is in a mood of self-analysis. Arguably, for example, it is more difficult attractively to present the past as unknown territory, than it is to equate the material remains of the past with identifiable human groups, or with dateable events such as battles or the history of the building of particular structures. The very real problem arises that in divesting itself of unwanted baggage as a result of its self-analysis, archaeology may alienate itself from its wider public. To do so could all too easily spell the end of any social, public role for the past in the present, with archaeology returning to being merely the intellectual pastime of a small elite.

Given the importance, therefore, of communicating successfully about the past with the wider public, it is all the more surprising to realise how little research has been undertaken which is

relevant to the question of how best to communicate about the past. Much of the discussion to date has been at the level of assertion and untested belief. For example, although it is popular to assert that hands-on experience is attractive to both young and old, there has been almost no informed discussion, within the archaeological context, as to what such 'direct' experience of the past is intended to achieve. Although it may be clear that students remember more about the past through hands-on learning, it is not known what it is they 'remember'. There is no in-depth research which seeks to investigate whether the knowledge of a past acquired in this way – by constructing one's own mud house, by making pots, or by using objects of the past – creates a past that is 'concrete' or tangible in a way that is different from that acquired without such hands-on experience. Still less is there any concrete evidence to show whether such an approach to teaching about the past removes some of the biases nowadays believed to be inherent in many of the existing attempts to create a story about the past from archaeological material evidence. It can easily be argued that because the people of the past were different from the people of today, and since they worked in very different contexts and cultural environments from our own, even when teaching through the use of past technologies, the instructor is – inevitably – merely creating a contemporary experience which relates to current interpretations of past processes.

Most archaeologists recognise a variety of important lessons which they hope can be demonstrated to a wider public. One of the problems is that these lessons may vary in their intensity – or even in the significance of their message – depending on the contemporary social and cultural context of those destined to receive the message(s) at any particular moment. There can be no doubt about the potential significance of the matters under discussion: they include encouraging pride in the past, recognising the longevity of tradition, stressing the complexities and ingenuity of those who have gone before. But, quite apart from the particular contexts within which these messages may be received and interpreted, archaeology may not currently be the most suitable vector of such matters, at the very moment that the discipline itself struggles to recognise and express the subjectivity of much of its own interpretation, and attempts to make explicit any biases or hidden agendas both of those who accumulated archaeological data and those who subsequently interpreted them.

Archaeologists are becoming more and more aware that archaeological evidence has often been used to 'fabricate' a (or, the) past that is the most appropriate one for those in power, for those with nationalistic aspirations, or for those seeking to establish pedigrees for their ethnic identities. As a result the realisation is growing that basic research to assess the most effective way(s) to disseminate such information is of fundamental importance. That such realisation is at least in the making is seen from current archaeological criticisms of the contextual nature of western-based museum collecting and display, and criticisms of the way that a particular 'frozen' moment in time is often arbitrarily selected, captured and presented to the public at (and often, as) an archaeological site. Despite the welcome growth in ways of enlivening museum and site visits, and attempts to combine entertainment with education, many of the significant questions, as this publication makes clear, still remain relatively under-researched and therefore poorly understood.

A final problem confronting those responsible for the future of the presentation of the past concerns the need for a fundamental revolution, whereby the use of the archaeological past is wrested away from those who control it from their positions of authority. Frequently, the current situation has resulted either in the physical evidence of the past being forcibly isolated from any living investment by the present, or has resulted in the knowledge about the past being made inaccessible to all but the privileged. Often somebody appears to have decided that the past is too important a commodity to allow its archaeological evidence to become a playground for all; somebody – and it may often have been an archaeologist – appears to have decided that archaeological interpretation should remain the preserve of those in positions of influence who

claim to 'know' the past, to have the right to preserve aspects of it, and who deny the possibility that its ongoing vitality should be allowed to result in re-interpretation of a site, or in modification of a monument's outward characteristics – or even, sometimes, in the actual destruction of a relic. No wonder, therefore, that archaeology currently is often perceived by the public as representing a conservative and anti-development stance, the epitome of those forces which they consider to be against 'progress'. Of course, in many western contexts at least, this is one of the reasons for its attractiveness.

Given the complexity of the current contexts within which the past is to be interpreted and displayed to public audiences, it is all the more vital that heritage presentation is undertaken not only within a clear realisation of the aims(s) of re-presenting the past at all, but also with all the above potential complications in mind. Gone are the days when it could simply be claimed that objects 'on display' will speak for themselves, unaided by contextual or other educative information easily accessible to the visitor; today's world is more aware of the deficiencies of past attempts to display archaeology to public audiences. Nowadays the world should demand the right to know that museum and site presentation practice is embedded in reliable research about its audience, both in terms of the public's expectations and how best to communicate with the public in the context of such expectations, and in terms of the most up-to-date baggage-free interpretations of the evidence from the past.

In short, therefore, although it would be easy simply to demand that archaeological evidence, and archaeological interpretation, should be well presented to the public, such an apparently simple conclusion would amount to deceit. The 21st century aim must be to encourage intelligent discrimination, by the onlooker, between alternative 'explanations' of the past. For the archaeologist to afford the evidence to enable such public discrimination demands the highest level of archaeological skills.

Peter Ucko
Director
Institute of Archaeology, UCL
June 2000

Introduction

Paulette McManus

In the four years since the first edition of *Archaeological Displays and the Public* was published I have witnessed heritage professionals moving towards an intense focus on matters related to the audience for heritage interpretations. People here in Europe, the Americas and in Australia have been asking questions such as 'Who is in my audience? What do they need or like? How can we create a new audience? What does our audience think of us?' Accordingly, this second edition has replaced five chapters with six new ones which reflect such current audience preoccupations more closely. A core of six chapters relating to perennial concerns is retained from the first edition.

Preparing any museological interpretation, on any subject, for the public is a difficult task, made doubly difficult for archaeologists because of the added complications of dealing with the problematical concepts of time long past, of authenticity, of provisional professional interpretation, and, additionally, those of cultural identity and nationhood. Trying to employ visitor research based understandings of the audience when preparing communications for the people who make leisure visits to sites and museums while at the same time avoiding the pitfalls of trivialisation is a daunting assignment.

Intellectual access to an informed sense of the past and the continuation and variety of human life lies at the heart of all archaeological interpretations for the public. This has particular relevance for the average visitor who will very likely use a mental framework of time past and lives led from which to interrogate communications prepared for them, whether or not they were intended to do so by those who prepared the communication.

The papers gathered here are not intended to represent ideals of best practice – good practice is so dependent on context – nor are they intended to cover every aspect of the interface between archaeology and the public. Rather, they report on current, or recent, areas of high communicative activity in the field of heritage interpretation for the public in Britain and abroad. Collectively, they have in common evidence of enthusiasm for accommodating the communicative needs of the public while maintaining high levels of archaeological and anthropological integrity. Some of the projects reported on are long term, some could be adapted for use elsewhere in a few weeks, some are costly, some are distinctly low budget. The intention is that they should serve as a source of inspiration and information for those preparing archaeological communications about any period anywhere in the world.

The institutional setting

At the institutional level, most museums and heritage sites rely either on income from payments on entry or allocations of funding according to audience size and , increasingly, diversity, for financial independence or survival. Therefore, being able both to give a description and to demonstrate a deep understanding of an audience to a particular institution could be seen as a managerial obligation. Most museums and heritage sites, no matter what their size, welcome large numbers of domestic and foreign tourists, particularly during peak spring, summer and winter holiday periods. Tourists can commonly make up more than half of a visiting audience. However, strangely, very few institutions appear to see such cultural tourists as a, if not the, major part of their audience and

so do not attempt to describe them clearly as a segment. For example, in Britain, where institutions conduct audience surveys (and not all do), they are still likely to exclude those visitors who are non-English speaking from questionnaire samples. A new chapter should help reluctant investigators to frame appropriate questions to ask of their tourists. Greg Richards provides a well-researched view of heritage tourism from within the broader field of European cultural tourism that helps us to think more perceptively about responding to the background and experiences of those who visit from far away. Working with others in the European Association for Tourism and Leisure Education, he has studied cultural tourism in Europe for almost a decade and provides an expert view on the motivations which drive tourists to visit museums and sites.

The remaining chapters in this section are retained from the first edition. They describe successful adherence over many years to visions which required much attitudinal change within quite large institutions. Having the will to change something is important. Perceiving how to change the motivational atmosphere of an institution and its management structure so that change can be allowed to take proceed is a visionary process. Together, these three papers can be mined for a model for change processes.

Jordi Pardo is an unusual archaeologist in that he has also been to business school. He describes the centralised administrative context which had to be replaced with a more entrepreneurial management model in order to turn a somewhat moribund, but important, Mediterranean archaeological site into a very successful, almost self-financing, archaeological park in which high levels of archaeological research, preservation and dissemination are now enthusiastically conducted. In describing the organisational framework he devised, he gives an overview of the many activities that were developed in the four years after the vision of change was first enunciated. Furthermore, he articulates the driving force behind the project – the social dimension of archaeology.

Living history museums are very popular in the USA. David Simmons, another archaeologist, tells how the introduction, over twenty years ago, of archaeologists to a team of research historians at a New England living history museum was accepted because colleagues found that the contributions of the archaeologists were advantageous, compatible with their concerns and produced observable results in that they improved the quality of historical presentations to the public. He provides details of a recent excavation project that fed its findings directly into the living history interpretation provided for visitors. Interestingly, he describes how the interpreters take part in excavations and how the archaeologists often rely on the interpreters' expertise and experience (of using a similar location as a base for interpretation to the public) to locate or interpret patterns of former activity on an excavation site.

Archaeological activity can unearth objects which belonged to people. The descendants of those people, whether biological or cultural, naturally have an interest in such objects. When objects are collected by anthropologists, the same interest of 'cultural stakeholders' applies. Talking from a museum context and looking back over nearly three decades, Jim Specht and Carolyn MacLulich describe the manner in which exterior social and political forces initially impinged upon their institution causing it, first, to react to outside forces and, gradually, to adopt a proactive, leading stance in matters, including repatriation, related to working with indigenous peoples. They indicate that possession of artefacts from the cultural past of peoples involves the museum with present-day representatives of that culture. They also illustrate the manner in which acceptance of this philosophy has affected their museum's mission, exhibition and employment policies.

Archaeology Indoors: Museum Exhibitions

All the three chapters in this section are new. They illustrate the driving forces of the current audience focus since one describes positioning to create an additional, new audience, another the

desire to make collections accessible rather than remain in store while the last considers the fine grain of an appropriate language for written texts for a general audience.

University museums and collections have traditionally been under-funded, often neglected and one suspects, almost forgotten. Sally MacDonald has recently been appointed as the Manager of the Petrie Museum of Egyptian Archaeology, University College London, at a time of innovative development of the administration of UCL's very varied collections. She describes the changing relationship of the museum with its parent institution as she develops plans towards serving a general public as well the Petrie Museum's traditional specialist, scholarly audience. Her plans are based on audience research, marketing and outreach projects.

Jenny Hall and Hedley Swain describe a truly ambitious outreach project which will maximise public access to the Museum of London's Archaeological Archive while creating a new, off site, audience for its nationally important Roman archaeological collection. The plan is to eventually provide a 'mini museum' of Roman material to over two thousand schools – every state and special school in greater London. Naturally, such a project requires much thought and planning. We are given a full history of the project and its development up to the stage where two hundred 'mini-museum' boxes were distributed for an evaluated pilot scheme earlier this year.

My own paper considers written communications for museums and heritage sites. In it the concern is to influence the attitude of the text writer to the job in hand in a manner that will increase confidence and provide a sense of autonomy. A communications-based model for text writers is provided along with suggested guidelines for text writing. Importantly, the feasibility of testing and adjusting written texts, intended for a future audience, at the time of writing is illustrated with descriptions of three formative evaluations conducted in the Victoria & Albert Museum, London.

Archaeology Outdoors: Site Interpretation and Education

Two chapters replace others in this section to join those on live interpretation, audio-tours and guidebooks. The new chapters are concerned with the public's perception of the identity of an institution and the role that conservation measures can play in site interpretation.

Site interpretation can be difficult for a myriad reasons ranging from the need to respect the sensitivity of a landscape setting, especially that of a large, ancient site with little in the way of ancient features remaining, to restrictions imposed by the conservation of an historic fabric which is, for the most part, complete. Site museums and visitor centres are not always a feasible interpretation solution for archaeological site managers because of their establishment and maintenance costs, their physical impact on the atmosphere of the site and an imperfect balance between what there is to see and what can be said about it. From the visitor's point of view, anything other than an overview given at a centre at the start of a visit is disadvantageous since a decontextualised memory task is imposed because the visitor must leave the source of information to contemplate its subject. For this reason, three chapters in this section describe 'portable' means of giving visitors a certain depth of information at appropriate places on site.

Before the visitor can enjoy such provisions he or she must be motivated to visit. Such motivation is very likely to be based on a perception of what the site is about and an impression of the nature of the people who run it. These factors contribute to an image of 'identity' for the site. In marketing parlance the 'identity' is the 'brand'. In Britain, the National Museums and Galleries on Merseyside (NMGM), an umbrella organisation responsible for seven museums and galleries around Liverpool, has recently begun a branding investigation which involves surveys and interviews with a range of stakeholders from staff, at all levels, to members of the public. The intent is to describe the NMGM to itself and its public in a coherent way. Also, Sir Neil Cossons,

just prior to taking up his new position as chief executive of English Heritage, recently spoke at the Institute of Archaeology, University College London, of the need to 'brand' that heritage organisation. Often nationally scheduled archaeological sites and heritage buildings are controlled by such centrally organised structures and it occurs to me that it is the individual site which requires to have an identity in the mind of potential visitors rather than the bureaucratic centre. The identity of a site can easily be swamped by that of the organisation or trust that controls it. Accordingly, I have included in this section Carol Scott's chapter on the branding investigations undertaken at the Powerhouse Museum in Sydney. She writes about a museum situation but she also writes about a single institution, a sole destination. Her explanations and descriptions of the survey work she undertook may inspire, and will inform, site managers and planners about a current trend in the heritage sector.

Elaine Sansom provides an invaluable taxonomy, and an exhaustive summary of the advantages and pitfalls, of the field of live interpretation at archaeological sites. Her report helps to put the work described by David Simmons (in the first section) into the broader context of a movement which, starting in the USA, has gained much acceptance in Britain. She points to the recent emergence of this form of rather costly site interpretation; the reasons, including ready public appreciation, behind its adoption; and the assumptions, untested by visitor study research, behind its acceptance as a justifiable and reliable form of site interpretation. Her chapter is also interesting in that it points to the difference between market research inspired 'promotion' and communicatively intended 'interpretation' and, hence, lays out an agenda for research on the impact of live interpretation on visitors. She also provides an example of 'best practice' that integrates various approaches to live site interpretation into a themed programme which varies over an annual period.

I suspect that, for many members of the public, the identity of a national heritage service, be it similar to the British National Trust or to English Heritage, is tied in with the way such organisations require most of the buildings and sites in their care, and their facilities such as cafes and shops, to be conserved or presented in a particular manner or to a particular standard. A site can easily lose its individuality under such regimes. When this happens it becomes very difficult to provide a site-relevant communication which has impact for the visitors. What is seen and said seems very similar to what has been seen and said elsewhere. At the beginning of the 1990s focus groups were conducted with people who lived around Brodsworth Hall, Yorkshire, in order to gather information that would help English Heritage to plan its presentation. The furnishings and decoration of the house, which had just been taken into care, showed advanced stages of gentle decay. The local people were entranced by the 'time warp' quality of a tour through the grand rooms and abandoned Victorian kitchens. Their response helped to confirm a proposal to present the site 'as found' rather than restore it to the appearance it might have had when all inside was new. Presenting a site 'as found' is difficult but has the twin advantages of confirming the individuality of the site while powerfully evoking the visitor's imagination. Glyn Coppack has adjusted a paper he wrote for a differing audience to give an account of the recent conservation of Wigmore Castle, Herefordshire, 'as found' so that it is now presented evocatively to visitors as a 'proper ruined castle'. He reminds us that conservation initiatives can have a very powerful interpretive effect.

Brian Bath wrote from his considerable experience with audio-tours when head of Design and Interpretation at English Heritage, an organisation which looks after over 350 historic buildings and monuments throughout England that are open to the public. His detailed descriptions of specific projects make clear the interpretive concepts and principles behind the use of the recorded word in heritage communication. Detailed criteria – costs, demands on staffing, housing, reliability, user-friendliness, visitor volume, flexibility – to be used when considering the use of particular

systems are given. This chapter has not been updated to indicate the very latest technology for carrying audio-tours because the technology which can be used to do so is changing and diversifying so fast so an update would soon be out of date. Only yesterday I heard that the London Canal Museum has prepared a 'WAP-walk' guide for use along the canal that leads to the museum which visitors can access using their own WAP-enabled mobile phones.

Guidebooks, with their echoes of travellers' reports and the European 18th-century grand tour, are a taken for granted and much maligned form of site interpretation. However, it is still possible to visit sites of World Heritage Site quality, especially, I find, around the Mediterranean, which offer no site interpretation at all – not even an overview panel with a map in the car park. At such sites the visitor is heavily reliant on the pre-purchase of a guidebook since they are often, unforgivably, not available on site. My chapter reports on a survey of what guidebook users like to find in a guidebook and the manner in which they are used.

Increased archaeological activity, combined with local and national interest, and mass tourism, will ensure that many more archaeological exhibitions and sites will be opened to the public in the future. The audiences for these interpretations will be more educated in a general sense and, increasingly, more sophisticated in appreciating the use of communication media than former audiences for archaeological displays. This is a challenging situation. The papers gathered here indicate that an attitude which engenders a strong drive to provide high levels of public service to the recipients of archaeological interpretations will be likely to give satisfaction to professionals and public alike.

The
Institutional
Setting

Cultural Tourism

Greg Richards

To all intents and purposes, museums can be regarded as one of the cornerstones of cultural tourism. Museums have long played an important role in presenting the history and culture of nations or regions to visitors. In recent years cultural attractions have also come to be viewed as an essential means of attracting visitors to urban and rural destinations worldwide. In 1997, 17% of domestic tourists in the UK visited heritage sites of which museums are the largest category. For overseas tourists, the figure rises to 37%. In major European cities tourists can be even more important. In Amsterdam, for example, 75% of museum visitors are tourists (AUB, 1996).

However, the very word 'attraction' is laden with a major semantic problem – it tends to suggest that the museum can somehow act as a magnet for visitors. Just open the doors, and the visitors will flood in. However, as Leiper (1990) has pointed out, the idea of an attraction is misleading – tourists are in fact 'pushed' towards attractions by their own motivations, not magically drawn by some invisible force within the attraction.

Attracting more visitors therefore depends on knowing the visitor and their needs. Many museums know their local audience quite well, but many have little idea of the wider European visitor market. Recent research in the UK by the Museums and Galleries Commission revealed that 25% of museums do not know how many foreign tourists they receive. Only 20% of museums had participated in seminars and workshops on international customers during the past three years. More significantly, only 20% of UK museums outside London have a strategy for attracting foreign tourists. UK museums are not unusual in this respect – in fact they are probably more aware of tourism markets than many of their continental counterparts.

This chapter examines the cultural tourism market, and the position of museums as major suppliers of cultural tourism experiences.

Cultural tourism – hope or hype?

Cultural tourism has been adopted as an element of tourism policy by national and regional governments in all corners of the world. Cultural tourism is popular with policy-makers because it supposedly attracts high-quality, high-spending tourists and at the same time provides economic support for culture. Increasing interest in tourists on the part of cultural attractions is to some extent due to necessity, and also due to the fact that cultural tourism is seen as a major growth market. The World Tourism Organization (WTO) for example has quoted cultural tourism as accounting for 37% of global tourism, with growth rates of 15% per year. According to the European Heritage Group, attendance at museums, historical monuments and archaeological sites has doubled between 1977 and 1997 (European Commission, 1998). In the UK, it was estimated that cultural tourism accounted for 27% of tourism earnings, and in 1997, over 400 million visits to tourist attractions were culturally based (Leslie, forthcoming).

In other cases, however, actual growth has lagged behind the high-blown expectations. Recent data indicate that cultural attractions have not increased their attendances as a

proportion of all visits to tourist attractions. Figures on attraction attendance in the UK, for example, show an average growth in attraction visits of 15% between 1989 and 1997, compared with a 9% increase for historic properties and 14% for museums and galleries (Table 1). As a proportion of total visits, museums and galleries slipped from 23.1% in 1991 to 19% in 1997, and historic properties grew slightly from 19.1% to 20% over the same period. Longer term trends for England indicate a slower growth rate for cultural attractions between 1976 and 1991, with historic properties (+24%) and museums and galleries (+23%) lagging behind the growth for all attractions (+35%).

Why do the attendances at individual museums not seem to match up to the apparent high rate of total market growth? One explanation might be that many museums either do not consider themselves to be in the tourism market, or even if they do, they do not promote themselves effectively to that market. Another potential explanation is, however, that the growing supply of cultural attractions in recent years means that there is growing competition for cultural visitors. This is certainly true for the European market as a whole, as Figure 1 indicates.

Attraction type	Constant sample	Total market
Farms	+65	+71
Visitor centres	+17	+55
Gardens	+26	+28
Country parks	+22	+23
Workplaces	+15	+15
Museums and galleries	+11	+14
Leisure parks	+6	+12
Historic properties	+8	+9
Steam railways	+7	+9
Wildlife attractions	-8	-1
Total	+11	+15

Table 1. Visitor trends at UK attractions 1989 to 1997 – % change.

Growing competition is a particular problem for museums, since the supply of museums has grown faster than that of most other cultural attractions. In Spain, for example, the number of museums has doubled in the last twenty years, largely thanks to a flourishing of regional museums in the post-Franco era. In Catalonia in particular the revival of national identity has had a strong influence on the development of new museums (Dodd, 1999). In the Netherlands, the supply of museums also doubled between 1975 and 1993 (de Haan, 1997). In the UK the supply of museums has also been strongly stimulated by regional development initiatives and more recently National Lottery funding. Some observers have even been prompted to ask if there are not already enough museums in the UK (Glancey, 1999).

In a period of increasing competition for visitors, the 'build it and they will come' philosophy (Richards, 1999a) is not enough – you need to be able to anticipate and meet the needs of the visitor. This in turn entails an understanding of the cultural tourism market and the different visitor segments it contains. The rest of this chapter examines the nature of cultural tourism, and goes on to look at the profile, motivations and behaviour of the cultural tourists.

Cultural Attraction Supply and Demand in Europe

Fig.1. Growth of supply and demand for cultural attractions in Europe.

What is cultural tourism?

Cultural tourism is extremely difficult to define. There are over 300 different definitions of 'culture' in circulation, which indicates why no widely accepted definition of 'cultural tourism' has been produced in the past. This is not just a problem for tourism academics – policy documents across Europe tend to duck the issue of definition as well, tending to make the assumption that everybody knows what cultural tourism is. This explains the heterogeneous assortment of terms which have arisen in the literature and in policy statements in recent years. Cultural tourism, heritage tourism, arts tourism, ethnic tourism and a host of other terms seem to be almost interchangeable in their usage, but it is rarely clear whether people are talking about the same thing.

In order to try to clarify the meaning of cultural tourism, a conceptual definition was proposed by Richards (1996), based on the way in which tourists (people travelling away from home) consume culture. Culture can be viewed as comprising what people think (attitudes, beliefs, ideas and values), what people do (their 'way of life') and what people make (artworks, artifacts, cultural products). Culture is therefore composed of cultural processes and the products of those processes. Looking at culture in this way, cultural tourism is not just about visiting museums and monuments, which has tended to be the 'traditional' view of cultural tourism, but it also involves consuming the way of life of the areas visited. Both of these activities involve the collection of new knowledge and experiences. Cultural tourism can therefore be defined as: 'The movement of persons to cultural attractions away from their normal place of residence, with the intention to gather new information and experiences to satisfy their cultural needs' (Richards, 1996). According to this conceptual definition, cultural tourism covers not just the consumption of the cultural products of the past, but also of contemporary culture or the 'way of life' of a people or region. Cultural tourism can therefore be seen as covering both the material culture found in museums and the 'living culture' of everyday life.

Although in the past most emphasis in the development of cultural tourism was placed on the

3

development of museums and other heritage products, tourism based on 'popular culture' is now becoming an increasingly important part of the cultural tourism product. This partly reflects the broadening concept of culture being used by policy makers, which is increasingly encompassing 'popular' as well as traditional 'high culture'. Some artforms are also becoming more important because arts institutions are beginning to recognise the potential of tourism as a source of income, and partly because of the improved communications and distribution channels available through new technology, which are making arts events more accessible to tourists. Another important factor is the 'experience hunger' that increasingly characterises modern society (Shulze, 1992). People are increasingly looking for an 'experience' when they visit museums and other attractions. Museums have until recently not paid much attention to the visitor experience, and in consequence are losing out to 'new' heritage attractions designed to generate easily consumable experiences.

In order to study the development of cultural tourism, the European Association for Tourism and Leisure Education (ATLAS) launched its Cultural Tourism Research Project in 1992. Initially funded by DGXXIII of the European Commission, the project set out to analyse the cultural tourism market in Europe, and to develop a profile of the European cultural tourist. Reports of the initial phase of the research have been published elsewhere (Richards, 1996). A major feature of the research programme was a survey of visitors to cultural sites across Europe. Almost 6,500 visitors to 26 sites in 9 countries were interviewed in 1992, and the survey was repeated with over 8,000 visitors in 10 European countries in 1997 (Richards, 1998). A total of over 70 cultural sites across Europe has been surveyed, allowing a profile of cultural tourists to be constructed. Further research has been conducted in 1999/2000, expanding the scope to cover key marketing variables. The ATLAS research provides a valuable tool for assessing the cultural visitors market in Europe and examining the way in which cultural visitors experience museums and other cultural attractions.

Who are the cultural tourists?

The pressure on many museums to increase their visitor numbers and/or broaden their visitor profile means that it is important to know who their visitors are. Although many museums undertake surveys of their own visitors, these are very rarely comparable with research undertaken at other museums in the same country, let alone on a European basis. Museums therefore rarely have a clear picture of their own position in the national or international tourism market. The ATLAS research has helped to address this problem to some extent, by using the same research methodology at cultural institutions across Europe. Using these data a reasonable picture of the relationship between cultural tourists and museums can be developed.

One of the first findings to emerge from the ATLAS research was that there are significant differences between 'heritage tourism' and 'arts tourism', both of which are usually lumped together under the label of 'cultural tourism'. In general, heritage attractions such as museums and monuments tend to be more easily accessible and attract a broader audience than arts attractions. This reflects the higher level of 'cultural capital' required for visitors to understand or appreciate certain art forms, such as ballet or opera. Museums and monuments are therefore among the most accessible forms of cultural attraction, in spite of their reputation for lack of visitor-friendliness.

Comparing museums with other cultural attractions, clear differences in the visitor profile emerge. Museums tend to have a much broader appeal as far as tourists are concerned. Over a third of tourists visiting museums surveyed in Europe came from outside Europe, compared with 15% of tourists visiting other cultural attractions. Local residents accounted for only 16% of visitors to surveyed museums, although it should be noted that this high level of tourist visitation is typical of large museums in major cities, and not of museums in general.

Visitors to museums tended to be older than visitors to other sites. Over a third of museum visitors were aged 50 or over, compared with 22% of visitors to other cultural sites. This tends to support the argument that the growth of nostalgia is a particularly important factor in the expansion of demand for heritage tourism. Arts attractions in particular tend to appeal to a younger audience, with a particularly high proportion of student visitors.

The older age profile for museum visitors explains why museums have more visitors with a secondary or further education than other cultural sites. The expansion of higher education in recent decades means that younger visitors generally have higher educational qualifications. This also accounts to some extent for their higher level of cultural capital and their subsequent ability to consume arts attractions. In spite of these differences, the proportion of museum visitors with a higher education qualification is still almost double the European Union average, and the proportion of visitors with a postgraduate education is just as high as for other sites. This underlines the fact that museum visitors are better educated than the population as a whole.

High education levels mean that museum visitors also tend to have high status occupations, with almost 60% having managerial or professional jobs. Museum visitors are almost exclusively 'white collar' workers, with less than 20% in manual or unskilled jobs. The indications are that the museum audience is dominated by what Urry (1995) refers to as the 'new middle class', for whom cultural and heritage consumption is an important element in their identity formation. Previous research by ATLAS has also indicated that cultural attractions tend to be visited by a relatively high proportion of people with cultural occupations, many of whom are using their trips as a way of increasing their cultural capital relative to their area of work.

The predominantly white collar profile of museum visitors combined with the older age profile means that the average incomes are also high. Over 30% of museum visitors have a household income of over 40,000 Euro per year, which is significantly higher than the European average.

Holiday characteristics

Museum visitors are by no means all cultural tourists. Only 16% of tourists interviewed at museums classified their holiday as being 'cultural'. A large proportion of tourists interviewed were on a touring holiday (30%) or a city break (10%). Many visitors were therefore just 'passing through', with over 50% of respondents staying in the area of the interview for three nights or less. The museum market tends to be more of a 'short break' market than other forms of cultural holidays.

The role of the travel trade in selling cultural products is still relatively weak. As with European tourism in general, the vast majority of visitors are travelling independently, and just over 40% of museum visitors had booked some element of their journey through travel intermediaries before departure. The proportion of tour group participants is even lower, at 22%. The typical cultural tourist visiting a museum tends to be travelling with their partner, and staying in relatively upmarket hotels.

What are their motivations?

The basic motivation for cultural tourism is learning and experiencing new things. Almost 70% of visitors interviewed in 1999 indicated that learning was an important motivation for their visit. Not surprisingly, new experiences were particularly important for tourists (75% indicated this was important). However, relaxation (important for 62% of visitors) and entertainment (60%) are also motivating factors, indicating that 'edutainment' is becoming almost as much a part of the museum experience for visitors as in a theme park.

We also need to be aware that not everybody who visits a cultural attraction is motivated by culture. In general the visitors can be divided into three groups on the basis of their cultural orientation. The 'culturally motivated' tourists, for whom culture is a primary motive for travel accounted for less than 20% of visitors, the 'culturally inspired' tourists for whom culture is an important but not primary motivation made up 30% of the visitors, but the 'culturally attracted' tourists for whom culture was simply one element among many in their holiday product accounted for 50% of visitors. As Davies and Prentice (1995) point out, some visitors do not even enter the galleries, being satisfied with the signs of status conferred by a purchase from the museum shop.

This makes the point that the basic cultural product is not the sole benefit sought by most cultural tourists. Museums intending to attract tourists therefore need to pay more attention to the needs of many tourists to combine cultural and pleasure motivations in their visit.

What do they do?

The research indicates that museums form an important element of tourism consumption, with over 50% of cultural visitors having visited a museum at some stage during their holiday. The role of museums is also underlined by the fact that over 40% of all visitors agreed with the statement 'I always visit a museum on holiday'.

There are also indications that some people are shifting their museum visits from the weekend to day trips and holidays. About 40% of cultural visits made by respondents during the year were taken during holiday time. As people's daily lives become more time-pressured, the holiday is taking over many of the functions of the weekend. Attracting tourists will become even more essential for museums in the future, as the normal leisure time visits will suffer even more competition from other leisure experiences. This is underlined by the fact that although museums remain the most important cultural attractions, the proportion of survey respondents visiting museums has fallen over the years (see Figure 3). Museums were visited

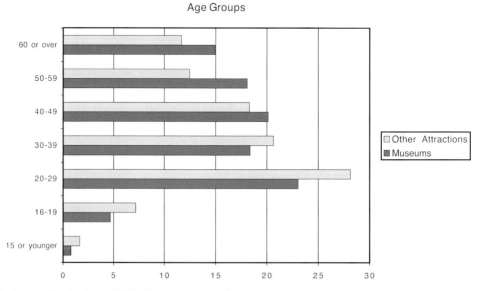

Fig.2. Age distribution of ATLAS survey respondents.

by 58% of all respondents in 1992, but by 1999 this had fallen to 54%. Festivals in particular seem to be gaining ground, seeming to confirm the importance of experience consumption among cultural visitors.

A more worrying sign for museums, however, is the extent to which museums are able to stimulate visitors to come to a particular destination. Museums were seen as having an important role as a trip motivator by only 40% of museum visitors, compared with over 50% of visitors to other cultural attractions. However, this emphasises the fact that for tourists, museums function as just one element of the tourism product. Museums will be visited in combination with other museums, other cultural attractions and leisure facilities as well. This gives ample opportunities for joint marketing, as one attraction alone will seldom provide enough impulse to attract visitors to the destination. The most popular cultural destinations in Europe are those cities that have significant clusters of cultural attractions, providing tourists with ample opportunities to fill their schedules (Figure 4).

Another issue is the extent to which museums can develop new visitor markets. As already mentioned, in general, museums tend to attract older tourists and those with higher educational attainment and incomes – 13% of museum visitors had jobs connected with museums, compared with 7% of cultural visitors overall. This indicates that museums are finding it hard to attract new audiences among the tourists. Perhaps this is not surprising given the low level of co-operation between museums and the tourism industry, and the relative paucity of research carried out by museums on their tourist visitors.

The ATLAS research indicates that museums can indeed be a very important element of the tourism product, although they often do not see themselves in this role. In an increasingly competitive leisure market, however, if museums wish to attract increasing numbers of visitors, they will need to pay more attention to the motivations and needs of tourists.

How do visitors find out about museums?

The 1999 ATLAS research has for the first time asked questions on the sources of information used by visitors to cultural attractions. The most important source of information for museum

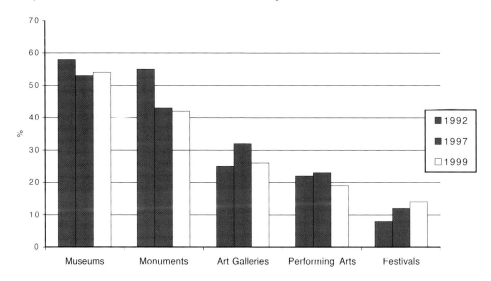

Fig.3. Cultural attractions visited by tourists in the ATLAS surveys, 1992–1999.

visitors was word of mouth, with almost half the respondents having gathered information from friends and relatives. The influence of the Internet is already very strong among museum visitors. Over 26% had used the Internet to gather information about the attraction. This compares with the very low level of Internet use found among cultural visitors in the Netherlands (2.3%) just two years previously (de Jong and Paulissen, 1998). Guidebooks are the most important source of printed information for the museum visitors interviewed (31%). The tourist industry (tourist boards and tour operators) is consulted by about 20% of visitors, which is a higher proportion than those gaining information from the media (7%). In comparison with other cultural attractions, museums have a higher level of Internet use and more use of the tourist industry and guidebooks than other cultural attractions. This may indicate that some headway is being made, at least by the larger museums, in forging links with the tourism sector.

When do visitors decide to come to a museum?

Over half the tourists visiting a museum decide which attractions they are going to visit after they have left home. Foreign tourists are particularly likely to make their decision on the spot. Two-thirds of domestic tourists decide before leaving home. Foreign tourists tend to pick up information en route, as in the case of the many tourists on a touring holiday, or they gather information once in the destination itself. Guidebooks become particularly important in determining where tourists go once they arrive. Only 31% indicated that they had consulted a guidebook before they left home, but this had risen to 43% once they had arrived in the destination. Tourist boards were particularly important for those making the decision to visit the attraction before they left home (57%). This underlines the importance of ensuring that information about the museum is available through different channels in order to reach all segments of the visitor market.

Conclusions

It is clear that some of the assumptions made about cultural tourists are grounded in fact. Cultural tourists are upmarket, well educated, and tend to be highly motivated by culture. The market has basically grown as education levels have increased, but the growing supply of attractions means that more attractions are vying for the same market.

In order to compete effectively in this market museums have to be even more aware of the needs of their visitors and potential visitors. The ATLAS research indicates that the cultural product itself is not enough to satisfy most visitors. It is increasingly important to provide a total visitor experience that satisfies not just the passive tourist gaze (Urry, 1990), but that engages all the senses. In any increasingly competitive market, it is important for museums to make a link with cultural tourists by tapping their own experience and cultural backgrounds. Many leisure attractions have begun to use theming as a means of achieving this, packaging their products in easily absorbable cultural messages. Museums, of course, cannot use all-embracing themes in the same way as leisure attractions, but they can link their collections and their interpretation more clearly to the cultural needs of the tourist.

As museums and other traditional cultural institutions begin to lose the automatic legitimacy they enjoyed as 'factories of meaning' (Rooijakkers, 1999), they will increasingly need to be creative in developing narratives around their collections that appeal to the visitor. These narratives should not just provide a coherent context for the objects being displayed, but they will also increasingly need to leave room for the visitor to develop their own interpretations.

In this respect we are arguably seeing a shift away from the traditional forms of cultural consumption. As de Haan (1997) has noted in the Netherlands, passive forms of cultural consumption now account for less than 1% of leisure time use. Unless museums can engage

with the need of time-pressured cultural visitors for a satisfying, engaging experience, they will lose out in the race to attract larger numbers of consumers. We are now witnessing a shift towards more proactive forms of cultural consumption by tourists, which has been termed 'creative tourism' (Figure 5). Creative tourism is essentially a form of tourism that allows visitors to acquire knowledge and also to develop their own skills and capabilities. Our research indicates that there is a growing demand from tourists for more active involvement in the cultural forms that they come across in their travels (Richards, 1999b). There is no reason why museums should not be able to play a role in providing such experiences. As Rooijakkers (1999) points out, one of the most effective ways of doing this is by using 'shifted

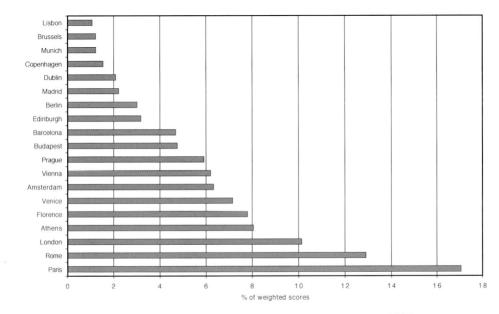

Fig.4. Most popular cultural destinations among ATLAS survey respondents, 1997.

Form of Tourism	Time Focus	Cultural Focus	Form of Consumption
Heritage Tourism	Past	High Culture	Products
Cultural Tourism	Past and Present	High and Popular Culture	Products and Processes
Creative Tourism	Past, Present and Future	High, Popular and Mass Culture	Experiences

Fig.5. The evolution of cultural and creative tourism.

perspectives'. Narratives can be presented from the perspectives of different actors in the narrative, and also from the perspective of the people constructing the narrative and the perspective of the visitor. By allowing the visitor to choose between perspectives, and to compare and contrast these perspectives with one another, the tourist can link the narrative being presented, the location of the narrative and its 'way of life'. In this way the essential link can be made between cultural products and cultural processes and the local culture of the destination and the museum, and the global culture of the tourist.

References

AUB, 1996 De Kunsten Gewaardeerd: de maatschappelijke en economische beteknis van de professionele kunsten voor Amsterdam. Amsterdam: Amsterdams Uit Buro

Davies, A. & Prentice, R. 1995 Conceptualizing the latent visitor to heritage attractions. *Tourism Management* 16, 491–500

De Haan, J. 1997 *Het Gedeelde Erfgoed*. Rijswijk: SCP

De Jong, J. & Paulissen, H. 1998 *Onderzoek naar de Haalbaarheid van de Toeristisch Ontsluiting van het Cultureel Erfgoed in de Provincie Limburg met behulp van Moderne Communicatiemiddelen*. Maastricht: University of Maastricht

Dodd, D. 1999 Barcelona the Cultural City: Changing Perceptions. In: *Planning European Cultural Tourism* (eds D. Dodd, D. & A-M. van Hemel), 53–64. Amsterdam: Boekman Foundation

European Commission 1998 *Culture, the Cultural Industries and Employment*. Commission Staff Working Paper SEC (98) 837, Brussels: EC

Glancey, J. 1999 That's enough culture. *Guardian*, December 27th, p.10

Leiper, N. 1990 Tourist attraction systems. *Annals of Tourism Research* 17, 367–84

Leslie, D. Forthcoming, Urban Regeneration and Glasgow's Galleries with particular reference to The Burrell Collection. In: *Cultural Attractions and European Tourism* (ed. G. Richards). Wallingford: CAB International

Richards, G. 1996 *Cultural Tourism in Europe*. Wallingford: CAB International

Richards, G. 1998 Cultural tourism in Europe: recent developments. In: *Actas del Congreso Europeo sobre Itinereos y Rutas Temáticas* (ed. J. Grande Ibarra), 105–13. Logroño: Fundación Caja Rioja

Richards, G. 1999a European Cultural Tourism: Patterns and Prospects. In: *Planning European Cultural Tourism* (eds D. Dodd, D. & A-M. van Hemel), 16–32. Amsterdam: Boekman Foundation

Richards, G. 1999b *Developing and Marketing Crafts Tourism*. Tilburg: ATLAS

Rooijakkers, G. 1999 Identity Factory Southeast: towards a flexible cultural leisure infrastructure. In: *Planning European Cultural Tourism* (eds D. Dodd, D. & A-M. van Hemel), 101–11. Amsterdam: Boekman Foundation

Schulze, G. 1992 *Die Erlebnisgesellschaft: kultursoziologie der gegenwart*. Frankfurt: Campus

Urry, J. 1990 *The Tourist Gaze*. London: Sage

Urry, J. 1995 *Consuming Places*. London: Routledge

The Development of Empúries, Spain, as a Visitor-Friendly Archaeological Site

Jordi Pardo

Abstract

This paper describes the rapid transformation of Empúries from an under interpreted archaeological site on the Costa Brava to a popular, visitor orientated archaeological park. I shall discuss the administrative history of the site, recent administrative developments, the philosophy behind the change programme and the importance of the site's autonomous nature during its development. I shall then describe how Empúries functions today and the visitors who come to the site before concluding with a discussion of the social dimensions of archaeological activity.

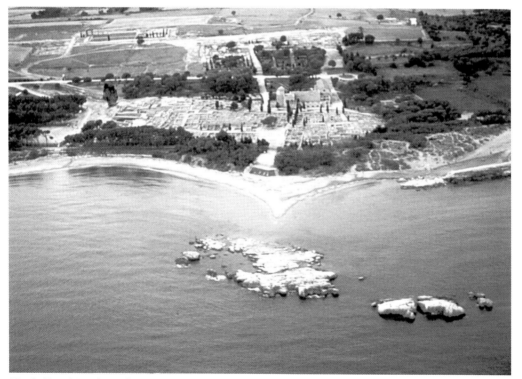

Fig.1. Empúries from the air, showing the Hellenistic wharf, the Greek city near the shore and the Roman city behind it.

The site

The monumental site of Empúries contains the remains of Emporion, the only remaining Greek colony on the Iberian Peninsula, founded in the 6th century BC by sailors from Phocaea (in the Eastern Mediterranean sea). The initial Phocaean settlement of the Palaiapolis (located on the ancient islet of Sant Martí d'Empúries, now joined to the mainland) maintained a syncretic relationship with an indigenous settlement. This seaport was the site chosen by the Romans for the disembarkment which signalled the beginning of the 'Romanisation' process of Iberia. From 218 BC a Roman military camp coexisted side by side with the Greek city and it was used on a more permanent basis after the arrival of Marcus Porcius Cato, towards the year 195 BC. In the late second century BC the camp served as the foundation for a new Roman city. Around 30 BC the two independent cities (one Greek and the other Roman) physically and legally united and became the *municipium Emporiae*. Empúries played a key role in the first stages of Romanisation, but it entered a stage of decline around 300 AD, although it preserved its distinction as an episcopal centre. Later, Charlemagne set up a castle on the top of the islet of Sant Martí d'Empúries.

An administrative history

The process of scientific re-discovery and public reclamation of the site began with the support of the Barcelona Provincial Council in 1908, within the context of the 'Noucentisme' period, an era of special interest in the recovery of the cultural and political identity of Catalonia. With the restoration of democratic institutions in Spain in 1976, numerous efforts were made to transfer the management of Empúries to the Generalitat (Autonomous Government) of Catalonia. Finally, on April 1, 1995, an agreement was signed to this effect.

This institutional act was an historic landmark in the plan to promote the archaeological site which was set in motion by the Barcelona Provincial Council in 1991. It marked the fulfilment of a fundamental goal: to improve the preservation, research and presentation of one of the most significant Classical era archaeological sites in the Western Mediterranean in which the remains of the only Greek colony in the Iberian Peninsula and of one of the most historically important Roman cities in the context of the Romanisation of Hispania are preserved. The general objective in promoting a process of transformation at Empúries between 1991 and 1995 was to establish a new model of management which would enable greater optimisation of resources and an increased capacity for social impact. The model would work through a philosophy of integrating the management of research, preservation and dissemination. Accordingly, a break was made with the traditional bureaucratic administration of the site and a new results-oriented organisation was promoted which considered visitors as end-recipients of the ancient message hidden amidst the ruins, recovered by researchers and presented in an inviting and clear way to all the segments of the audience for this unique archaeological site on the Costa Brava.

The formalisation of the 1995 agreement between the Barcelona Provincial Council and the Autonomous Government of Catalonia enables the integration of Empúries into the Catalonia Museum of Archaeology, along with the Barcelona Archaeological Museum, the Sant Pere de Galligants Museum in Girona, and the Ullastret and Olérdola sites. Hence, this signifies a great step forward which should enable an even more intense development of the potential and accomplishments of Empúries, thanks to the coordination of efforts under the new framework provided by the Generalitat.

In drawing up the Catalonian Museums Act of 1990, the Barcelona Provincial Council backed a plan for the development of the Monumental Site of Empúries. The purpose was to close a long historical period of administration and financing of the site by effecting a change which would link Empúries with a new conceptual and public management model which provided the

conditions needed for further development of the scientific, cultural, social and economic potential of a cultural heritage project which would have an impact on the local area and was clearly intended to become a cultural facility to be used by people from all sectors of society.

The public recovery of Empúries began in 1908. One year after the creation of the *Junta de Museus de Barcelona* (Barcelona Museum Council), of which the main institutional sponsors were the Barcelona Provincial Council and the Barcelona City Council, the enthusiasm and conviction of Josep Puig i Cadafalch (the first head of the successive excavation projects) gained the acknowledgement and support of the Barcelona Provincial Council, headed by Enric Prat de la Riba. From then on the Barcelona Provincial Council took on the financing of the excavations, which were interrupted only during the Spanish Civil War (1936-1939), and the permanent upkeep of the site.

In 1976, after the re-establishment of democracy in Spain, numerous attempts were made to normalise the institutional administration of the ruins through the creation of a board or consortium, unfortunately, to little effect. Throughout the eighties, while awaiting the agreement with the *Generalitat*, Empúries was accorded special attention by the Technical Museum Department of the Barcelona Provincial Council, which brought about significant improvements in services, gardening and signposting. When the Catalonian Museums Act was passed in 1990, the Barcelona Provincial Council signed an agreement with the European Heritage Centre of Barcelona, enabling the creation of the Empúries Project Office, the immediate implementation of new cultural services, and the drawing up of proposals to develop new forms of presentation. After an in-depth analysis of the existing historical and administrative documentation, and of previous proposals, reports and studies, a sweeping three-pronged approach to project development was devised. Firstly, a visitor survey was conducted covering their opinions of their visit and indicators regarding the state of preservation of the ruins, archaeological research and interpretation were collected. Secondly, services which would serve as a driving force of change were promoted. Thirdly, a new model of management in conceptual and administrative terms was designed and justified.

The initial diagnosis made the serious shortcomings of the site's preservation very clear, despite the significant improvements carried out since 1985. It also revealed the need to encourage research efforts and the urgent need to provide new services for visitors and thus ensuring an effective and measurable cultural development. The visitor study provided indicators which enabled us to make decisions on new measures which have now improved the degree of comprehension of the archaeological structures and the main presentation problems encountered by users of the itinerary major difficulties.

This project, initiated in February 1991, was meant to handle the transfer from centralised management under a large bureaucratic administration (the Barcelona Provincial Council has some 5,000 employees and a budget of close to 60,000,000,000 pesetas) to a new, small, independent public non-profit-making organisation.

Since 1991 the development of the project has brought increased revenues to Empúries and a significant increase in the ability to generate new income without affecting the cost of a visit, which has remained unchanged since 1990. This was made possible thanks to a strategy which consists of diversifying the supply of cultural services and outside financing sources and includes the operation of peripheral services with the participation of private companies. The archaeological park at Empúries now has its own trademark, publishing house, activities organiser, permanent centre for the research of classical archaeology, functions as museum and a vehicle for divulging our cultural heritage. The staff has gone from a small group of archaeologists (1991: 1 staff researcher and two part-time aides) to an organisation with a core workforce of over thirty persons including fourteen specialists. To this one must add a

cultural services firm initially sponsored by the Organisme Autònom Conjunt Monumental d'Empúries and also Emporiton, a training workshop for 45 students, whose goal is to create an independent private company devoted to archaeological restoration and the upkeep and improvement of the site.

Recent developments

Between February 1991 and November 1992 the activities undertaken faced all the difficulties affecting any attempt at managing change with limited funding and from a centralised organisational environment. For these reasons, and in order to optimise resources, streamline management and foster the development of the project, the Barcelona Provincial Council adopted a key project proposal: to create an autonomous management environment for Empúries.

This process began in 1991 with the first proposal for budget segregation of the *Museu Arqueològic de Barcelona* (also run by the Barcelona Provincial Council) by the Cultural Service's Technical Museum Department. By 1992, Empúries already had a specific differential economic existence within the budget programmes set forth by the Cultural Service. The next step was to draw up a separate budget proposal including the items thus far attributed to the central administrative structure. Finally, in 1992, a plenary session of the Barcelona Provincial Council approved the Statutes which would from then on govern the Organisme Autònom Conjunt Monumental d'Empúries (OACME), thus creating a Board of Directors, which came into being on January 8, 1993, to which the plenum added two members representing the University of Girona and the Town Council of L'Escala. This additional representation was in keeping with the twin goals of allowing the local territorial authorities to participate in running the site and strengthening institutional co-operation. These two local representatives joined those who represented the plenum of the Barcelona Provincial Council. On April 1st 1993, OACME began its fiscal activity so fulfilling the strategic goal set two years earlier as the prerequisite for development and meeting the project objective, namely to be granted legal existence in its own right.

The Philosophy behind the developmental programme

How can one improve the relationship between the museological message and the visitors to an archaeological park? How can one develop substantial improvements in public comprehension and create a setting which provides a quality cultural experience? How can the presentation of a cluster of ruins be improved? How can all this be set in motion without funds? These are the difficulties facing the heads of many projects when faced with inadequate resources to effect a process of change. There are no concrete solutions.

Empúries is a small-scale project which managed to get off the ground exclusively through tapping its potential development. Without funds, but with much enthusiasm and very clear goals, this site has now become one of the best-equipped classical archaeological sites in the Mediterranean basin in exhibition terms, where a balance has been struck between research, preservation and dissemination. It is already the most visited archaeological park in Spain, and it has a permanent structure and staff involved in research, preservation and presentation.

The Twelve Guiding Principals of the Developmental Programme

Adopt a clear public service awareness. In Spain, the cultural heritage is public property. Therefore, the beneficiaries of our work are the citizens of Europe and of the rest of the world who visit us. Our decisions have to be made in keeping with the public's needs, the monument's needs, and our project-development goals.

Work towards goals. Design a results-oriented organisation, which involves working non-stop to get to know our visitors and the effectiveness of our communication and presentation strategies. Also, analyse the qualitative factors of the visitors' cultural experience and reaction to the site. This principle ordains that we must be agile and simplify all working processes and internal operations as much as possible to in order to concentrate our energy on the application of rigorous and effective criteria regarding the achievement of goals.

Conduct archaeological research in order to know the monument better, renew and broaden its historic message and bring to life the display area. Visitors can now recognise that Empúries is an archaeological site still under research, with a life of its own.

Audience awareness. Decision-making should always be guided by the rationale of ensuring consistency between preservation, research and dissemination while reaching out to different user segments from schoolchildren to specialised archaeologists.

Consideration of the landscape. The site forms a landscape in and of itself. The strength of the cultural experience has to be consistent with the landscape in which the remains stand. The 'landscape of ruins' is one of the basic elements which needs to be preserved in order to create the most suitable setting for a visit to the site, and the strength of the unique beauty of this stretch of the Mediterranean coast must also be tapped.

Display techniques. Use reversible, non-aggressive, techniques to display the use of the remains, and do not restore what history has carved away. Use new information technologies to enhance the interpretation and presentation of the site.

Avoid trivialising the communicative messages.

Orientation of interpretation. Favour the interpretation of the visit as a social experience. A visit to a cultural centre is most satisfying when interaction between a number of visitors is made possible in the context of a relaxed atmosphere where the main characters are not the museum nor display area but the visitors themselves. At Empúries we have always given preference to collective-use services rather than personalised services.

Visitor impact. A cultural visit should be remembered as a personal, non-transferable cultural experience.

Keep goals in mind. The funds needed to start up a project are ephemeral and secondary if we do not have precise answers to the specific questions needed to determine our goals. In many cases, a larger budget simply means greater risk of squandering.

Aim for quality of visitor experience. Measuring success in terms of number of visitors only gives us a usage figure. What is important is to assess the information and the intellectual and personal impact on the visitor. In other words, to appraise the quality of the experience.

Cultural access. Stimulating collective and individual cultural consumption is as important as disseminating the central theme of the site's message.

The significance of Empúries' autonomous nature

One of the problems common to public administrations throughout continental Europe is the organisational and functional difficulties in managing goal-based public services. The organisational nature and the logic and culture of our administrations are more in line with the idea of ensuring compliance with legal and judicial frameworks and the administration of taxes and citizens, which, along with the needs of culture itself, is required in order provide goals-based public services. The bureaucratic and compartmentalised nature of traditional government has been a significant obstacle to providing quality public services in a proactive

quick, dynamic and efficient way. For this reason, the autonomous organisational framework permitted under Spanish law, and in general terms throughout the rest of continental Europe, offers countless advantages to cultural projects when they are developing new models to optimise economic resources, potential, time and energy. Attempts to make decisions more quickly to achieve a closer and more consistent relationship between goals and results and to make the administration more penetrable and receptive to the social and cultural needs of a changing environment, ensuring adjustment processes based on the assessment of results, are basic requirements for modernising public services.

It is not necessary to break with the public sector in order to develop innovative models. However, it is necessary to use legal formula which allow more opportunities to adapt. In keeping with the objective of facilitating the final transfer of Empúries's management to the Generalitat (Autonomous Government of Catalonia), the most suitable formula enabling the development of this first stage of the Empúries development was to create an independent administrative body. Bearing in mind future needs, in which the need to manage a larger area integrating both public and privately-run services was foreseen, the legal status of a consortium was deemed to be the most appropriate.

Throughout this process of change, contacts with the Generalitat were stepped up to enable the agreement which would allow the application of the Museums Act. The main points of the preliminary diagnosis included: the need to encourage research activity in Empúries in relation to its potential as a research centre with international impact; the challenge of preserving structures after over eighty years of excavations and their proper display; the complexity of interpreting Empúries in its archaeological and historical dimensions to a non-specialised public; the possibilities of increasing the site's social impact by designing a management system which ensured a consistent balance between research, dissemination and preservation while optimising resources and generating new sources of income to increase the project's self-financing capacity; and the need to create a working environment which would reinforce the project plans and emphasise the services-based nature of the organisation by breaking down its isolation which had arisen historically because the site was run in the province of Gerona by the provincial council of Barcelona.

This diagnosis, backed by indicators referring to all of the points, made it possible to set the basic objectives of the preliminary document, written in 1991 and submitted to 'Diputació de Barcelona'. The first goal was **to develop one of Spain's most important permanent centres for classical archaeological research**, due to the international importance of the site and its potential for future research. The second goal was, **to promote an integrated archaeological park management model** which would ensure a balance of priorities and the distribution of resources and lines of action between research, preservation and cultural dissemination. The model required was more in line with British experiences in displaying and interpreting cultural heritage which appeared to us to be designed and geared towards public service. Finally, **to open up the management of Empúries, launching new offerings and attractions, and to consider its strategic value from the standpoint of the territorial, economic and social impact** of Empúries as a significant ingredient in relation to the rebuilding of the tourist trade in the Costa Brava region.

Empúries is now a reality in progress. Despite the brief life of the administrative body (OACME) created on January 8, 1993, and the brevity of the preliminary stage which was marked by the creation of the Empúries Project Office, the enthusiasm and capabilities of the human team currently at work on the project is doubtless its primary guarantee for the future. Empúries is no longer an autonomous body as it became part of the Museum of Archaeology of Catalonia on 1 May 1995.

Empúries in 1995

Finances

In four years, Empúries has managed to increase its annual ordinary budget tenfold. This increase has come about thanks to the increased equity generated by the project. At present, only a third of the budget is directly funded by the Administration. The remainder is the result of new services and financial re-investment in increased scientific, preservation and cultural dissemination activities. In this sense, direct subsidies do not even meet total personnel costs. Thus, growth has been achieved without increasing direct Government contributions.

Management structures

In order to ensure management structure consistency and the link between decisions affecting research, preservation and dissemination, Empúries is an organisation that is working towards the integrated fulfilment of its statutory and project-related objectives. Its organisation is

Fig.2. Restoring Roman mosaic pavements.

structured in four basic areas, which are coordinated by the management: the Administrative Section, Archaeology Section, the Information Section and the Emporiton area.

The Administrative Section handles financial and administrative management, personnel management, hiring and general administrative support of the OACME.

The Archaeology Section is in charge of both the museological collection and the maintenance and preservation of outdoor archaeological structures. It is also in charge of developing research and scientific extension projects and the archaeological supervision and development of the Special Empúries Plan (development management plan) in combination with the Town Council of L'Escala. This area also works in co-operation with the Area of Dissemination in planning museological programmes and in the design of new services and publications.

The Information Section is organised into three distinct units. Firstly, the Department of Educational Management, which manages new educational services on offer and also runs the company *Artemis* which is promoted by the OACME to provide training services. Secondly, the Department of Tourist-Oriented Communications and Promotion, with twelve official tour guides. Thirdly, the Department of Public, Infrastructure and Presentation Services, which is entrusted with drawing up visitor studies. The Information Section is in charge of museological development jointly with the Archaeology Area and the Training Workshop Area.

The Emporiton Area, the Empúries Training Workshop, is fully integrated into the Empúries project with the aim of training and promoting a company which may eventually take over the task of preservation and upkeep of the archaeological structures and the museological areas. This project, with an initial duration of two years, was promoted by OACME with financing from the National Institute for Employment in Girona and with the co-operation of the L'Escala Town Council. Forty five students participate in this training workshop which is divided into three categories: archaeological restoration (primarily walls and pavements), maintenance and gardening (museology and general services), and native plant breeding. This last endeavour is concerned with the design of a proposed Mediterranean garden, staff development and the implementation of specific landscaping projects. Landscape projects are not seen as a decorative element but rather as an instrument of a museological presentation that is consistent with the ecological surroundings and the paleo-landscape of the site. The landscape will, in future, function as an instrument to achieve greater overall quality as regards the cultural experience of visiting Empúries. In addition to participating, in a wider sense, in an occupational project of high social interest, the training workshop is achieving a very important improvement in the overall preservation and presentation of the outdoor structures.

The Empúries human team, in which over 90 people participate in one way or another (34 permanent staff members, six technicians from the Educational Services company *Artemis*, promoted by Empúries, 45 student workers from the Training Workshop, and the official guides), is effecting a management of change which goes far beyond the simple growth of the management structure, services or number of visitors.

Transformation

Empúries is in the midst of a transformation from a simple site to a veritable archaeological park, in which, in addition to the development of one of the Western Mediterranean's most significant research projects in classical archaeology, work is being conducted on improving the presentation and display of the ruins and the museological message: Empúries, ancient Mediterranean seaport. There are four main themes: Empúries, instrument in the

Fig.3. The staff of Empúries (March 1995) with museum and administrative building behind them.

Hellenisation of Iberia; Empúries, bridgehead for the Romanisation of Hispania; Empúries, key reference point in the organisation of medieval Catalonia; and the archaeological activity behind the recent 'discovery' of Empúries and the unveiling of its social and cultural impact in the time between Catalonia's 'Noucentisme' period and today.

Infrastructures

Priority actions have simultaneously affected the Empúries project on different fronts, effecting an improvement in the infrastructures. These include an increased supply of electrical power to the facilities, the improvement, equipping and extension of offices, storage areas and security systems and the implementation of a computer system covering all internal needs. We have also developed a software application for managing the archaeological space and the scientific documentation of the site so enabling overall management of such aspects as cartography, filecards including stratigraphic units of an excavation, photographic, planimetric and bibliographical documentation and management of museum pieces, including recording, inventory and location in the museum's storage area.

Archaeological research

As for research, the top-priority 'fronts' include, firstly, the publication of all jobs pending and the documentation of the actions undertaken and completed over the past years. For this reason, OACME is preparing a series of publications ensuring the continuity of the

Jordi Pardo

Monografies Emporitanes, which, in this new stage, will become an annual archaeological publication. The first edition will be devoted to the scientific meeting on common Roman pottery held in Empúries in 1994. Another priority is the sorting of archaeological documentation using the new computerised infrastructure and the refurbishing of all storage areas and the modernisation of storage management. We are also drawing up an archaeological action plan to solve scientific interpretation problems deriving from many excavations conducted decades ago, so hoping to ensure the correct identification and preservation of archaeological structures. Another important priority is the strengthening of scientific relations at the national and international level by entering into co-operation agreements and protocols with archaeologists based elsewhere.

The completion of the project in the southern sector of the *Neapolis* has made it possible to open up to visitors this significant area of the Greek city, consolidating and restoring its structures. The execution of the second stage of the Roman Forum project with the excavation of the *cryptoporticus* (a semi-subterranean structure of the porticoed building enclosing the *temenos* in the temple area) currently under way completes thirty one years of research (the Roman Forum was identified in 1964) into this important urban element of the Roman city.

Work at Sant Martí d'Empúries, the nearby former islet which is now joined to the mainland, has provided exceptional finds of extreme historical importance. The location there of the structures of the first Greek settlement at the *Palaiapolis*, dating from the *Phocaean* disembarkment in the 4th century BC constitutes literal confirmation of Strabo's texts concerning the founding of Emporion. But this work has led to other surprises. Beneath the level of the first *Phocaean* settlement, researchers found remains of an indigenous settlement dating from the late Bronze Age, so documenting a syncretic relationship with the new colonising element. Work conducted in conjunction with the University of Girona at the Santa Margarita and Santa Magdalena churches, located just west of and outside the enclosure, is part of an initiative which will open up and encourage a new front of research: the study of the late Roman and early medieval eras, up to Charlemagne's creation of the County of Empúries.

Cultural Dissemination

In the area of cultural dissemination, priority activities include: the progressive improvement of the site's facilities (new museum displays, development of new outdoor information units); extension of the studied areas, of the Neapolis insulae, the area of the ancient seaport, projects involving houses 1 and 2 of the Roman city and, focusing on the influence of ancient Empúries, outside the park (projects involving the protection and study of the Hellenistic wharf, Sant Martí d'Empúries and, with the co-operation of the L'Escala Town Council, the churches of Sant Vicenç, Santa Margarita and Santa Magdalena); the maintenance of educational services to ensure the optimum use of Empúries as a wonderful teaching resource for work involving the Classical era, attracting a high level of visiting schoolchildren from throughout Catalonia (in 1993 close to 80,000 children visited) and a progressive increase in visits from schools located in the rest of Spain and from foreign schools, primarily in France, Belgium and Germany; and the drawing up of a new plan for the interpretation of the site. The important offering of services managed by the Information Section, has developed into a broad range of free and hired services for schools, including learning workshops, guided tours, teaching folders, activities outside the park, and a wealth of specific educational material.

In the area of cultural services aimed at the general public, different types of guided tours have been designed for groups, organisations, and tour operators. Work is already under way

22

on the improvement and development of the infrastructures and facilities meant for public use, particularly the creation of a restaurant serving Greek and Roman fare. The regular scheduling of theatrical performances, the construction of a new visitors' reception centre, and an increase in publications, are planned.

Preservation

The Emporiton training workshop is drawing up a preliminary list of urgent actions under the direction of Empúries's team of archaeologists assisted by specialists in the restoration of ruins. It is also working in the areas of archaeology and information to complete the 'General Action Programme' which will lead to a significant improvement in the general level of protection and preservation of the archaeological structures. The *Neapolis* is one of the areas in which a thorough consolidation plan is being developed. The restoration and consolidation of walls and other architectural structures there will bring about an important change in the itinerary of the public tour, opening up one of the most interesting areas of the site which has been closed to the public for over a decade.

Visitors to Empúries

Empúries is a cultural project which, albeit under way, still has a long way to go. Its greatest strength lies in the project's broad nature, clearly determined as an instrument in the service of the cultural heritage of the territory. The best way to generate awareness of the significance of this heritage and to enhance the credibility of, and support for, archaeology amongst the general public and institutions, involves treating research as a driving force integrated into broad-based cultural projects which ensure social use and benefits for the entire community. This option, which is not only possible but necessary in the case of Empúries, requires sincere management of the scientific, cultural, social and economic dimensions of the heritage, governed by two fundamental concepts: breadth in the conception and perception of the project, and quality offerings to the public from a project which is available to everyone – from researchers to schoolchildren, from scholars to the general public. For this reason, our satisfaction lies mainly in the increased average time spent at the site, indicting an enhanced cultural experience, rather than in our significantly increased numbers of visitors.

Volume and duration of visits

The number of visitors to Empúries has not only increased; the average time spent by visitors at the site has grown spectacularly (from one hour and ten minutes in 1991 to nearly three hours), as have the level and quality of comprehension of the site and of its historical significance. The number of visitors grew from 198,000 in 1992, when the Empúries project got off the ground and the first visitors' studies and surveys were conducted, to 220,000 in 1993. In 1994, over 245,000 paying visitors visited Empúries. This 19 per cent increase in attendance over two years is due to the combined effects of improvements at the site, the reactivation of archaeological research work, and the enhancement of key public-service elements, including complementary facilities, services, information and altered visiting hours. Empúries is now open to the public 363 days a year, and visiting hours are from 10 am to 6 pm (October-March) and from 10 am to 8 pm (April-September).

The profile of typical visitors to Empúries is that of a couple with one child, travelling in their private vehicle. The development of the Empúries project has not only increased the number of ordinary visitors but also that of organised tour groups, associations or other organisations, and school groups.

Languages

Fifty-three per cent of the visitors come from other countries, and of the remaining 47 per cent the majority come from other Autonomous Communities in Spain (65 per cent, with 35 from Catalonia itself). The volume of visitors by nationality in descending order is Spain, France, Germany, UK, Holland, Belgium, Eastern European countries, Italy, other European countries, followed by the Americas as a whole and then by Japan, Taiwan, Korea and Australia. Clearly Empúries is an archaeological park which caters to an international clientele. This factor has made us give special attention to languages and communication systems. We view the archaeological heritage as a universal communication agent which should be widely accessible.

The languages most frequently spoken by our visitors are: Spanish, Catalan, French, German, English and Dutch, with a progressive increase of Italian. The official languages used at the site for presentations and literature were Spanish, Catalan and English. But after a visitors' study we added French in order to help meet the requirements of our visiting public.

The signs and information panels outside the site include brief texts, drawings and simple diagrams, as well as indicators of the various structures and areas of the city. They are in Catalan, Spanish, English and French.

The brochures handed out at the entrance to all visitors include illustrations, a brief introductory text and general information regarding the services provided at Empúries and other matters of interest. They are published in the following languages: Catalan, Spanish, German, English, French, Dutch, Italian, Czech and Japanese.

Presentation systems aimed at individuals or small groups, for example taped tours that can be used by groups of up to six people, are in Catalan, Spanish, French, English, German, Italian and Dutch.

New community-oriented presentation projects use visual techniques which avoid any reliance on written or spoken language. For example, the Empúries 'multi-visión' audio-visual, one of the most effective and spectacular measures adopted to date has no modern languages on its soundtrack. It which was awarded the LAUS prize in 1992 and a special prize at the 1993 International Festival in Munich, and successfully synthesises the spirit of the project. We worked on this communication to uncover the glory of the ancient stones of Emporiton and to convey their historic message as a priceless legacy, of which we are merely temporary managers at the service of the people. The programme is shown in a mini-theatre, seating 85 people, at the entrance to the site museum.

The audio-visual programme uses conventional slide projectors with three screens: a central screen for narrative purposes, and two side screens where complementary images are displayed. The 'Multi-Vision' audio-visual uses 36 projectors with the Swedish technology 'Dataton' with special effects featuring wind and smell. But the most unique aspect of the presentation is the narration – given the diversity of the languages of the visitors and the idea of developing an innovative concept, the audio-visual programme was created with voices speaking in ancient Greek, Latin and a smattering of Iberian, reading passages of ancient written sources related to Empúries. The creation of a soundtrack expressly made for this production, as well as the preparation of a well researched script, were instrumental in enhancing the museological message of Empúries.

The project was developed jointly with Konic Audiovisuals, a Barcelona-based firm specialising in information technologies, within the framework of a corporate co-operation formula. Its inauguration in October 1992 produced a spectacular increase in the level of comprehension of the site, and of its historical significance, and the demonstration to institutions that cultural heritage can be much more accessible, interesting, thorough and fun for the visitor.

Sadly, the idea that the archaeological heritage is still the province of the scientific community, and that it must be presented following methods conceptualised by archaeological researchers, is still widespread in Spain. Because of this, and because we wanted to distance ourselves from the many banal, trivial, profit-minded heritage presentations which have become widespread nowadays, we gathered together a multidisciplinary team from Empúries which included archaeologists, museologists and a collection of outside advisors, including linguists, designers, musicians, screenwriters and producers, to work on the project.

School groups

School group visitors coming mainly from Catalonia, France, the rest of Spain, Belgium, and Germany, in that order, amount to some 80,000 visitors yearly, of which close to 60,000 visit Empúries as part of a school-related activity. Sixty seven per cent of school groups choose to hire the paying services offered by the park. The rest can visit the park free of charge. This increase in school party visits is due to the availability, previously nonexistent, of free services which include information, visit programmes for teachers and professors, the free distribution to interested schools of a book containing general information about Empúries including suggested tours and learning activities, an inventory of educational resources on Empúries and teaching and topic folders. Paying services for schools include teaching workshops at the museum facilities, guided tours, boat excursions along the coast of Empúries, 'Roman' visits (Story Telling) and a ticket which includes a specialist escort for a full day. Empúries's Information Section has also developed a series of guided tours and activities aimed at adult visitors and tour groups.

Conclusion: Empúries and the social dimension of archaeology

Unfortunately, there are very few examples of integrated management or 'technified' projects in the field of cultural heritage. Empúries is a modest project which stands out in the context of Mediterranean archaeology. Difficulties in the organisation and supply of services by public administrations throughout continental Europe, the lack of close reference models and factors of change in the archaeological world linked directly with public financing, tremendously affect the status of this professional sector, its development and technical empowerment, as well as its social impact.

The prime cause of the restricted development in this field of work appears to be limited available resources which are granted primarily by public administrations. But this reality, rather than being seen as the cause of an adverse situation, must be seen as the norm if we take into account the need to contain public spending and to implement public deficit reduction measures required in the EC by the application of the Maastricht Treaty. Feasibility for the design of new archaeological projects must bear this limitation of traditional funding sources in mind.

Empúries has reached its present stage by applying two basic strategies. The first considers that archaeological, or any other actions, affecting the cultural heritage are a part of a series of cultural transfer processes aimed at society as a whole. This affirmation leads to a services management approach which differs from the traditional bureaucratic model in the context of the reigning public service culture in continental Europe. It aims to ensure that everyone has access to culture, without forgetting that these people have different motivations, levels of education, interests and needs. Social impact initiatives require the design of strategies to provide services that meet the needs of each of the groups into which we can theoretically organise the actual flow of users (researchers, schoolchildren, tourists, individual visitors, groups, age and interest segments, target groups and potential visitors). For this reason,

particular care has been taken at Empúries to ensure a balance between services directed towards the variety of our users. The second is aimed at obtaining results which can benefit from the synergy that can be achieved if cost approaches consistently take into account the necessary intersection of the objectives relating to research, preservation and dissemination. As mentioned previously, the organisational framework is the final element in facilitating the optimisation of the few available resources and energies.

Empúries has implemented an overall project design strategy with specific emphasis on orientation towards social impact. This approach is not just a basic public administrative duty and public-funded research. It is also a key element in gaining social awareness of, and acknowledgement for, the work of generations of archaeologists. It helps to obtain support from sectors that are traditionally far removed from archaeological activity in general. The social recognition of archaeology by society, in addition to being a legitimate outcome of projects such as Empúries, helps to justify greater expenditure on heritage related work. Indeed, the Empúries project set out to manage the three basic dimensions of all archaeological, or rather cultural, heritage related, projects: the integration of the scientific-cultural dimension, the social dimension and the economic dimension of the public display of archaeology.

The high value of archaeology as a generator of culture and enhanced quality of life, and as a factor in regional development, goes hand-in-hand with traditional values of identity, social cohesion and collective memory. Our challenge is to attempt to ensure an intelligent administration of heritage resources, avoiding all predatory, mercenary or corporate uses which could jeopardise the preservation of a site as a legacy for the community. Archaeology helps to tell the story of peoples. The visitor is the main character of the story.

References

Aquilué, X. & Pardo, J. Ampurias, perle grecque et romaine de la Costa Brava. In *Archéologia* 315: 18–31

Pardo, J. (ed.) 1993 *Imatges d'Empúries*. Barcelona: Empúries & Electa España

Pardo, J. 1995 La gestió del patrimoni cultural. In *Interacció '94. Documents de política cultural.* (ed. Diputació de Barcelona), 13–18. Barcelona: Diputació de Barcelona

Pardo, J. 1994 Empúries: un projecte cultural en marxa. In *l'Avenç* 185: 64–7. Barcelona

Bibliography

Benitez de Lugo, F. 1988 *El patrimonio Cultural Español. Aspectos jurìdicos y fiscales.* Granada. Comares

Feist, A . & Hytchison, R. 1990 *Cultural Trends in the Eighties.* London. Policy Studies Institute

McManus, P. M. 1987 Communication With and Between Visitors to a Science Museum. Unpublished PhD thesis, University of London

McManus, P. M. 1993 Memories as Indicators of the Impact of Museum Visits. In *Museum Management and Curatorship,* 12: 367–80

McManus, P. M. & Miles, R. 1993 En el Reino Unido, el mercado es el objetivo. In *Museum Internacional* (Unesco, París) 178: 26–31

Naisbitt, J. & Aburdene, P. 1990 *Megatrends* 2000. London: Pan Books

Schouten, F. 1991 Els Museus dels 90: Tendències i futur. In *L'Avenç* 151: 46–51. Barcelona

Acknowledgement

We would like to thank Dr. P. McManus for her kind help. Her experience in filtering the audiences and public studies was very useful for us, specially at the beginning of this project.

Archaeology and Interpretation
at Old Sturbridge Village

David M. Simmons

Introduction

Embedded within and upon the landscape of the central New England countryside are vestiges of the individual and collective life experiences of a host of generations. Among the thinnest traces are those left by the farmers, artisans, and millers who, together with their families, knew this place in the years between the Revolution and the Civil War. While these people and the relationships they fashioned have long since vanished, the record of their world survives fitfully in town halls and county courthouses, in private repositories, in the objects and structures which once surrounded and enveloped them, and in alterations they made to the broader landscape and to those spaces around which they lived and worked. Clues to a cultural system profoundly different from that which guides our own thoughts and actions today, these bits of evidence are the focus of researchers and curators at the largest living history museum in the northeastern United States, Old Sturbridge Village (OSV).

Established more than 40 years ago, the museum's early defined mission was to recapture the vanished handcrafts and work processes of 1790s-1840s central New England through display and presentation. These were set amidst structures of the period, moved to the site of an 18th century farm along the banks of the Quinebaug River in Sturbridge, Massachusetts. Across the years, the museum's mission has broadened to take a more comprehensive approach to our presentation of the past, focusing attention on landscape and community setting, which have come to life through research-based infusion of the social and ideological dimension. Today, this holistic presentation of life in 1830s central New England, strengthened through a living history interpretation, offers our nearly 500,000 visitors each year the opportunity to explore the complexities of this bygone culture from the perspective of their own. As they wander about the recreated village, museum visitors encounter a number of sights and activities whose interpretation is the result of the most recently introduced research foray into the world of what we call the 'village period'. The impressive bottle kiln, and the interior arrangement and flow of work within, the Hervey Brooks potting shed; the assemblage of dishes and glassware at a farmer's table; discussions by the interpretive construction crew about the sequence of housewrighting; the physical arrangement of the millyard; the use of a kitchen dooryard; the presentation of a blacksmith's home and the subtleties of his work processes at the forge across the road – these and many other everyday activities are founded upon and are, at times, the direct result of, American historical archaeology.

Archaeologists joined the museum's team of research historians in 1977, expanding the disciplinary repertoire brought to bear upon a new project: the plan to create a second museum adjacent to our own, focusing upon the nascent textile industry in the early 19th century countryside. While over the next few years it became no longer economically feasible to

continue the project, historical archaeology had established itself as an important part of our research base. Nearly twenty years later it continues to be a viable, integral, active, and innovative partner in the Old Sturbridge Village ongoing programme of research and education. There are a number of reasons for its success.

In large measure, these are closely related to the successes or failures of anything newly introduced into an organisation through a process of communicating innovations. When the organisational decision unit determines that change is needed and that an innovation or possible solution will be tested, that intention is communicated to the adoption units who will implement or utilise the innovation. Critical to the outcome of the process are the relative advantages, compatibility, and degree of observability of the results of the innovation, determined by both decision and adoption units – in our case museum officers and staff, respectively.

The introduction of historical archaeological research at Old Sturbridge Village has satisfied needs and requirements at both levels. Most significantly, it fulfills the museum's mission by increasing the quality of the historical presentation to the public, it is observable. Archaeology undergirds the authenticity of our exhibits, thereby strengthening the educational posture of the institution. Embraced by historian colleagues in the Research Department for providing answers and clues not forthcoming through other avenues of research, historical archaeology also found favour within other areas of the museum's programme division. Its research provided curators with tight contexts for the presence and absence of a myriad of material remains in and about dwellings, houses, and mills, while affording hitherto unknown construction details about such structures. Historical archaeology also satisfied the desire on the part of the Museum Education Department to expand its curriculum in the area of material culture studies. Working with Museum Education staff, the archaeologists helped develop a non-destructive archaeological component to complement gravestone and architectural studies by elementary students in a local school district. We have worked with these and other elementary through to high school students across the years, introducing them and their teachers to the rudiments of the processes of archaeological recording and excavation.

For the department of interpretation, historical archaeology also addressed clear-felt needs on the part of the staff. Our potters, for example, were frustrated in their attempts, over the years, to comfortably demonstrate to the public their pattern of work within the confines of the potting shed. Enter the archaeologists who, over several seasons, returned to the site of the Goshen, Connecticut shop of Hervey Brooks, which had been transferred to the museum site some twenty years earlier. Their meticulous excavations within and about the shop site, combined with extensive analyses of Brooks' surviving accounts and public documents provided the fodder for a rejuvenated, expanded interpretation at the museum, one which would benefit visitor and interpreter alike. Newly discovered forms and decorative motifs would join others now reproduced in a shop laid out as Brooks had intended. The preparation of clay on a plaster pad, its storage in a brick-lined clay cellar, and the keeping of accounts were now demonstrated along side the throwing of pots within the shop and the process of glazing and firing moved outside. Centrepiece of the new interpretation, the kiln, like the other functional, interpretive changes, had a strong, significant archaeological correlative. Its reproduction and use, consequent to the discovery and materials analysis of nine courses of surviving brickwork, embodies the new dynamism of this exhibit.

The interpretation of the place and products of the redware potter in village period New England communities has been buttressed by the archaeological excavation of the shop sites of three other late 18th/early 19th century potters. In all of these, and other archaeological research endeavours, our staff – blacksmiths, coopers, millers' potters and farmers have been key players. Whether wielding trowel and dustpan in the field, or analysing deed, census return, or account

Fig.1. Reproduction Pottery Kiln at Old Sturbridge Village, Sturbridge, Massachusetts. Archaeologically derived data has helped bring to life the process of glazing, stacking and firing redware pottery at Old Sturbridge Village. The wood-fired kiln requires four cords of wood and two days to slowly heat up to 1900 degrees F. (Old Sturbridge Village Photo by Thomas Neill.)

book entry during a winter project, our interpreters are given the opportunity to work directly with research staff. This hands-on experience is not only a motivating factor for the interpreters, it serves, as well, to strengthen and enrich their interaction with the public, allowing them to speak from first-hand knowledge of a stratum or text. The participation by interpreters in our excavations is equally important to our research effort, as we regularly rely upon their expertise and experience to both locate and interpret the patterning of activities and to identify excavated material culture. We often continue to rely upon their input and feedback, as they test in the flesh the viability of the implications of an archaeologically discovered pattern in the 'living laboratory' of Old Sturbridge Village.

The contribution of archaeological research to the creation and interpretation of an OSV museum exhibit is perhaps best exemplified in our most ambitious project to date: study of the family, work, and community life of an early 19th century blacksmith and farmer named Emerson Bixby. Emerson and his wife Laura spent their lives together in a remote, yet bustling, crossroads neighbourhood in the central Massachusetts town of Barre. Located some four miles distant from the town centre, the neighbourhood, historically known an Barre Four Corners, was nearing its economic and population apex when the Bixbys moved there in the 1820s. Emerson, Laura, and their daughters lived for nearly half a century in their small house, and in the fold of neighbouring artisans, millers, and farmers. Daily routines of working, preparing and consuming meals, entertaining, disposing of refuse, socialising and sleeping, and a myriad of other household activities took place as the girls grew to maturity, learning from their parents the rules of their culture. They each married, leaving Emerson and Laura alone in the home. Emerson died in 1870,

Fig.2. The Bixby House at Old Sturbridge Village, Sturbridge, Massachusetts. (Old Sturbridge Village Photo by Henry E. Peach.)

Laura died nine years later, and for the next 100 or more years the house, still furnished with Emerson and Laura's belongings, was silent, save for summer visits by the Bixby daughters, their families and descendants. The house, together with many of its furnishings, was donated to Old Sturbridge Village in 1981, and in the fall of 1986, the structure was moved to the living history museum, where it was opened in 1988.

The multi-dimensional research providing the holistic framework for the Bixby exhibit was far-reaching and extensive, involving computerised analysis of thirty years of Emerson's accounts; examination and study of the Bixby furnishings; detailed surface, documentary, and architectural study of the broader panorama of the physical and social landscape encircling the Bixby house and painstaking analysis of the architectural fabric of the house itself. Together, this research joined all the other facets of the project which were planned, executed, and evaluated under the guidance of the museum's programme and technical exhibit committees.

What follows here is but one brief portion of the Bixby story, garnered through four seasons of house, home and shoplot excavation in Barre Four Corners. Anchored in our total site matrix and organised in a three-phase progression of change upon the Bixby landscape, it is suggestive of the at times subtle, yet significant, thoughts and decisions which were enacted near the crossroads so long ago.

The first evidence of activity upon the parcel which would be home to the Bixbys took place even before Emerson and Laura were born. Beginning with surface quarrying and roadbed improvement in the 1770s and continuing with the clearing off of the site by fire, raising of the roadbed, building of one or more agricultural outbuildings and a four bay English barn, and harrowing and tilling the site, the early use of the parcel was primarily agricultural. The outbuildings would be removed before the house was built, some of their timbers and ghost moulds being sealed beneath the house's cellar ejecta. The barn, however, would stay, joining the house in the initial structural cluster.

Fig.3. The Bixby Homelot, Barre, Massachusetts. Phase I, c. 1809–1815. (Drawing by Melanie Shook.)

While constructed during the first decade of the 19th century by Daniel Hemenway and son, Nathan, housewright and carpenter, the small, 27-foot-square house would not appear, to visitor or passer-by, to be completed for many years to come. Weathering patterns on its original sheathing indicate that the house was neither clapboarded nor trimmed for an extended period. Inside, only the best room – a place for dining and entertaining, as well as the parental bedroom and occasional workspace – revealed a sense of fine finish.

The asymmetrical form of this three-room plan house, with kitchen extending across its north side, two unevenly sized rooms on the south, and chimney stack and fireplaces off-center, was rooted in the local vernacular tradition and was a form which found expression in a number of neighbourhood and regional structures. Door location offered no mediation between the outside world and intimate family spaces. One road-facing and one gable end door presented entry to the kitchen, while a rear-facing door, surprisingly found to be the formal entry to the house, provided access to the best room.

It was this tightly clustered complex, that Nathan's younger brother, Rufus, purchased in 1809. Spanning Rufus' later tenure and the Bixby's first decade at the site, the second phase was marked by major structural reorientation. An impressive stone cellar drain, patterned after English field drainage systems, was one of Rufus' early improvements, as indicated by its stratigraphic position. Rufus effected the bulk of his site transformations, however, in the area of the kitchen dooryard. From that area, the barn was moved farther back into the lot, a stone wall on its original front foundation somewhat distancing the flow of animals and vehicles from the house. The barnyard was also enclosed, a fence row delimiting the western, ploughed portion of the property from that nearer the house, whose deep, irregularly disturbed, highly organic soils are typical of livestock quartering. Terrace retaining walls were constructed in the dooryard to accommodate the directional shift in traffic flow toward the newly oriented barn, and a shed was constructed in this side yard area.

Rufus' attention to the kitchen dooryard in the early stage of Phase II underscores the functional significance which that area held for the house occupants throughout Phases I and IIa. The patterning of all recovered phased data indicates that this space between kitchen, well, and barn served as the outside hub of family activity. Very little evidence was found for exterior use of the front and only moderate use of the best room doorways. The percentage, by weight, of each soil sample, for example, with particles greater than 2mm in size was highest in the kitchen dooryard, reflecting this yard space's compacted pathways whose traction appears to have been seasonally enhanced by the regular scattering of ashes underfoot. Elevated phosphate readings from this area, together with these soils' high organicity and chicken dung inclusions suggest that barnyard fowl, and perhaps other livestock, were active in the dooryard area. The chickens likely pecked at the table scraps which, again, predominated in the side yard. The distribution of common pins and sewing needles, of pipe bowl and stem fragments, and of broken slate boards and pencils suggests that all family members shared in the strong orientation toward the kitchen dooryard. It is in the patterning of such household rubbish as container glass and ceramics, however, that the ejection of wastes through the dooryard portal is most striking. While significant sherd clusters were found throughout the house yard spaces, bespeaking traditional disposal through the handiest door or window, of the almost 6,900 ceramic fragments recovered from Phase I and IIa loci, more than 80 per cent appear to have been tossed or swept through the kitchen door, becoming clustered near the side yard terrace or cascading down the side-front yard, where they collected in the depressions left from the removal of the early outbuildings.

Rufus' last major structural alteration which, for us, marks Phase IIb, was the building of a wing which connected the kitchen with the shed and also enclosed the well within the house's interior. Constructed not long before his sale of the property in 1824, Rufus' wing was designed to accommodate a chimney and so function as a kitchen. That intention remained unrealised, and the

addition was never ceiled nor fully sheathed. What it did do, however, was to dramatically alter the disposal patterns just described, for the wing bifurcated the front and rear spaces of the side yard.

The home with its expanded, yet still unfinished house, became home to Emerson and Laura Bixby and their three-year-old daughter in 1826. During their tenure within the site's second phase, the Bixbys would effect few changes to the living and working patterns of the Hemenways who preceded them, and they appear not to have altered the architectural fabric or its decoration. In her discard of broken dishes, Laura appears to have used the parlour door and windows more than did Lucy Hemenway, 56 per cent of the London-shaped bowls and 33 per cent of tablewares, for example, emanating from that room during Phase II. This disposal may suggest the common practice, at the conclusion of a meal, of washing dishes in a pan of hot water at the table – the best room we know to have been the primary room for eating. Laura Bixby would make a very bold decision about the way she would dispose of her household ceramics, however, for by the 1830s and continuing throughout that decade, she enacted one of the most dramatic shifts in refuse disposal at the site. During this period, while there continued to be a general scattering of sherds throughout the yard spaces, the overwhelming majority – almost 1000 fragments – were carried down the steps from the wing into the woodshed and tossed back into the wing's crawlspace through a break in the foundation. Analysis of seventeen very distinctive printed, painted, and banded motifs which predominated among this assemblage, indicates in no uncertain terms the deliberate nature of its creation: cross comparison of these motifs from the assemblage to the site's entire 12,000-plus sherd count show that in only nine – or two per cent – of 458 instances were these motifs found in non-disturbed contexts in any other than the crawlspace. Further examination of the ware types within the assemblage suggests the possibility that at least partial explanation for their disposal may lie in their linkage with so many other such ceramic caches of similar temporal frame, whose predominant pearlwares and creamwares have been seen as part of an almost wholesale housecleaning and discard of the 'old' in favour of the more fashionable.

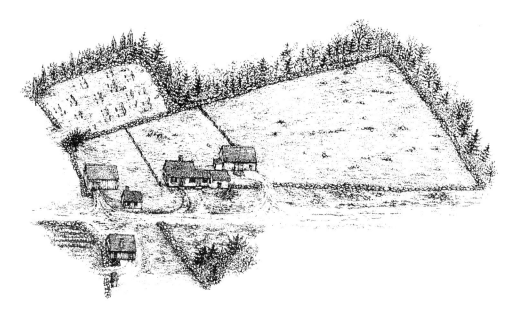

Fig.4. The Bixby Homelot, Barre, Massachusetts. Phase II, c. 1815–1838. (Drawing by Melanie Shook.)

The proximity of these sherds' disposal to the wing, moreover, suggests that space as the potential origin of their breakage. While an 1851 entry in the Bixby account book documents the arrival of a new sink into the household, that new sink may well have replaced an earlier one which had been in use for some two decades. Exit holes through the sheathing, but not later clapboarding, in the area of the well, together with numerous water-laid deposits within early loci in the ground space below, lend credence to the possibility that even in the 1830s, the task of dishwashing was moving from the dining table to a centralised space distanced from the dwelling's main living quarters. What is certainly clear is that a conscious effort was being made, during the 1830s, to begin to clean up the Bixby yard spaces, the majority of ceramic, and even glass and faunal debris being removed from the purview of the household inhabitants, its guests, and passers-by.

It was during the third and final phase, when the Bixbys were to make their most significant mark upon their home, that a new material expression would be evident. In a flurry of activity between 1838 and 1845, as documented through account book entries for building materials, major structural and functional changes were effected to both the house and its lot, changes that would suggest to visitor and traveller alike that, in their own modest way, these folk were transforming their everyday world.

The house's interior spaces were lightened considerably by the plastering of the kitchen and sitting room ceilings and by the painting of the formerly dark, light-absorbing walls and floors with a more reflective light grey color and application of lighter wallpaper. Forty per cent more light, in fact, now entered the small dwelling with the front and rear doors closed and replaced with windows. The change in these apertures necessitated a shift in traffic patterns, with entry now restricted to the house's wing. The mediation offered by that space provided a new level of privacy. The private life of Emerson and Laura and the comfort of their daughters were enhanced still further by the building, in 1844 and 1845, of a two-room addition, trimmed in up-to-date neoclassical fashion. The parents, for the first time, had their own bedroom, which became the most secluded of the downstairs spaces, and the daughters now enjoyed a plastered, finished room which replaced the spare, cold garret that had been their domain for so many years.

During the 1840s the Bixby girls, Eliza, Lucy, and Ruth, entered their teens, initiating a new cycle in the life course of the family. Not only were they in a position to influence familial stylistic choices and preference, as they neared their years of courting and greater socialisation, but the site's documentary and material records suggest that they, like the daughters of other central New England farming families, now contributed, in substantial fashion, to the household economy. Numerous cut leather scraps and sewing equipment found both within the house during its dismantling and within yard spaces as excavated imply that the daughters and Laura were stitching more shoe uppers than a single account book entry with a cordwainer neighbour would suggest. And the many traces of palm leaf and split rye straw and braid similarly discovered, together with a receipt interleaved in Mr Bixby's accounts, inform us that the Bixby women were producing hat materials for exchange at the store of Harding P. Woods of Barre's town centre – the leading regional merchant for that expanding outwork industry. The girls also participated in the family's modest dairy production of butter and cheeses for market, theirs and Laura's workspace expanding into the new dairy room added within the wing and woodshed as part of the house's growth in the 1840s.

The dairy room addition brought an end to disposal of refuse into the no longer accessible wing crawlspace. Reflective of the broader trends of waste disposal after the house's face-lift, the concentration of ceramic discard would now be found outside the rear door of the wing. A great many of the mid-19th century sherds found in this area, unsealed beneath the large door stones, were likely dropped on route to other destinations. For while the immediate yard spaces' ceramic assemblages from Phases IIb and III totalled just more than half of that from the earlier use of the site, it became clear through excavation across the home that broken ceramics and other refuse

were now being carried to the edge of the property and tossed against, over, and even within the stone walls enclosing the lot. Household waste, like the privacy of family members, was being deliberately still further removed from the view of others. Most significant of the archaeological representation of different vessel forms was the increase, in Phase IIb and III of teawares to 37 per cent of the assemblage total, again reflecting upon the Bixby daughters and their social activities.

Laura and the girls' household cleanup treks were not impeded by the barn and barnyard, for in one of the more significant Phase IIb and III changes, Emerson was belatedly heeding the advice of the editor of the *New England Farmer* who, in 1823, recommended that the barn 'be placed at a convenient distance from the dwelling-house and other buildings,'... it being 'disagreeable and unwholesome to live too near manure heaps, and, as it were, in the midst of your herds of cattle and swine'. Account book entry, deed, and strata inform us that Emerson dismantled his barn in 1841, planted a garden in its place, and replaced it with the converted Ethan Hemenway carriage shop which, with its small plot, was purchased that same year.

The Bixby homelot of Phase III would appear a far cry different from the 'low toned landscape' of the Hemenways. 'There is something so pleasing in the appearance of neatness and cleanliness about a dwelling house,' we hear again from the *New England Farmer*, 'that even a stranger, transiently passing by, cannot help being prepossessed with a favourable opinion of those within. He passes along with the idea fixed in his mind of happiness presiding within those walls'. Happiness or not, the transformation a passerby would observe at the Bixbys would, in large measure, be due to the expanding influence of Laura and her coming-of-age daughters, the increase in their orbit accompanied by increase in its remove from the male- sphere.

Through extensive initial and ongoing training of interpretive staff, these and many other aspects of the story of the Bixbys have come to life at Old Sturbridge Village. The setting is the museum's mill neighbourhood, whose component saw, grist, and carding mills, nearby craft shops, and farm

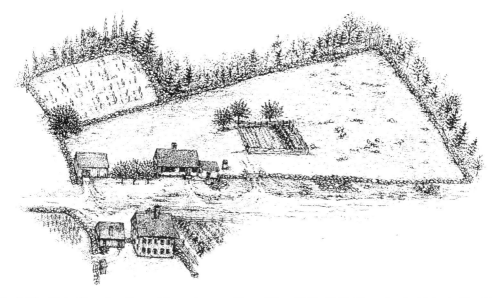

Fig.5. The Bixby Homelot, Barre, Massachusetts. Phase III, c. 1838–1845. (Drawing by Melanie Shook.)

are strikingly similar to the house's surround in Barre Four Corners. Informed by archaeology, the physical setting – the house resting upon a scraggly grass and earth bare terrace, appropriately littered, with garden and outhouse nearby – and the interior configuration and accoutrement, including tea and tablewares, are as the Bixbys knew them. The story, of course, is so much more than the synchronous vision, here presented, of the Bixbys' world of the late 1830s. While there are signs of change in view within the house – the in-progress papering of the parents' bedroom, for example – the entire sweep of the tale, including that which preceded the Bixbys and that which would occur beyond the 1830s, must be orally recounted by trained staff to our visitors. It is a rich, illuminating interpretation of the cultural and economic forces that swept unevenly across the region, forces which would demarcate the traditional from the modern world.

Compatible with cross-disciplinary approaches in its execution, and inter-departmental collaboration in its implementation, historical archaeology provides Old Sturbridge Village with a distinct advantage in its recovery of fragments of the historic central New England landscape. It is significant that these pieces of a past era are brought to life not in the academy – though, of course, they are presented there – but before the wider audience of the museum-visiting public, perhaps the most important and appropriate audience for the fruits of American historical archaeology.

References

McCallum, K. 1993 *A Visitor's Guide: Old Sturbridge Village*. Sturbridge, Massachusetts: Old Sturbridge Village

New England Farmer 1823 Vol. I, No. 45, June 7, 353

Simmons, D.M., 1995 Researching the Contemporary Population of a 19th-Century Museum Village: Visitor Services at Old Sturbridge Village. In *Visitor Studies: Theory, Research, and Practice – Volume 7. Proceedings of the 1994 Visitor Studies Conference* (eds D. Thompson, A. Benefield, S. Bitgood, H. Shettel, & R. Williams) 12–18. Jacksonville, AL: The Visitor Studies Association

Simmons, D.M., Stachiw, M.O., and Worrell, J.E. 1993 The Total Site Matrix: Strata and Structure at the Bixby Site. In *Practices of Archaeological Stratigraphy* (eds E.C. Harris, M.R. Brown III, and G.J. Brown), 181–97. San Diego: Academic Press

Sloat, C.F. 1988 No Soap: *The Story of Dishwashing in the Bixby Household*. Old Sturbridge Village Research Report, Sturbridge, Massachusetts

Worrell, J. 1985a Ceramic Production in the Exchange Network of an Agricultural Neighborhood. In *Domestic Pottery of the Northeastern United States, 1625–1850* (ed. S. Turnbaugh), 153–69. New York: Academic Press

Worrell, J. 1985b Recreating Ceramic Production and Tradition in a Living History Laboratory. In *Domestic Pottery of the Northeastern United States, 1625-1850* (ed. S. Turnbaugh), 81–97. New York: Academic Press

Worrell, J.E., Stachiw, M.O., and Simmons, D.M. 1996 Archaeology From the Ground Up. In *Historical Archaeology and the Study of American Culture: Proceedings of the 1991 Winterthur Conference* (eds B.L. Herman and L.A. De Cunzo). Charlottesville: University Press of Virginia

Changes and Challenges:
The Australian Museum and Indigenous Communities

Jim Specht and Carolyn MacLulich

Abstract

In common with museums around the world, the Australian Museum in Sydney has experienced major changes in several critical areas of its business over the past quarter of a century. This paper discusses some of the factors which initiated these changes and describes how the Australian Museum's relationship with indigenous peoples within Australia and the western Pacific Islands have been altered by them. The most significant changes have occurred within Australia in matters relating to Aboriginal and Torres Strait Islander peoples. The nature and effects of some of these changes on the museum's exhibitions, the repatriation and loans of artefacts, publications, and the employment and training of Aboriginal people are reviewed. It is expected that the next twenty-five years will witness equally major developments.

Introduction

For much of their history, museums have held a position in western societies as authoritative sources of enlightenment and education. The undermining of this privileged position gathered momentum in the years following the end of World War II in response to a changing world order. Over the last ten years, in particular, museums have experienced more fundamental changes than in their entire previous history. What museums do, how and why they do it, have been questioned by their stakeholders in ways that once would have been unimaginable. For long regarded as quiet havens of scholarship and authority, museums now receive attention from all quarters of society for matters other than interesting discoveries or exciting exhibits. Their public role and responsibilities are under scrutiny; their authority and actions have been challenged. In no area is this more evident than in the relationships between museums and the indigenous peoples whose cultures are represented by the artefacts which museums hold and display.

Between 1970 and 1995, the Australian Museum in Sydney was involved in almost one hundred activities relating to indigenous peoples, mainly in Australia and the western Pacific Islands. In this paper we describe some of these activities, and attempt to situate them in the broader social and political contexts of the time. A multiplicity of reviews and histories could be written about this period. What we offer here is a limited appraisal, one with which others may disagree in terms of its selectiveness and emphasis (especially the omission of any account of research projects) but not, we hope, with its intent.[1] We describe how an increasingly complex organisation has sought to relate to, and operate within, an increasingly complex and rapidly changing world. This is an on-going process in which the relationship between the Museum and its society, particularly indigenous Australians, is under continuous negotiation and appraisal.

The Australian Museum – historical summary

Australia was first settled about 60,000 years ago by people who learned to deal successfully with its extremes of environment and unusual fauna. The next major phase of settlement began in

1788, when the British Government set up a colony at Port Jackson, now part of the city of Sydney, as a place of confinement and correction for convicts. This began the alienation of land from the indigenous Aboriginal and Torres Strait Islands' peoples, as well as the attempted destruction of the people themselves. It was within this context that the first museum was authorised in 1827 as a Colonial Museum of Zoology to collect and describe specimens of the unique Australian fauna (Strahan, 1979). This museum subsequently became the Australian Museum.[2] Its first staff member, appointed in 1829, was a convict instructed to collect specimens of the native fauna.[3] Subsequently, the interpretation of fauna was broadened to include the artefacts and skeletal remains of the indigenous peoples themselves as 'lasting memorials', since it was widely accepted that these peoples would die out under the impact of British settlement (Specht, 1979a, 1980). Thus began a period during which the Australian Museum, according to one commentator, 'promulgated the "evidence" of theories that justified expropriation of Aboriginal land and at times the extermination of Aboriginal people' (Rigg, 1994).

Following the loss of most of its artefact collections in the Sydney Garden Palace fire of 1882 (Bolton *et al.*, 1979), the Museum started rebuilding the collections, but with a strong emphasis on Pacific Islands' items, reflecting the extension of colonial, commercial and missionary activities into that area. In 1902, the Ethnological Committee of New South Wales (NSW) was formed under the Museum's curator, R. Etheridge Junior, with the specific objective to acquire artefacts of Aboriginal or Torres Strait Islands' origin, partly to prevent their export (Thorpe, 1931; cf. Specht, 1980). Acquisitions, however, still emphasised the western Pacific Islands. Indeed, for twenty years the Museum acted as the formal repository for the official collections of the colony of Papua. Today, the Museum holds about 100,000 ethnographic items, mostly from Australia, the western Pacific Islands and Southeast Asia. Items from indigenous cultures in other parts of the world, such as the Americas and Africa, have been acquired opportunistically through private donations or exchanges with other organisations. The archaeological collections primarily relate to the history of the indigenous peoples of Australia. Since 1967, the Museum has been the official repository of Aboriginal 'relics' found on certain lands in the State of NSW.[4] The collections thus reflect an emphasis on indigenous cultures, including contemporary art and craft items, but exclude artefacts representing the peoples who arrived from 1788 onwards.

The origins of change

By 1970 the dismantling of the major colonial empires had progressed to the point where the voices of formerly colonised peoples were being heard forcefully in a range of international forums. Not least of these was UNESCO, the General Assembly of which adopted in that year a Convention aimed at preventing the illegal movement of cultural property. In its conception, this Convention was not directed specifically at museums, but one of its outcomes was to focus attention on both the present and past acquisition activities of museums, and to prepare the way for many museums to adopt policies on ethical behaviour when acquiring items for their collections. The Convention highlighted the stark contrast between the 'haves' and 'have nots' in terms of who held and controlled heritage items of the cultural 'others'. This was especially significant for newly independent nations, which now had responsibility for managing the care of their material heritage. Coupled with this was widespread concern among the newly independent peoples to assert post-colonial cultural identities freed from the direct constraints of foreign powers. Discussion on the control and elimination of illegal exports and movements of cultural items inevitably included debate on the failure of former colonial powers to exercise their power and responsibilities to prevent illegal exports during their time of colonial dominance. In this debate museums were high profile targets for criticism and opprobrium.

1970 was also the year of perhaps the most outspoken and violent opposition within Australia,

the USA and elsewhere against the war in Vietnam. This opposition arguably accelerated the redefining of Australian attitudes towards the Southeast Asian region. Hitherto, the largely Anglo-Celtic Australian population focused upon its British and Irish origins. For many Australians, support for the USA in Vietnam was based on fear of Asian communism and reflected a deep-seated distrust of societies not based on a British model. Although Australia was established in 1901 as a nation with its own Constitution and independent of the United Kingdom, many political, legal and emotional ties with the United Kingdom remained.[5] In this respect, 1970 also had special significance for white Australians as the 200th anniversary of the visit to eastern Australia by the English navigator, Captain James Cook. To mark the occasion, the Australian Museum hosted a special exhibition, opened by HRH The Duke of Edinburgh, about Cook's voyages and the indigenous peoples of Australia and the Pacific (Parliament of New South Wales, 1971: 11-12). This was unashamedly an exhibition celebrating Cook as an explorer and navigator, in which the indigenous peoples of Australia and the Pacific merely provided a backdrop for his achievements. Eighteen years later, when much of the nation was celebrating the 200th anniversary of the start of white settlement in 1788, the Museum declined to present a similar celebratory event from its own collections.

In late 1972 the Australian voters chose a non-conservative national government for the first time in twenty three years, when they elected the Australian Labor Party to government under E.G. Whitlam. Although Whitlam's term as Prime Minister lasted only three years, there were many reforms which effected major changes in the nature of Australian society. Not least among those changes were the passing of the first legislation to recognise land-rights for Aboriginal Australians, and the ending of Australia's involvement with colonialism through the establishment of the Independent State of Papua New Guinea in 1975.

The land-rights legislation had special significance, for Aboriginal and Torres Strait Islander cultures and identities are intimately linked to their lands. Until 1967 Aboriginal and Torres Strait Islands' peoples were effectively not recognised as citizens in their own lands. In its original form, the Australian Constitution referred only twice to the relationship between the Australian federal government and the indigenous peoples of the country: once to deny the government the right to pass laws affecting Aboriginal and Torres Strait Islands peoples living in the States, and once to deny those people the right to be included in a national census of population. Both of these provisions were changed by referendum in 1967 (Solomon, 1992: 64-5).[6] These changes, however, did not alter provisions in the Constitution which prevented a national government from legislating for land-rights within the States. This situation was changed only in 1992, and then by the High Court of Australia. The High Court has among its functions the responsibility to interpret the Constitution. Its interpretations have proved at times more effective in causing or permitting change to the meaning of the Constitution than the use of referendums. This is nowhere more evident than in acknowledging Aboriginal and Torres Strait Islander possession of Australia prior to British colonisation. Although several States passed local laws granting Aboriginal rights to lands controlled by them, the 19th century concept of *terra nullius* ('land belonging to no one') remained in place until 1992. In that year, a decision of the High Court in what has become known as the 'Mabo decision' rejected the concept of *terra nullius* (Commonwealth of Australia, 1993).[7] This resulted in the federal Native Title Act of 1993, one of the final, and arguably the most significant, actions of the Australian Government during the International Year for the World's Indigenous People. The impacts of both the High Court decision and subsequent Act are still being worked out.

Mainly about Aboriginal exhibitions

Among its actions directly relevant to museums and their relationship with indigenous peoples, the Whitlam Government established the Australia Council for the Arts, a federally funded arts

and cultural body which included within its structure an Aboriginal Arts Board. In addition to directly supporting Aboriginal artistic initiatives, the Board opened contacts with museums around Australia to encourage them to present these initiatives to their public, particularly through the acquisition and display of contemporary art and craft items. This culminated in the exhibition *Renewing The Dreaming* presented at the Australian Museum in late 1977 in conjunction with the Board. The primary purpose of this exhibition was to introduce non-indigenous Australians to aspects of contemporary Aboriginal life through the 'homelands' or 'outstations' movement (Isaac, 1977). This movement involved a number of Aboriginal communities asserting their rights by moving back to live on their traditional lands, often in remote situations. This began around the time of the 1967 referendum, and received additional impetus from the Whitlam Government's land-rights legislation. The 1977 exhibition, as far as we know, was the first occasion in Australia on which an entire exhibition was devoted to a contemporary issue relating to indigenous people.

In 1973, the Museum mounted an exhibition about contemporary life in Indonesia, *Indonesia Today* (Moore & Freeman, 1973). This exhibition marked a major break from previous approaches to cultural exhibitions, which had been backward looking, depicting the past as if it were the present. The exhibition curator, David Moore, and designer, Jeff Freeman (who joined forces again to produce *Renewing The Dreaming*), sought to dispel some of the ignorance and fear that the Australian public held about its most populous neighbour, Indonesia. *Renewing The Dreaming* went further, presenting the story of the outstations at Amata and Yirrkala as a social statement about Aboriginal people. The objects displayed, assembled from special collections made by the Aboriginal Arts Board, were also a break from the standard approach. Few represented a traditional artefact category: instead, items such as leatherwork, including a horse saddle, wooden carvings decorated with poker-work, and screen-printed cloth illustrated how the outstation communities were attempting to gain some degree of economic independence from the dominant white society. The Museum's acquisition of many of the displayed items represented one of its first steps in documenting contemporary Aboriginal lifestyles, rather than emphasising a virtually timeless 'traditional' period.

The exhibition was subsequently shown at the South Australian Museum in Adelaide in conjunction with the 1978 UNESCO Regional Seminar on museums and indigenous peoples (see below). From a museum insider's point of view, the exhibition established two significant points. Firstly, most of the visiting public were ignorant about what was happening within Australia; the limited media exposure about the outstation movement conveyed little understanding of its realities. The Museum, therefore, had a role to play in helping to dispel that ignorance. Secondly, the exhibition emphasised that Aboriginal cultures neither stopped nor died after 1788, but continued to develop and change in new ways and directions. It was essential, then, for museums to acknowledge this, and to cease presenting Aboriginal cultures as though only the 'traditional' forms were authentic. These points set the pattern for subsequent exhibitions about Aboriginal and other indigenous peoples at the Australian Museum.

The Museum and the Aboriginal Arts Board joined forces once again for an exhibition in 1982 about the art of the Aboriginal women of Yuendumu in the Northern Territory as part of a 'Women and Arts Festival' covering Australia, Indonesia and Papua New Guinea (Khan, 1983). Up to this time, Aboriginal women's art had been overlooked by most museums, which had concentrated on works created by men: men's works were viewed as art; women's works as functional craft (Konecny, 1983). The Yuendumu exhibition was a welcome antidote to this imbalance. Through Kate Khan, Aboriginal Projects Officer in the Museum, a group of nine Yuendumu women from the Yuendumu Women's Museum prepared painted items – such as food bowls – and visited the Museum to perform dances and songs and to demonstrate their art forms.

Khan was also involved with the magnificent exhibition, *The Woven Image* (1990), of woven items made by Aboriginal women of the Northern Territory.

Gender balance is now sought with most exhibitions on cultural themes at the Australian Museum, though occasionally a one-gender exhibition is presented. This happened in March, 1995, when the Museum took part in a nation-wide project to promote and focus attention on women's art in general, and staged the exhibition *Women's Views*. This exhibition featured the works of several Aboriginal women artists, including Aboriginal Education Officer, Sheryl Connors.

The Aboriginal Arts Board also encouraged interactions between museums and indigenous Australians by combining with the Australian National Commission for UNESCO to organise a Regional Seminar in Adelaide in September 1978 on the theme 'Preserving Indigenous Cultures: a new role for museums' (Edwards & Stewart, 1980). This conference brought together cultural spokespersons from the Pacific and Australian regions together with representatives from all levels of all major Australian museums. Most importantly, the conference provided the first significant opportunity for indigenous Australians to speak directly to museum people on matters relating to their cultural heritage. The final session of the conference lasted over seven hours, during which indigenous participants repeatedly criticised Australian museums and their boards of management for their insensitivity, arrogance and exclusiveness. As one non-indigenous commentator expressed it in an understated way, 'The meeting was dynamic, the interfaces sometimes rough ...' (Edwards, 1980:6). After the Adelaide conference, museums had to change. In many respects, the agendas of museums since 1978 have been largely shaped by the criticisms and recommendations of the Adelaide conference. Indeed, the Australian Museum Trust formally adopted some of the recommendations into its own agenda.

One general outcome of the conference was the formation of the Conference of Museum Anthropologists in 1979. The name was deliberately chosen for its acronym (COMA), which many of us present at the early meetings of the group felt was an appropriate way to describe the situation in most Australian museums at that time. COMA was set up as an informal association of Anthropology staff in museums throughout Australia and any Aboriginal or other people who wished to participate in discussion of issues raised at the Adelaide conference; not least among the Aboriginal people were those involved in the development of cultural centres and keeping places. COMA still operates as an informal body, without a constitution or office bearers, but meeting annually and publishing a bulletin. Some museum directors initially viewed COMA with suspicion, fearing that such an amorphous body would be outside their control, and sought to have it integrated with the then national museums' body, the Museums Association of Australia. This pressure was resisted, allowing the group to develop a unique character. Far from becoming an uncontrolled monster, COMA's ability to bring together, on an equal footing, a wide range of people from a wide range of organisations has contributed considerably to maintaining the dialogue between museums and Aboriginal people.

Among the benefits gained from this dialogue was the opportunity for museums and Aboriginal and Torres Strait Islander peoples to discuss projects such as the *Aboriginal Australia* exhibition at the Australian Museum. Planning for this began at about the time of the Adelaide conference. From the start of the project the anthropology person on the project team, Ronald Lampert, insisted on a consultation process with Aboriginal and Torres Strait Islander people. These consultations covered themes, content and design. This was the first time we had attempted such a process within Australia (Lampert, 1986). The exhibition about the Abelam people of Papua New Guinea which opened in 1982 also included a consultation process; this is discussed further below and it is sufficient here to note that this project was much simpler because it focused on one village only, whereas *Aboriginal Australia* covered many groups throughout Australia.

The consultations carried out by Lampert and Philip Gordon, then Aboriginal Liaison Officer in

the Museum, resulted in several fundamental changes to the original plans. Instead of having only a white view of Aboriginal history and archaeology, the exhibition included both views, giving the Aboriginal view priority in terms of its position at the entrance to the exhibition. Two Aboriginal elders, David Mowaljarli from Mowanjum in Western Australia, and David Milaybuma from Maningrida in the Northern Territory came to the Museum to produce, on imitation rock walls, full-scale paintings illustrative of the Aboriginal view. Inside the exhibition the white view of Aboriginal history is represented by a reconstruction of Lampert's excavation of a rock shelter at Burrill Lake, south of Sydney, where the initial occupation is dated to more than 20,000 years ago. When the exhibition is dismantled to make way for a new one in 1997, the 'rock paintings' should become part of the reserve collection, but will present special problems for storage!

There was agreement among the Aboriginal people consulted that the exhibition should not discuss or display any aspects of religion. Consequently, the Museum adopted a position which respected this view, and religion is not featured in the exhibition. This has occasioned comments from visitors who are unaware of the Museum's position on not displaying Aboriginal secret or sacred items; in retrospect, this position should have been made public in the exhibition itself.

The exhibition has an audio section about the many languages of indigenous Australians. The initial concept was fine, until we learned of the death of one of the persons talking in it and featuring in a photograph. In customary law, the person's name should not be mentioned, and to hear the voice would have been equally offensive to the Aboriginal people of her community. This recording, therefore, had to be silenced and the photo removed.

In common with *Renewing The Dreaming*, *Aboriginal Australia* also addresses the present day. A small video viewing area shows films about Aboriginal people made by Aboriginal people. These include a satirical film made by Aboriginal film-makers, *Baba Kiueria*, which reverses the situation in 1788. Aboriginal people are the invaders and act out the attitudes and actions of the white invaders. The Aboriginal invaders, for example, encounter a group of white people holding a barbecue; they ask the name of the place, and when told it is 'barbecue area', this becomes the name of the 'new' country. For many visitors, this film makes points about racism far more clearly and forcefully than any display of objects and words could achieve.

The contemporary theme is maintained throughout the second part of the exhibition. One of the more controversial components is the actual-size diorama of the dry season campsite of Frank Gurrmanamana and his wife[8] of Maningrida in the Northern Territory. This camp was obtained through Betty Meehan, who later joined the Museum staff, and Rhys Jones of the Australian National University, who had worked with Gurrmanamana and his wife for many years. The Museum purchased the dry season campsite in its entirety – including the wooden *bela bula* shelter, all of the personal possessions in use at the time, and the rubbish and sand around the *bela bula*. Gurrmanamana and his wife visited Sydney to help with setting up the display, making sure that items were arranged where they should be. This was actuality 'in the raw', and proved too much for some visitors. One wrote to a local newspaper complaining that visitors do not want to see such things, preferring to hold to a view of Aboriginal people that was pure fantasy. Despite several similar complaints, the *bela bula* will remain until the new exhibition is to be installed. Like the 'rock paintings', this unit will present some very special storage headaches.

The final section of the exhibition was designed to be changed periodically, especially to accommodate small displays that might be proposed by Aboriginal people themselves. This section has become a photography space, showing the work of Aboriginal photographers such as Tracy Moffat and Peter McKenzie promoting Aboriginal issues and causes (cf. Goodall, 1990). Contemporary Aboriginal artworks are also displayed here.

The effect of this exhibition and its development process on other aspects of the Museum's work was very marked. One aspect was the development of new education programs; previously, education had focussed for over two decades on traditional Aboriginal practices and lifestyles. As one of the few sites in Sydney that could be used as a resource in teaching Aboriginal Studies, the Museum was well used by both primary and secondary level students. From the mid 1980s, coinciding with the development of the *Aboriginal Australia* exhibition, education programs expanded to include both contemporary and traditional Aboriginal practices. This change occurred over ten years ago, even though it was not until 1990 that Aboriginal subjects and perspectives became mandatory in some areas of the NSW school syllabus. At present, three Aboriginal staff in the Education Division provide a range of programs from hands-on, activity-based lessons to formal presentations, to exhibitions tours, and to in-service sessions for teachers. After the development of the main *Aboriginal Australia* exhibition, a smaller version was prepared as part of our 'Museum-on-the-Road' program. This smaller version travels to rural centres throughout NSW, where it is set up for use by school groups and the local communities, thus widening the reach of the original exhibition.

The Museum is currently developing a replacement exhibition for *Aboriginal Australia*, to be opened in 1997. The project team for this exhibition is predominantly Aboriginal, and is undertaking far more extensive consultations with Aboriginal and Torres Strait Islander people than was possible for the 1985 exhibition. In large part, this wider consultation is occurring because of the many contacts developed by Gordon in his work with communities on heritage matters. Research has also been undertaken with both indigenous and non-indigenous stakeholders through focus groups, community days, surveys of visitors, tourists, teachers and adult education groups. The content areas have been defined and work is now progressing on the range of interpretive strategies to be used. The content of the new exhibition is likely to surprise and challenge many visitors, since much of it will be based on contemporary issues, rather than 'traditional' Aboriginal life. Another development, which will be part of this exhibition, is the new work on the language of exhibition texts which has been developed at the Museum over the last two years. This work, which provides critical tools, has a potential to enable the representation of Aboriginal cultural practices in a more sensitive and explicit way than has been the case in the past.[9]

In March 1992, the Museum explored more new ground by organising an international conference of several hundred indigenous peoples from Australia, the Pacific and North America titled 'The Future of Australia's Dreaming'. This conference was not restricted to indigenous cultural issues, but went beyond the scope of the Adelaide conference of 1978 to include issues of indigenous land and water rights, law, media representation, and economic and social problems (Australian Museum, 1992). The conference resulted in many recommendations addressed to governments, which lay beyond the Museum's capacity to implement. It generated goodwill towards the Museum, however, and among its lasting mementoes are the signatures of many participants on the large 'banner' displayed during the conference.

When a follow-up conference was proposed for the International Year of the World's Indigenous People (IYWIP) in 1993, the Museum was once again the venue. This second conference, organised by the Environmental Defender's Office of NSW and the NSW State Aboriginal Land Council, covered similar issues to the 1992 conference, but on a more restricted scale. For the IYWIP the Museum decided against staging just one major event, and instead ran a series of activities designed to have both short and long term impacts. Among these were exhibitions such as *Black Art* (Aboriginal children's art works), a range of performance activities, a series of publications about the Museum's collections, and a commitment to improving the Museum's record as an employer of Aboriginal people.

Employment and training of Aboriginal people

The Adelaide conference of 1978 called on museums to train and employ Aboriginal and Torres Strait Islander people in the management of their heritage collections and in the presentation of information about Aboriginal cultures. The Australian Museum first employed an Aboriginal person in 1972, to train with the newly appointed conservator for the Anthropological collections. The timing proved to be totally wrong: there was insufficient office space, no laboratory or equipment, and the state of materials conservation at that time was, to put it mildly, poorly developed. The appointment also coincided with major damage to the Pacific collections due to storm water, and most of the time was spent trying to control the spread of mould. Not surprisingly, the trainee lost heart and moved on. The next employment opportunity arose after the Adelaide conference, when the Museum obtained funds in 1980 under a federal scheme to promote employment of Aboriginal and Torres Strait Islander people. Philip Gordon was appointed to assist with managing the Australian collections. Gordon subsequently took on other duties as the Museum's Aboriginal Liaison Officer, a position which has evolved over the years and is now known as the Aboriginal Heritage Officer. Although a designated position of Aboriginal Collections Manager was created in the mid-1980s, this could not be filled by an Aboriginal person until 1991.

The post-Adelaide agenda adopted by the Trust also called for the appointment of an Aboriginal Education Officer. This position was eventually filled in 1990 with the appointment of Sheryl Connors. Subsequently, the Museum obtained additional training funds in 1993 to employ eight Aboriginal and Torres Strait Islands people for periods between one to three years in Anthropology (two positions), Education, Exhibitions, Materials Conservation, Information Science, Photography and Public Relations. Of these eight people, two left before the end of the training period: one to complete university studies and the other to take up employment in a field more suited to her interests. The funds also allowed the appointment of an Aboriginal Artist-in-Residence, Nikki McCarthy. Her works created during the residency drew inspiration from Aboriginal cultures and the Museum, and formed a stunning temporary exhibition in 1994. Further funding was obtained in 1995 for an additional trainee position in the Education Division. The Museum now has five permanent positions for Aboriginal and Torres Strait Islander people: four in Anthropology, and one in Education, in addition to the trainees.

Among the recommendations from the Adelaide conference was one about museums employing Aboriginal and Torres Strait Islander people to 'responsible positions' in museums. Since 1978, the Australian Museum has had three Aboriginal and Torres Strait Islanders on its board of Trustees. The current representative, Aden Ridgeway, is the Executive Director of the NSW State Aboriginal Land Council. The Museum has also attempted on several occasions to establish an Aboriginal and Torres Strait Islander Advisory Committee to the Trust, but none of the attempts has been successful. The consultative framework that Gordon has developed throughout and beyond the State, however, means that opinions and ideas on policy issues can be obtained more quickly – and as needed – through this network than would be possible through an advisory committee that would meet only a few times each year.

Repatriation and reburial

The holding of Aboriginal human remains by museums is undoubtedly the most sensitive issue that we collectively face. Museums throughout the world have been damned and condemned for holding these human remains, our own no less. Irrespective of how the remains were acquired, and many did reach museums through grave robbing (e.g. Brocklebank & Kaufman, 1992; Murray, 1993: 514-16; Turnbull, 1991), the return and reburial of the remains to appropriate indigenous Australians or their organisations is a critical issue. Unlike the United States of

America, where the Native American Graves Protection and Repatriation Act (NAGPRA) has set legislated conditions for returns, including a deadline for informing tribes about museum holdings, Australian museums have generally acted to forestall the introduction in Australia of legislation similar to NAGPRA. The Australian Museum, as a member of the national body Museums Australia, subscribes to the policy and code on the relationships between museums and Australia's indigenous people set out in *Previous Possessions, New Obligations*, adopted by the Council of Australian Museum Associations (Council of Australian Museum Associations, 1993; Griffin, 1996).

The Australian Museum has been repatriating human remains for 15 years, and almost a half of its holdings have either been returned or are awaiting return. In 1979 the Museum Board of Trustees set up an advisory committee 'on the potential scientific value of remains reaching the Museum from the Coroner's Court' (Lampert, 1983). Many of the Aboriginal remains reaching the Coroner's Court have been accidentally exposed during development or construction projects or as a result of exposure by natural erosion of river banks and sand dunes. Over a four year period, eighty five sets of Aboriginal remains from NSW were received from the Coroner's Court. Of these, twenty two were returned to Aboriginal communities for reburial and fifteen were reinterred locally by the Sydney Morgue because, for various reasons, they were not wanted by the communities.

Negotiation about returns of human remains can be a long, complex and exhausting task. In 1992, Gordon spent three months in Queensland returning remains to eight communities. Yet there are many remains for which provenance data simply are too inadequate (e.g. where only 'S.E. Australia', 'Western NSW' are recorded) to identify an appropriate person or group to receive them at this stage. Until this problem can be resolved, these remains are housed in the Museum's skeletal remains keeping place, along with other remains that communities have requested that we retain for the time being. In one case, it took several years for a community to identify how and where it would rebury remains from its area. The problem of provenancing poorly documented human remains is now being tackled at a national level through a special federal government grant. This project is being managed by the South Australian Museum in Adelaide, the only museum in Australia to employ a fully qualified physical anthropologist.

In 1988 the Museum opened a permanent exhibition about human evolution, *Tracks Through Time*. The Museum wished to show in the Australian section either originals or casts of human remains found at Lake Mungo and elsewhere in western New South Wales, which are among the oldest remains so far found in Australia.[10] We were unable, however, to obtain permission from the relevant Aboriginal communities to do so. The communities also objected to the use of photographs of the remains. The final accommodation allowed us to represent the 'missing' items with outline shapes only. We do not hold, incidentally, any material from Lake Mungo.

Repatriation of artefacts has also been an issue for many communities, and distance has often caused difficulties in holding face to face discussions. In 1994, the Australian Museum returned archaeological materials from the Northern Territory to the Northern Territory Museum and Art Gallery in Darwin, which is better situated to discuss with local Aboriginal people how the materials might be best handled. On the other hand, the Australian Museum has negotiated with communities in NSW and Queensland to set up long-term loans of artefacts, rather than outright returns. Under this arrangement, the Museum retains responsibility to ensure the well-being of the artefacts on loan.

These requests have come from communities which have established or are in the process of setting up their own local museums or cultural centres. Under this arrangement, the Museum acts as an adviser to the community on conditions of storage, handling and display, and periodically checks to ensure that the basic standards are met. In several cases, the borrowing community has asked the Museum to remove the loan items, and to replace them with material from another

region. Contrary to popularly held expectations, not one item has been lost through theft or serious damage during the fifteen years that we have been making loans along these lines. When a loan item was 'stolen' recently from a community museum, the media immediately expected us to cancel our loan program. Our community contacts, however, assured us that the artefact would be returned; and so it was, undamaged, within two days. In this respect, the items are as safe with the communities as they would be in the Museum.

Outreach and publications

Few people who have not visited Australia can appreciate the distances between capital cities and other points in the States. New South Wales is fortunate in being one of the smaller States, yet it still takes about ten hours driving to reach its most distant points from Sydney. Outreach projects, therefore, are essential to deliver cultural services. Since early 1994, Gordon has been managing a NSW-wide outreach programme for Aboriginal communities, funded by the federal Aboriginal and Torres Strait Islander Commission (ATSIC). This program has two main objectives: firstly, to assist communities to develop their own local museums, cultural centres or keeping places through training schemes, workshops and provision of professional and technical advice; and secondly, to help them set up a State-wide network of Aboriginal museums, cultural centres and keeping places.[11] The network has been established and consideration is being given to extending it beyond the State boundaries.

A central feature of the outreach programme is training in basic museum practices. During the mid-1980s, the Museum received funding from the federal government to provide training for Aboriginal people wishing to work in community cultural centres and museums (Thomsett, 1985). All of the training was done in the Museum, and few of those who completed the training have remained in this field. Under the current ATSIC program, however, training is carried out both at the Museum in Sydney as short-term familiarisation visits, and more intensively back in the communities themselves. A central component of the community workshops is Preventative Conservation conducted by Karen Coote of the Museum's Materials Conservation Division. These courses are supported by an introductory collection management manual specially prepared for the project (Pulvertaft & Gordon, 1994). The ATSIC funding also allow for the purchase of some basic equipment, such as a display case, for the community museums and centres. The Museum itself can usually loan artefacts from the relevant area or from one close-by. This scheme in which fourteen NSW communities are currently participating achieves a major objective of the Museum of getting out to the people of NSW, especially in rural areas.

Fundamental to this scheme is a series of low-cost publications about the Museum's Aboriginal collections from NSW (Florek, 1994; Gordon & Patrick, 1994a, 1994b; Patrick & Simmons, 1994; Patrick & White, 1994; White 1993). These are basic catalogues designed to make information available at the community level; copies are distributed free of charge to the relevant communities. A similar project is underway for the Museum's important collection from North Queensland, mostly collected at the turn of the century by W.E. Roth (Khan 1993, 1996). These catalogues build on the national inventory of collections of Aboriginal artefacts in Australian museums prepared by Betty Meehan (Meehan, 1984, 1988; Meehan with Bona 1987). This survey was coordinated through the Australian Museum with funding from the Council of Australian Museum Directors and the Aboriginal Arts Board.

Beyond Australia

Interactions between the Museum and indigenous Australians are a daily occurrence. As might be expected, we have rather fewer contacts with indigenous peoples overseas, but these are no less significant to us. Of increasing frequency, however, are the contacts with representatives of those

peoples living in Australia. Thus, although we do not maintain close links with Maori groups in New Zealand, Maori residents in Sydney from time to time visit the Pacific storage area to conduct ceremonies to keep their *taonga* (treasures) 'warm', and participate in performance programs and exhibition development. Similarly, members of the Balinese community in Sydney have a regular booking to come into the Museum to play the Balinese *gamelan* orchestra; they also teach the *gamelan* to anyone who is interested, including school classes, and frequently present performances of music and dance in the Museum's public spaces.

Whereas these local contacts are directly with senior community members, most of our contacts overseas are with the national and other major museums of the various countries represented in our collections. These contacts fall into three main areas: repatriation, training, and exhibitions. While repatriation covers a wide range of countries within and beyond the Pacific, the other two are primarily concerned with our nearest Melanesian neighbours: the independent States of Papua New Guinea, Solomon Islands and the Republic of Vanuatu.

Each of these countries experienced colonial occupation: Papua New Guinea by the British, Germans, and Australians. Solomon Islands began as a German colony, but later came under British control. Vanuatu, the former New Hebrides, had the worst deal: a joint British and French 'condominium' that was sometimes called unkindly the 'pandemonium'. For several years parts of both Papua New Guinea and Solomon Islands were under Japanese military control during the Pacific War. Although Australia did not have a formal colonial relationship with either Solomon Islands or Vanuatu, both countries were used, often violently and illegally, as labour pools for Australian sugar cane farms and for coconut plantations in various parts of the Pacific (Corris 1972; Docker 1970).

Repatriations beyond Australia

The most important events in the development of relationships between the Australian Museum and these countries in recent times were the gaining of political independence in the period between 1975 and 1981. In each country the approach of independence led to appeals to traditional ways, or 'custom', as part of defining an identity freed from colonial constraints (Specht, 1993). In each case, these were accompanied by proposals for new or redeveloped museums or cultural centres. Papua New Guinea's new national museum was opened in 1977. To mark this occasion, the Australian Museum repatriated seventeen artefacts from various parts of the country as a gesture of confidence and goodwill (Specht, 1979b). This confirmed a resolution of the Council of Australian Museum Directors in 1973, that Australian museums should return, as a gift, 'representative cultural material of Papua New Guinea origin' once the new museum was completed (B. Craig, pers. comm.).

A similar gift, of two canoe prow figures, was made to the Solomon Islands' National Museum in 1978 to mark the completion of a new storage wing (Specht, 1979b). Two returns to Vanuatu were particularly important, because they represented kinds of items no longer available there: a rare vertical slit drum from Efate (Anon. 1981) and a painted barkcloth from Erromango (Huffman, 1985), returned in 1981 and 1984 respectively. In each case, these repatriations were seen from the Sydney end as simple returns, based on the personal links developed between the staff of the Australian Museum and those in the various countries. It was with some surprise, and much pleasure, therefore, that we later received gifts in exchange from each of the countries, maintaining a balanced reciprocity in accordance with Melanesian traditions. The latest phase of exchange occurred in 1988, when the Directors of the national cultural bodies of the three countries were invited to the opening of the major temporary exhibition at the Australian Museum, *Pieces of Paradise*. Each was invited to select an artefact from the collection for repatriation as a gift to celebrate the opening of the new wing at the Australian Museum. On the

exhibition opening day, each country made a reciprocal gift to the Australian Museum.

As part of our policy to make information about the Pacific Islands' collections available to as wide an audience as possible, the Museum produced, with UNESCO support, a summary survey of Pacific Islands' artefacts in major Australian collections (Bolton, 1980). This summary was followed up by an item by item inventory for the Micronesian and Polynesian islands (Bolton & Specht 1984a, 1984b, 1985). The original plan was to cover the Melanesian collections as well, but it soon became evident that the cost of doing so would be prohibitive, and they remain not done. Furthermore, although the inventories were widely distributed in the relevant areas of the Pacific, they were found to be of limited value; the verbal descriptions could not replace an illustration. On the other hand, production of such surveys and inventories was consistent with Australia's ratification of the 1970 UNESCO Convention (Prott & Specht, 1989).

The Australian Museum has also completed repatriations to New Zealand, in one case exchanging a carved Maori wooden bowl for a carved tree trunk from NSW which had been exchanged with the Auckland Institute and Museum in 1935 (Australian Museum, 1983: 10-11). In 1988 a major repatriation was arranged to Canada via the Canadian Museum of Civilization. This repatriation consisted of important carvings which had reached the Australian Museum in 1912 as a result of a touring group of performers from Cape Mudge being stranded in Sydney without funds. The repatriation was arranged as an exchange, with the Canadian Museum of Civilization giving the Australian Museum a major totem pole on display in the Canadian Pavilion at the 1988 Brisbane Expo, plus two complete dance costumes (Hise, 1995). The imposing totem pole is now on permanent display, and one of the costumes was used in a temporary exhibition developed by the Museum in 1991 titled *The Living Mask*. A second stage of repatriation has been discussed but remains uncompleted.

The most recent request for repatriation, still under negotiation at the time of writing, has come from India. The Museum holds a significant collection of village items from near Erode, in Tamil Nadu State, acquired by an Australian Christian missionary early in the 20th century. Few collections of its type apparently exist, and the Tamil Nadu Government is requesting that it be repatriated for a new museum at Erode.

Training and the Pacific Islands

The first Pacific Islander to receive training at the Museum was Francis Bafmatuk, now Conservator at the National Museum and Art Gallery of Papua New Guinea. Bafmatuk first visited the Museum in 1973, and returned for a six month 'refresher' visit in 1994. We have also provided shorter periods of training at the Museum to other museum people from Papua New Guinea, Solomon Islands, Vanuatu and Tonga. With the exception of Vanuatu, the training, as work experience, has been on an *ad hoc* basis.

Under a Memorandum of Understanding signed with the Vanuatu National Cultural Centre in 1995, the Australian Museum will provide a series of training courses at the Centre itself over the next three years, building on previous training and technical assistance provided to the Centre. This training covers both collection management and materials conservation, and is of particular importance as the new National Cultural Centre building was opened in November 1995. As part of the agreement for her research permit to work on the island of Ambae in Vanuatu, Lissant Bolton undertook to provide field training for a member of the National Cultural Centre and now has a continuing program of training for ni-Vanuatu women 'fieldworkers'.[12]

Exhibitions and the Pacific Islands

Working closely with people in the Pacific Islands on exhibition projects can be a complex business, as we found out when developing a permanent exhibition, *The Abelam: a Papua New*

Guinea People. This exhibition, developed between 1979 and 1982, set a completely new direction for the Australian Museum. Hitherto, exhibitions about the Pacific Islands had followed the old-fashioned approach of small sections about various peoples, none in any detail and on a very superficial level. We proposed to build an in-depth exhibition around one group of people, with an emphasis on the present rather than on some constructed 'traditional' past. A two-person team consisting of Specht and Freeman, who had worked with Moore on the earlier ground-breaking exhibitions, visited Papua New Guinea to discuss the project with relevant cultural agencies and government bodies. They were also able to visit a selection of villages to discuss the idea at village level. As a result, the Abelam area was selected, specifically Apangai village.

The Museum advertised for a social anthropologist to manage the project, which would include sending a team of exhibition preparators, designers, photographers and conservators into the field. Quite by chance, we were able to obtain the services of Diane Losche, who had based her doctoral research in Apangai and was well known, therefore, to the village people. Losche commissioned a range of artefacts and several houses for the exhibition, including a scaled-down *haus tambaran* (male cult house), and arranged for two senior Apangai men, Narikowi Konbapa and Neru Jambruka, to visit Sydney for two months to supervise the exhibition installation. This included the setting up inside the *haus tambaran* of a display of artefacts for a male initiation rite. In Abelam custom, women and uninitiated men are forbidden to see such displays, but by working together with the people of Apangai the Museum was permitted to present it. In the comparative tradition of Anthropology, Losche included references to white Australian culture throughout the exhibition, the most famous of which, perhaps, was a wedding cake to illustrate that the decoration of ceremonial food is not unique to, or unusual among, the Abelam (Losche, 1982a, 1982b). *The Abelam* was a high maintenance exhibition which rapidly aged. By the time it was dismantled in 1993, it had certainly passed its 'use by' date.

In 1988, a temporary exhibition about the Pacific Islands, *Pieces of Paradise*, was presented at the time when the rest of Australia was celebrating 200 years of white settlement. *Pieces of Paradise* marked the opening of a new building with temporary exhibition spaces, library and collection storage areas. The exhibition was about the Pacific Islands, but not on one continuous theme. Some visitors found this confusing; each of the eighteen 'concept units' looked at a different topic, according to the geographical/cultural region being represented. In describing the exhibition as 'a revisionist presentation', Stanley (1993: 328) identified one of the main purposes of the exhibition: to make visitors look at artefacts from new perspectives. Thus, the Middle Sepik River section was not about Middle Sepik ritual, but about the way that local memory and legend has retained elements of a major transformation of the landscape from an inland sea to a vast low-lying swamp. The Small Nambas section from Vanuatu was not about initiation and grade-taking, but about the desire of the Small Nambas to insulate themselves from the pressures of social and political change that were threatening their existence. The Gogodala section depicted a cultural revival movement, in reaction to oppressive practices of a fundamentalist Christian group. For the Trobriand Islands, the theme was indigenous aesthetics – a topic largely ignored by museums (Specht, 1988). Some visitors, however, saw only an array of beautiful artefacts and regarded it simply as an exhibition of 'tribal' art, which was not its intention! In that sense the exhibition was not successful, but it revealed some of the varied ways that artefacts can be re-interpreted or re-contextualised.

Following *Pieces of Paradise* in 1989, we tried another experiment in exhibition development, *Taonga Maori*, in conjunction with the National Museum of New Zealand (Anon., 1989). The concept was derived from the highly successful *Te Maori* exhibition which toured the USA in the middle 1980s. As with *Te Maori, Taonga Maori* was effectively curated by Maori people, who were consulted on which topics and artefacts could be included and what the exhibition texts should say

(these were bilingual Maori and English). The exhibition departed from the *Te Maori* model by including women's items and items representing contemporary Maori artists. The exhibition had a formal Maori ceremonial opening and closing, and visitors were greeted by Maori people who acted as guides. Sydney has a large New Zealand-derived population, many of Maori origin. These close contacts have since been maintained through Maori elders periodically visiting the Pacific storage area to pay respects to their *taonga* as well as to advise on matters of protocol relating to the care and storage of the *taonga*.

These exhibitions were at the large end of the scale. Smaller and less complex exhibitions also have an important contribution to make. For three of these we teamed up with the Macleay Museum, University of Sydney. The first two, prepared by Beth Hise, presented selections of the Australian Museum's Inuit and African collections. The third was about an aspect of our current archaeological research in Papua New Guinea. At the end of her 1993 research season in West New Britain Province, Robin Torrence (Australian Research Council Fellow in the Australian Museum) organised a small exhibition about her project's work at the Provincial Cultural Centre, and this was developed further by her and Sarah Colley (University of Sydney) as an exhibition at the Macleay Museum. Titled in Pidgin English *Luk luk bek long taim bifo* (loosely paraphrased as 'Looking at the Past'), this exhibition was subsequently opened at the National Museum and Art Gallery of Papua New Guinea in 1995.

Redefining stakeholders

During the twenty five years since 1970, there have been many changes in the relationships between the Australian Museum and its 'community', the stakeholders who through their taxes make the Museum possible. To these have been added another group, the cultural stakeholders with interests and rights in the collections held in the Museum. Although often small in number and physically distant from the Museum on the College Street site, these cultural stakeholders hold a significant position in our strategic planning and daily activities, and are specifically targeted in our corporate strategic plan.

The emergence of these cultural stakeholders has been a long, uneven and, at times, difficult process. It would be foolish to pretend that the current situation is perfect or has been reached without occasional mistakes. This latter point was brought home to us during the temporary exhibition *Beyond The Java Sea: Art of Indonesia's Outer Islands* in 1993. This exhibition was prepared overseas, with no curatorial control exercised by the Australian Museum. It was intended to introduce the Australian public to peoples of Indonesia from islands other than Java and Bali. Indonesia has a richness of cultural diversity little appreciated by most Australians, for many of whom Indonesia consists of a holiday destination in Bali. One commentator viewed the exhibition as a political act by the Indonesian government and quoted Agio Pereira, chairperson of the East Timor Relief Association in Australia as saying that it was 'part of Indonesia's cultural offensive and a main component of their foreign affairs policy' (Cronau, 1994: 32). Of particular concern were items allegedly from East Timor, and two *korwar* human skulls from the island of Biak. Ironically, having castigated the Australian Museum for displaying these skulls, the commentator then included a photo of one of them in his article. There is obviously much yet to be learned on several sides.

In one sense, there is no such thing as the Museum's 'community' – rather, there are several. Sydney has become a cosmopolitan city of great cultural diversity in the last half-century. Previously, the population was dominated by people of Anglo-Celtic origin, but this has been diversified by migrants from all parts of the world. Among these migrants are Pacific Islanders, Indonesians, Chinese, Vietnamese and others from Southeast Asia and the rest of Asia, as well as Africans and Native Americans. All such communities have items of potential cultural relevance in our collections, and we are now exploring ways of making these more accessible.

One avenue that is proving successful is *Our Place*, an experimental community access space which opened in 1994. Together with a permanent display section dealing with identity and contemporary Australian society, *Our Place* provides space for community groups to mount their own small exhibitions, as well as a central performance area. During the eighteen months that *Our Place* has been open, the Museum has co-developed twelve exhibition and performance programs in partnership with sixty six different youth groups, including Aboriginal youth groups and inter-city schools; ten African community groups; groups from the Sydney Italian, Indo-Chinese and Croatian communities; Latin American women's groups; and various community centres, community arts networks and dance groups, city councils and hospitals. Plans currently underway include a project with Pacific Islands' community groups in Sydney to present a festival of performances and displays; another project will provide young offenders from various cultural backgrounds in detention centres with an opportunity to display their artworks. The mounting of these programs has made a small but noticeable difference to the composition of our audiences, and to the general view of the Museum as more accessible to and inclusive of our diverse range of stakeholders.

Getting to know our cultural stakeholders and their wishes has been a challenging but exciting experience. The many and varied interactions between Museum staff and indigenous peoples have taken us far beyond where we were in 1970, or where we expected to be today. The Museum staff has had to change to meet the new challenges, as the Museum has grown in size, complexity and scope of its activities.

Past, present and future

We started this paper with reference to several factors external to the Australian Museum which we believe played some role in influencing our responses to the changing world. That summary is clearly over-simplified – it takes no note of small events of local impact, and may even make the Museum seem as though it is only reactive. That is not so. The Museum's Mission Statement specifically identified a role for the Museum to be pro-active in raising public awareness across a wide range of issues. Nowhere is this more important than in the area of the indigenous peoples, especially the indigenous Australians. While this paper has focused on the relationship between the Museum and indigenous peoples, we must not lose sight of another key role that the Museum can and must still play: that of providing opportunities for gaining an understanding and appreciation for the cultural 'others' who contribute to the diverse nature of Australian society. All, however, must acknowledge, as does the Museums Australia policy on museums and indigenous peoples, that the indigenous peoples of Australia have primary rights over the migrant cultural 'others'.

This is perhaps seen most vividly in the Report of the Royal Commission Inquiring into Aboriginal Deaths in Custody. This Royal Commission was established to determine why so many Aboriginal and Torres Strait Islander people die while in police custody. One of its key recommendations is Recommendation 56, which notes that:

> many Aboriginal people have expressed the wish to record and make known to both Aboriginal and non-Aboriginal people aspects of the history, traditions and contemporary culture of Aboriginal society. This wish has been reflected in the establishment of many small local community museums and cultural centres. ... The Commission recommends that government and appropriate heritage authorities negotiate with Aboriginal communities and organisations in order to support such Aboriginal initiatives (cited in New South Wales, 1994).

To achieve this objective, institutions such as the Australian Museum have an important role to play. Along with other government agencies, the Museum is required to make an annual report to

the State Government on what activities and actions it has carried out each year which contribute to the implementation of this recommendation (e.g. New South Wales, 1994).[13] The Royal Commission Report will continue to have influence for many years to come.

The last twenty five years have seen – certainly within the State of NSW – indigenous Australians having a much greater control over the management, care and presentation of their cultural heritages, be they artefacts in a museum collection or sites in the landscape. The *Report of the New South Wales Ministerial Task Force on Aboriginal Heritage and Culture 1989* offers some specific strategies to achieve this (New South Wales, 1989). One of its central recommendations is one to establish a State Aboriginal Heritage Commission, and several possible models were proposed. While we cannot guess what will happen, particularly which model, if any, will be adopted, it is reasonable to assume that the degree of Aboriginal control and involvement in museums will continue to increase.

It is perhaps in this area of Aboriginal and Torres Strait Islander involvement in and control over heritage collections and their presentation to the world that the most significant change has occurred since 1970. Back then, as our overview has tried to indicate, the Museum was reacting to outside influences originating either within the federal political arena or within the international arenas of UNESCO and the decolonisation process. The last decade in particular has seen a shift to the Museum responding to more local influences and events. The more distant forces still exist, but in modified form, and the Museum must continue to respond to them.

The period since 1970 has been one of constant experimentation for the Museum. Sometimes the experiments worked, sometimes they were not as successful as we had expected or were only partially so. None, however, can be regarded as a failure. No doubt the future will be similar; when navigating uncharted waters, yesterday's maps have little value. What will be critical will be the ability and willingness, on all sides, to take risks and to be prepared for occasionally falling short of the desired outcome. Since 1970 we have been fortunate in having supportive managements, Trusts and governments that allowed for these risks, even in times when resources were scarce; without that support, little could have been achieved. Fortunately, many of the things that we have attempted were comparatively inexpensive. The current relationship between the Australian Museum and indigenous people has been built on personal relationships which have permitted a degree of trust and obligation on both sides. This is a critical quality that must be protected. Much remains to be achieved, however, as we are frequently reminded (e.g. Fourmile 1992). As Gaye Sculthorpe (1989:24) has observed in her review of developments in the Museum of Victoria: 'Aboriginalisation in the Museum is a continuous process'. There is no simple, quick answer. The next twenty five years will bring their own challenges and we cannot predict their nature but, we believe, we will have a firm basis on which to meet them.

Acknowledgments

This paper draws upon the efforts and commitment of many people in the Museum over a long time. In presenting this overview, we are acutely aware of their contributions, but space prevents us from naming each and everyone of them. Three colleagues in particular, however, must be mentioned: Philip Gordon, Aboriginal Heritage Officer, and Sheryl Connors, Aboriginal Education Officer. To them both we extend our thanks for their support, advice and guidance over the years. Phil and Sheryl in particular have been central to many of the achievements described here.

We are also indebted to Des Griffin, Director of the Australian Museum (1976–1998), whose vision and support were crucial to achieving the progress described here. Having the will to try something is important, but to allow it to happen is visionary. All three colleagues commented on an earlier version of the paper, and its final form owes much to their criticisms and suggestions; none, however, is to blame for its deficiencies.

We extend our thanks to past and present colleagues who contributed to shaping the Museum's present and future, especially David Moore whose contribution is only now receiving recognition, and to the many indigenous people who have shared in the events we describe. Their commitment and dedication have been critical.

Footnotes

1. The authors of this paper are white, tertiary-trained museum staff. We were participants in many of the events described here, and for this reason can provide one view of them. In doing so, we have been greatly assisted by our Aboriginal colleagues at the Australian Museum, particularly Philip Gordon and Sheryl Connors who were central to many of the events and developments described here. We thank these colleagues for their advice and information, but do not expect them necessarily to agree with all of our interpretations or opinions. We look forward to other representations of the events of the last twenty five years, developed by both indigenous and non-indigenous writers.

 We have omitted discussion of the influence and effects on the Museum created by the various research projects of the Division of Anthropology. This field research takes us into special situations and relationships with indigenous peoples. Within Australia we have archaeological projects on the Aboriginal occupation of the Port Jackson catchment in Sydney (V. Attenbrow); a megafauna extinction project in western NSW (J. Furby and R. Fullagar); a rock art project in Arnhem Land (P. Taçon); and a study of Aboriginal stone tool use and subsistence in the Kimberley (R. Fullagar). Beyond Australia there are archaeological projects in Papua New Guinea (J. Specht, R. Torrence) and social anthropology and material culture projects in Vanuatu (L. Bolton) and Solomon Islands (L. Bomshek).

2. The name 'Australian Museum' was adopted in 1836, when the colony of New South Wales was regarded by the British as Australia. At that time, the colony embraced the entire eastern part of the continent. Despite moves to change the name after the National Museum of Australia in Canberra was established in 1980, the name has survived as part of institutional history. The Australian Museum operates under a Trust regulated by The Australian Museum Trust Act of the Parliament of New South Wales.

3. The first staff member specifically designated to look after the Museum's artefact collections was W.W. Thorpe, a completely untrained person who was appointed as Ethnologist in 1906, the same year that Australia assumed colonial control of Papua. Following Thorpe's death, F.D. McCarthy and E. Bramell became the first tertiary-trained Anthropology staff. The Museum now has a Division of Anthropology with fifteen staff filling the equivalent of thirteen full-time positions. Four of these positions are reserved for persons of Aboriginal or Torres Islander descent.

4. Since the National Parks and Wildlife (NSW) Act (1967), the Director-General of National Parks and Wildlife has had the authority to place the State's Aboriginal 'relics' in the care of the Australian Museum. The definition of 'relic' used in this Act includes human remains of Aboriginal origin, a discriminatory provision that is under review at the time of writing.

5. Few non-Australians realise that even today Queen Elizabeth II is officially 'Queen of Australia'. The Australian Governor General is appointed to act as her representative. The severing of this last major formal link with the United Kingdom is currently a matter of considerable debate within Australia.

6. This was a most unusual occurrence; in the ninety or so years since federation, the Constitution has been changed on only eight of the thirty-eight occasions on which referendums have been presented to the Australian voters (Solomon 1992:4). One reason for this low rate of change is that the Constitution can only be changed through a referendum carried by a majority popular vote in a majority of the Australian States.

7. The High Court case began in the Queensland Supreme Court as an action by Eddie Mabo and others from Mer Island in Torres Strait against the Queensland Government's refusal to acknowledge their possession and ownership of Mer Island and its surrounding reefs and waters.

8. Since it was the death of Frank Gurrmanamana's wife which led to the changes in the language section of the exhibition, it would be inappropriate to mention her by name in the text.

9. The following text written for the 1985 *Aboriginal Australia* exhibition illustrates how meanings can be constructed implicitly though, in this case, unintentionally:

 > *The Killing Time*
 > *When Europeans arrived, the way of life of the Warlpiri was changed. The best land was taken over by Europeans for cattle and sheep and the Aborigines had only the desert land to live in. In 1928, a severe drought forced the Warlpiri people from the desert. Some tried to get food and water on the better land and fights broke out. A large group of Warlpiri people were killed by Europeans. The Warlpiri refer to this as the Killing Time. Those people who remained became dependent on European society and were resettled at government controlled townships like Warrabri and Yuendumu. There, many people were alienated from their own country, their dreaming sites and their spiritual guardians.*

 In an analysis of this text, Ferguson *et al.* (1995) state that, on first reading, this text looks progressive as it openly acknowledges violence against Aboriginal people. It seems to acknowledge an Aboriginal point of view and uses an Aboriginal title as the text title. But an examination of the grammatical structures shows implicit meanings in the text. The focus, the beginning, of the text is 'Europeans' rather than Aboriginal people. The major point which is emphasised throughout the text is whether people actively shape their life or are acted upon by external factors. Throughout the text the Warlpiri are constructed as passive, acted upon by drought, European decisions and other events. Some of the events (changes in lifestyle, fighting, resettlement) just happen. When the Warlpiri people are active, even this is limited: they 'tried to get food', 'refer to ... the Killing Time', 'became dependent'. Europeans, on the other hand, are active throughout the text. However the most violent act – 'A large group of Warlpiri people were killed by Europeans'– is in the passive voice, lessening the impact.

10. Lake Mungo and several other 'lakes' are parts of an old river system with lakes which dried up in the last glacial maximum. Large sand dunes around these lake beds contain evidence of Aboriginal occupation at about 25-40,000 years ago. Human remains found in these dunes are among the oldest physical evidence for the early people of Australia.

11. 'Keeping places' are not museums in the normal sense, but locations – of any kind – where cultural items are looked after by and for Aboriginal people themselves. This applies

especially to items such as secret/sacred objects and human remains, access to which requires strict controls.

12. For general information on the range and nature of museums and cultural centres in the Pacific Islands, see Eoe & Swadling, 1990. The Vanuatu National Cultural Centre has developed along lines rather different from those of other Pacific museums, by emphasising the encouragement of rural activities rather than concentrating on a major central facility. The rural emphasis has seen the establishment of local people as 'fieldworkers' in their own areas, to record and to encourage customs. In keeping with those customs, there are both male and female fieldworkers.

13. In December, 1992, the Council of Australian Governments (federal and State) endorsed a document committing them, among other things, to:

> empower Aboriginal peoples and Torres Strait Islanders to protect, preserve and promote their cultures and heritage, recognising that their unique cultures are Australia's indigenous heritage (NSW Office of Aboriginal Affairs, 1995).

Addendum 2000

There is a constant renegotiation of the relationships between museums and indigenous peoples. We have been asked from time to time about our policies on these relationships and inquirers have often been surprised to learn that they are brief, sometimes very general and flexible. Some derive from government policy, others from our national body Museums Australia. These and various international standard-setting instruments adopted at the federal level provide the operational frameworks with which to deal with the complexity and diversity of situations that we encounter.

Since the original chapter was written, much has happened, but here we can mention only some of the activities and events. The 'rock art' section of the former *Aboriginal Australia* gallery has been relocated to an Aboriginal cultural centre in New South Wales, rather than remaining a 'dead' item locked away in storage. Similarly, our Balinese *gamelan* is now at the University of Sydney where a range of students as well as the Balinese community use it. The space allocated to *Our Place* is now part of our new *Indigenous Australians: Australia's First Peoples* gallery that opened in 1997. In its place, a new project titled *Viewpoints* has replaced *Our Place* as a community access program in a different location. In 1998, the Museum embarked on an ambitious off-site project known as *djamu Gallery* (see below). The outreach program for Aboriginal museums and keeping places in New South Wales has expanded and developed. The national project on the provenancing of human remains of Indigenous Australian origin has been completed, though its final report is still awaited. With the project's completion, the position of physical anthropologist at the South Australian Museum also ended, and currently no Australian museum has a staff member fully trained in biological anthropology or physical anthropology. The States and the Commonwealth Government are cooperating on a project to secure the return to indigenous people of human remains and secret/sacred objects held by museums. In some respects the situation for museums is becoming easier, as indigenous people are more actively involved in defining the future role and management of their heritage collections (e.g. Janke, 1998).

The new gallery *Indigenous Australians: Australia's First Peoples* opened in March 1997. The exhibition project team of indigenous and non-indigenous staff ensured that a number of conceptual shifts and new practices were employed in its development. From the outset, the team sought to include contemporary issues and to ensure that the voices and stories of the indigenous people would be prominent (Griffin & Sullivan, 1997). As a commitment to this, the exhibition

occupies more than twice the space (over 1000 sq m) allocated in 1985 (less than 500 sq m), and much of its content was developed and implemented by indigenous Australians. Extensive front-end evaluation with indigenous and non-indigenous people helped to form its major concept areas, identify communication strategies, and define a contemporary focus and positive messages (Sullivan & Connors, 1997). The resulting redeveloped concepts were tested with focus groups which gave widely divergent reactions. Indigenous respondents felt that the exhibition would not be sufficiently hard-hitting, whereas non-indigenous people said that it would be too confrontational. Six themes were eventually presented: Spirituality, Cultural Heritage, Family, Land, Social Justice and the Future (Sullivan & Kelly, 1997).

In addition to the consultative process, indigenous artists were commissioned to produce several key components. These include a maze of artworks by Kevin Butler based on his experiences as one of the 'Stolen Generation' which saw many Aboriginal and part-Aboriginal children removed from their families as part of the assimilation policy that persisted until the late 1960s. More than twenty audiovisual oral histories and six multimedia programs ensure that the indigenous voice is literally heard throughout the exhibition. This indigenous presence is reinforced by two Indigenous Interpretive Officers who staff the gallery. Their role is to discuss and explain the exhibition and its themes with visitors, and to present a range of activities. The exhibition is further supported by education programs for students from kindergarten to tertiary levels.

The most controversial section is that dealing with Social Justice. There is a replica of the Freedom Ride Bus that toured rural NSW in 1965 to protest against and expose racial discrimination. The problems of different cultural processes operating under a single legal system is explored in a recreated courtroom, with a replica of a prison cell to focus attention on the *Report on Aboriginal Deaths in Custody*. A smaller version of the exhibition is travelling throughout New South Wales under the Museum's 'Museum on the Road' program. Additional outreach support is provided to schools through a series of Museum-In-A-Box units covering the major themes of the exhibition.

In addition to an average of two temporary exhibitions per year on indigenous themes from Australia and the Pacific Islands, the Museum launched a special initiative in December 1998 known as *djamu* Gallery. The word *djamu* comes from the local Sydney Aboriginal language and means 'I am here'. The gallery was on the second floor of the former Customs House at Circular Quay, the site of the original appropriation of Aboriginal land by British settlers in 1788. The gallery was to operate as part of the Museum, but with freedom to explore themes and modes of presentation of exhibitions and other programs relating to the indigenous peoples of Australia and the neighbouring regions. This was a high-risk venture, without specific additional funding, and using non-standard museum approaches for the presentations. The experiment was successful in engaging indigenous participation and support and exploring new themes with old items. Indigenous people acted as curators and were supported by indigenous Australians and Pacific Islanders as exhibition hosts. Over an eighteen-month period, fourteen projects were presented, drawing primarily on the Museum's collections. Unfortunately, severe financial problems with the Museum's overall budget led to the gallery's closure in June 2000.

Repatriation has continued. In December 1997 the Museum returned to the Larrakia people of the Darwin area, Northern Territory, several items of ceremonial significance. The negotiations with the Government Museum in Chennai (Madras), India, were completed and in February 2000, thirty-three items were returned. At the time of writing, two other requests for repatriation – to Pacific Islands' nations – are under consideration.

The Aboriginal Museums Outreach Program for New South Wales has continued to expand, and the Australian Museum's Aboriginal Heritage Unit (AHU) now has projects in every part of the State. The activities vary considerably according to local need and resources available, and can

involve expertise from several areas of the Museum. At one end of the spectrum, there are small projects operating from a multi-purpose community building, and at the other end there are purpose-built facilities that will need a regular income stream to keep them viable. An evaluation of the outreach program underlined indelibly that there is no simple formula for the delivery of cultural services to remote communities. The AHU has developed a page on the Museum's website (http://www.austmus.gov.au), and is exploring how this can provide support to the communities. This will include giving electronic access to the catalogues of the Museum's holdings of Aboriginal artefacts and images from New South Wales.

A similar outreach project is under way in Victoria, and in 1999 the AHU organised a joint NSW/Victoria workshop in Canberra. While this may be seen as a step towards a national linking of projects, the need for local action and involvement will remain. This will be even more critical as reduction in the delivery of many other services to the rural sector continues.

Many of the Museum's activities beyond Australia have been hampered by financial constraints. The planned training and support program for Vanuatu faltered for this reason, but the Museum's Research Centre for Materials Conservation and the Built Environment has provided specialist support and training to Pacific Islands' museums through a series of workshops. It is currently examining ways to redevelop a provincial cultural centre in Papua New Guinea.

In 1998 the New South Wales Government established the Migration Heritage Centre. This broadly conceived project seeks to provide cultural heritage services to the many diverse ethnic communities that constitute much of the State's population. We are at the initial stages of exploring what contribution we can make to those communities originating from areas represented in the Museum's collections. This will require extensive consultation with a wide range of people and groups. Frequently there is no single community view or voice, but a multiplicity of views and voices reflecting, among other things, gender, age, educational background, and length of time in Australia. Not all needs and wants can be met with the resources available, and some selectivity is inevitable.

This last comment applies more broadly than to the groups covered by the Migration Heritage Centre. To date, our activities have required high levels of input from Museum staff – in many cases with external funding. One of the major challenges now facing us is to devise ways to accommodate the increasing levels of demand and expectation while operating with limited resources. Current planning processes to define the Museum's path in the 21st century will undoubtedly yield new possibilities and opportunities for the next generation of Museum staff to work together with the indigenous peoples of Australia and our neighbouring regions.

References

Anon. 1981 The Vanuatu slit-drum. *Museum* 33(3): 196

Anon. 1989 *Taonga Maori: treasures of the New Zealand Maori people*. Sydney: Australian Museum

Australian Museum 1983 *The Australian Museum Trust: Annual Report for the Year ended 30 June 1983*. Sydney: Australian Museum

Australian Museum 1992 *The Future of Australia's Dreaming: the rights and reality of Aboriginal and Torres Strait Islander people*. Sydney: Australian Museum

Bolton, L.M., O'Donnell, G. & Wade, J. 1979 Lost Treasures of the Garden Palace. *Australian Natural History* 19(12): 414–19

Bolton, L.M. 1980 *Oceanic Cultural Property in Australia: a pilot survey of major public collections.* Sydney: Australian Museum, for the Australian National Commission for Unesco, Canberra

Bolton, L.M. & Specht, J. 1984a *Polynesian and Micronesian artefacts in Australia: an inventory of major collections. Volume I: Micronesia.* Sydney: Australian Museum, for UNESCO

Bolton, L.M. & Specht, J. 1984b *Polynesian and Micronesian artefacts in Australia: an inventory of major collections. Volume II: New Zealand & Eastern Polynesia.* Sydney: Australian Museum, for UNESCO

Bolton, L.M. & Specht, J. 1985 *Polynesian and Micronesian artefacts in Australia: an inventory of major collections. Volume III: Fiji and Western Polynesia.* Sydney: Australian Museum, for UNESCO

Brocklebank, L.M. & Kaufman, M.H. 1992 An investigation into the identity of a skull in the Department of Anatomy collection, University of Edinburgh, marked as Tasmanian XXX2, and believed to be that of William Lanney. *World Archaeological Bulletin* 6: 70–5

Commonwealth of Australia 1993 *Mabo: the High Court Decision on Native Title – Discussion Paper.* Canberra: Australian Government Publishing Service

Corris, P. 1972 *Passage, Port and Plantation: a history of Solomon Islands labour migration 1870-1914.* Melbourne: Melbourne University Press

Council of Australian Museum Associations 1993 *Previous Possessions, New Obligations: policies for museums in Australia – Aboriginal and Torres Strait Islander peoples.* Melbourne: Council of Australian Museum Associations Inc

Cronau, P. 1994 Indonesia's "Cultural Offensive". *Snoop: a magazine of investigative journalism* 2: 32–4, 47

Docker, E.W. 1970 *The Blackbirders: a brutal story of the Kanaka slave-trade.* Sydney: Angus and Robertson

Edwards, R. 1980 Introduction. In *Preserving Indigenous Cultures: A new role for museums* (eds R. Edwards & J. Stewart), 1-8. Canberra: Australian National Commission for Unesco, and the Aboriginal Arts Board of the Australia Council

Edwards, R. & Stewart, J. (eds) 1980 *Preserving Indigenous Cultures: a new role for museums.* Canberra: Australian National Commission for Unesco, and the Aboriginal Arts Board of the Australia Council

Eoe, S.M. & Swadling, P. (eds) 1991 *Museums and Cultural Centres in the Pacific.* Port Moresby: Papua New Guinea National Museum and Art Gallery

Ferguson, L., MacLulich, C. & Ravelli, L. 1995 *Get the Message: Language guidelines for museum exhibition texts.* Sydney: Australian Museum

Florek, S. 1994 *Guide to the NSW Archaeological Material in the Australian Museum.* Sydney: Australian Museum

Fourmile, H. 1992 Tomorrow: The Big Picture – Cultural Ownership. In: *The Future of Australia's Dreaming: the rights and reality of Aboriginal and Torres Strait Islander people*, 9-16. Sydney: Australian Museum

Goodall, H. 1990 Representing The Daughters of the Dreamings: Aboriginal women and museums. *Museums Australia Journal, Special Issue on Women in Museums*, 12–16

Gordon, P. & Patrick, K. 1994a *Australian Museum's Aboriginal Collections*: Morrison Collection. Sydney: Australian Museum

Gordon, P. & Patrick, K. 1994b *Australian Museum's Aboriginal Collections: Brungle Mission.* Sydney: Australian Museum

Griffin, D. 1996 Previous Possession, New Obligations: A new Commitment by Museums in Australia to indigenous Cultural Heritage. *Curator* 39(1): 45–62

Griffin, D. & Sullivan, T. 1997 Working towards a shared history. *Muse* 3:11

Hise, B. 1995 The Cape Mudge Kwakiutl Collection: from Canada to Sydney and back. *COMA Bulletin* 26: 6–11

Huffman, K. 1985 An Exhibition of Bark Cloths from Vanuatu. *COMA Bulletin* 16:49–50

Isaacs, J. (ed) 1977 *Renewing The Dreaming: the Aboriginal Homelands Movement.* Sydney: Australian Museum

Janke, Terri 1998 *Our Culture: Our Future. Report on Australian Indigenous Cultural and Intellectual Property Rights.* Canberra: Australian Institute of Aboriginal and Torres Strait Island Studies, the Aboriginal and Torres Straight Islander Commission, and Michael Frankel Solicitor

Khan, K. 1983 Women and Arts Festival October 1982: Warlpiri women at the Australian Museum. *COMA Bulletin* 12: 22–5

Khan, K. 1993 *Catalogue of the Roth Collection of Aboriginal Artefact from North Queensland, Volume 1. Technical Reports of the Australian Museum, No. 10*

Khan, K. 1996 *Catalogue of the Roth Collection of Aboriginal Artefacts from North Queensland, Volume 2. Technical Reports of the Australian Museum, No. 12*

Konecny, T. 1983 Women and Arts Festival: the Australian Museum. *COMA Bulletin* 12: 21–2

Lampert, R.J. 1983 Aboriginal remains and the Australian Museum. *COMA Bulletin* 12:19–20

Lampert, R.J. 1986 The Development of the Aboriginal Gallery at the Australian Museum. *COMA Bulletin* 18:10–18

Losche, D. 1982a *The Abelam: a People of Papua New Guinea*. Sydney: Trustees of the Australian Museum

Losche, D. 1982b Gardens, Gods and Body Language. *Australian Natural History* 20(9) 304–10

Meehan, B. 1984 National Inventory of Aboriginal Artefacts. *COMA Bulletin* 15: 28–9

Meehan, B. 1988 The National Inventory of Aboriginal Artefacts. *COMA Bulletin* 20: 7–14

Meehan, B. with Bona, J. 1987 *A National Inventory of Aboriginal Artefacts*. Sydney: Australian Museum

Moore, D.R. & Freeman, J.J. 1973 *Indonesia Today: an impressionistic picture*. Sydney: A.H. and A.W. Reed

Murray, T. 1993 The childhood of William Lanne: contact archaeology and Aboriginality in Tasmania. *Antiquity* 67: 504–19

New South Wales 1989 *Report of the New South Wales Ministerial Task Force on Aboriginal Heritage and Culture, 1989*. Sydney: no publisher given

New South Wales Government 1994 *Annual Report 1992/93. Implementation of Government Responses to the Royal Commission into Aboriginal Deaths in Custody*. Sydney: New South Wales Government

NSW Office of Aboriginal Affairs 1995 *Office of Aboriginal Affairs Corporate Plan* (1995). Sydney: Office of Aboriginal Affairs

Parliament of New South Wales 1971 *Report of the Trustees of the Australian Museum for the Year ended 30 June, 1970*. Sydney: Parliament of New South Wales

Patrick, K. & Simmons, S. 1994 *Australian Museum's Aboriginal Collection: Wiradjuri*. Sydney: Australian Museum

Patrick, K. & White, P. 1994 *Australian Museum's Aboriginal Collection: Northern Tablelands, New South Wales*. Sydney: Australian Museum

Prott, L. & J. Specht (eds) 1989 *Protection or Plunder? Safeguarding the Future of our Cultural Heritage*. Canberra: Australian National Commission for Unesco

Pulvertaft, B. & Gordon, P. 1994 *Australian Museum's Aboriginal Collection: New South Wales Catalogue*. Sydney: Australian Museum

Rigg, V. 1994 Curators of the Colonial Idea: the museum and the exhibition as agents of bourgeois ideology in nineteenth-century NSW. *Public History Review 3*: 188–203, 329

Sculthorpe, G. 1989 What has Aboriginalisation meant at the Museum of Victoria? *COMA Bulletin* 22: 17–24

Solomon, D. 1992 *The Political Impact of the High Court: how the High Court has shaped Australian politics from Federation to today*. Sydney: Allen and Unwin

Specht, J. 1979a Anthropology. In: *Rare and Curious Specimens* (ed. R. Strahan), 141–50. Sydney: Trustees of the Australian Museum

Specht, J. 1979b The Australian Museum and the return of artefacts to Pacific Islands countries. *Museum* 31(1): 28–31

Specht, J. 1980 'Lasting Memorials': the early years of the Australian Museum. *Kalori* 58: 7–11, 31

Specht, J. 1988 *Pieces of Paradise*. Sydney: Australian Museum, *Australian Natural History, Special Supplement*

Specht, J. 1993 Museums and cultural heritage of the Pacific Islands. In: *A Community of Culture: the People and Prehistory of the Pacific* (eds M. Spriggs, D.E. Yen, W. Ambrose, R. Jones, A. Thorne & A. Andrews), 266-280. Canberra: Department of Prehistory, Research School of Pacific Studies, The Australian National University, *Occasional Papers in Prehistory*, No. 21

Stanley, N. 1993 Objects of Criticism: a contribution from the New Museology. *Journal of Art Design and Education* 12(3): 314–34

Strahan, R. (ed.) 1979 *Rare and Curious Specimens*. Sydney: Trustees of the Australian Museum

Sullivan, T.J. & Connors, S. 1997 Indigenous consultation: the "Indigenous Australians: Australia's First Peoples" exhibition. Paper presented at the Museums Australia (NSW) conference "Who's Dreaming?" in June 1997

Sullivan, T.J. & Kelly, L. 1997 Front-end Evaluation: Beyond the Field of Dreams. *Museum National* 5(4): 7–8

Thomsett, S. 1985 The Australian Museum's Training Programme for Community Museums, 1983-84. *COMA Bulletin* 16: 34–46

Thorpe, W.W. 1931 Work of the 1902 "Ethnological Committee". *Mankind* 1: 6

Turnbull, P. 1991 'Ramsay's Regime': the Australian Museum and the procurement of Aboriginal bodies, c1874-1900. *Aboriginal History* 15(2): 108–21

White, P. 1993 *Australian Museum's Aboriginal Collection: Tamworth Region*. Sydney: Australian Museum

Archaeology Indoors:
Museum Exhibitions

University Museums and the Public:
The Case of the Petrie Museum

Sally MacDonald

I first visited the Petrie Museum of Egyptian Archaeology on a snowy day in December 1997 carrying my baby in a sling. I was on maternity leave from my job running a local authority museum service, my previous museum experience had been in art or social history collections and I was looking for a change. The post of Museum Manager had been advertised and I was trying to decide whether or not to apply. As a prospective candidate I was given a guided tour, which was welcome because I had spent three fruitless weeks trying to find out how to visit the place on my own. Despite having lived in London for ten years I had never heard of the museum. It was listed in guidebooks, and in the telephone directory, under University College London (UCL), its parent body, but switchboard staff were unsure whether it was open to the public, and the museum extension just rang and rang. I later found out that I had called at a bad time; the museum had been closed for most of the year for security improvements, and strong diesel fumes from the main university boiler, located directly underneath the galleries, had caused staff to evacuate. I couldn't smell the fumes then – I can now, often – but as soon as the door opened I was overwhelmed with the feeling that I had found something precious. The approach to the museum, the building in which it was housed, was so uninspiring (Fig. 1), its contents by contrast so extraordinary and diverse, its displays so rich and yet so dry – I had to apply for the job. Getting it felt like being given a big gold key.

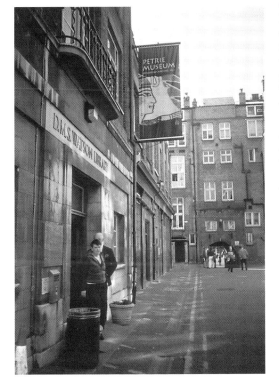

Fig.1. The Petrie Museum in 1999, housed in a 19th century stable block in a goods yard above UCL's main boiler. 'The present system of museums is the most serious bar to the progress of archaeology. The building, which is the mere modern shell, of no interest, and often of no beauty, is the master of the collection, which is restrained and crippled by such conditions that its use is impaired and its growth is stopped' (Petrie, 1904: 130) (photo: Petrie Museum of Egyptian Archaeology, University College London).

I am the first non-Egyptologist to run the Petrie Museum. The post of manager was created as part of a substantial restructuring initiated by the Director of the Institute of Archaeology (IoA) and intended to equip the museum to serve a broad public, although this was not explicitly stated in my job description. A structure where a generalist museum professional manages the work of subject specialists is the kind of set-up well-established in independent, local authority, and even now in national museums but still unusual in UK universities. I report to a committee which includes both university departmental heads and external museum professionals, and a Centre for Museum and Heritage Studies which oversees UCL's many museums and collections. Two years into the job I am still learning about the history of the place and am constantly overawed by the collections. This chapter is therefore not a description or an assessment of the museum's contents, nor a history of the many dedicated staff and volunteers who have ensured its survival; these subjects are covered ably elsewhere (Adams, 1992; Janssen, 1992). It is concerned instead with the purpose of the museum, its changing relationship with its parent institution and with the outside world. It is also about the museum's various audiences, and the displays and activities through which it communicates with them. The final section offers proposals for its present and future role as a university museum in the 21st century.

Rethinking the university museum

The last century has seen fundamental change in university museums. A hundred years ago there was a widespread belief in the importance of object-based teaching and learning in higher education. 'Every professor of a branch of science requires a museum and a laboratory for his department; and accordingly in all our great universities and other teaching institutions we have independent museums of botany, palaeontology, geology, mineralogy, pathology and materia medica, of archaeology – prehistoric and historic, classical and Christian – each subject taught having its own appropriate collection' (Murray, 1904: 275).

Ten years ago, that confidence seemed to have gone. University museums were frequently said to be 'in crisis'; a crisis of funding, reflecting a crisis of priorities. A survey of museum collections within higher education remarked 'often they are regarded as peripheral, or obsolete visual aids, and their wider significance is ignored' (Museums Association, 1992: 8). In England, a series of regional audits has taken place over the last twenty years, charting the extent, the diversity, the cultural riches and the financial poverty of the sector (e.g. Arnold-Forster, 1989, 1993). Questions have been raised about whether and why universities should hold museum collections at all (see Ucko, 1998). A pilot national survey has highlighted fundamental managerial problems that seem to link the most disparate university collections (Kelly, 1999). And a recent report provided some useful case studies of university museums and galleries looking outwards from their parent institutions to serve a wider community (Centre for Cultural Policy Studies, 1999). It is time for a reassessment of the idea of the university museum.

What is it for? The purpose of the Petrie Museum

The purpose of the Petrie Museum has been debated throughout its history. In 1928 Sir William Beveridge, the chair of UCL's committee on sites, stated that 'universities had no business with museums' (Petrie, 1931: 262). In the last twenty years, questions have been posed as to whether the collection might not be better cared for at the British Museum, ten minutes' walk away.

The museum's current mission statement, agreed in 2000 as part of the strategic plan, is:

To be a national and international centre of excellence for the research and teaching of Egyptian archaeology through material evidence and a source of understanding and inspiration for visitors.

The statement seeks to express the academic purpose and ambition the museum has always had, but to combine this with a commitment to serving a wider community who may have less specific but no less demanding aspirations. The university museum will always have an important 'internal' purpose, but the Petrie Museum, like many others, needs to expand its horizons if it is to fulfil its potential. In framing the statement, my colleagues and I felt that a university museum did have something special to offer, distinct from the purpose of a national or local museum. What it has to offer now is intricately linked to the nature of the collections and the way in which they were built up from the start.

A teaching and research collection develops

The Petrie Museum is now named after – and therefore naturally associated with – the great archaeologist William Matthew Flinders Petrie (1853–1942) (Fig. 2). Certainly the bulk of the museum's current collection consists of objects Petrie bought or excavated on his annual seasons in Egypt between 1880 and 1926. Its history, however, begins not with Petrie but with his patron, the traveller, popular author and journalist Amelia Edwards (1831–1892). Her passion for Egypt led her to establish the Egypt Exploration Fund (EEF, now Egypt Exploration Society), which helped fund some of Petrie's early excavations. In 1892 she left her fortune to UCL to fund a Chair in Egyptology for him. She also left to UCL and to Petrie's care her library and her collection, described in her will as including 'ancient Egyptian jewellery, scarabs, amulets, statuettes of deities in porcelain, bronze and stone, funeral tablets, sculptures, pottery, writings on linen and papyrus and other miscellaneous monuments' (Will of Amelia Edwards, dated 8/3/1891, copy in Petrie Museum archive).

Edwards was a strong advocate of women's rights; she chose UCL because it was then the only university offering degrees to women. She was also a popular writer who saw publicity as crucial to attracting continued sponsorship for excavation in Egypt (Drower, 1985: 57). The purpose of her bequest was to promote 'the teaching of Egyptology with a view to the wide extension of the knowledge of the history, antiquities, literature, philology and art of Ancient Egypt'. It seems likely that although her endowment was to a university, and specifically for teaching, she wanted to establish an institution that would have widespread public impact.

She had discussed her plans with

Fig.2. Professor Flinders Petrie in the Egyptian Museum, UCL, 1921 (photo: College Collection, University College Library).

Petrie well before making the will; he later recalled that her collection was formed 'nearly all from my excavations' (Petrie, 1915b: 4) and 'with much care, aiming that it should be as complete and typical as possible in a small space, so as to serve for teaching purposes' (Petrie, 1893). After her death, he sorted and packed her collection and library in preparation for the transfer and negotiated with UCL over the amount of space they would need. He also offered to lend to the university his personal collection, built up over ten years of excavation and purchasing in Egypt, which he described as 'mainly technical and ... very desirable for students' (letter from W. M. F. Petrie to the Secretary of the College, 8/11/1892, copy in Petrie Museum archives). The college accepted and, the year after, allocated space and cases on the second floor of the main building (Janssen, 1992: 7).

In his inaugural lecture on taking up the Chair of Egyptology in 1893, Petrie paid tribute to his patron – 'she sowed the seed, here we hope to raise the plants' – and set out his agenda, based on her legacy and wishes; 'to see a school of scientific excavation arise, to clear away the darkness in which we now stumble' (Petrie, 1893). He saw the role of both collections, his and hers, as supporting the training of a generation of Egyptian archaeologists; the museum's main mission was to serve live excavation in Egypt. Existing public and private collections could not, he felt, meet this need; they 'have been rigorously preserved from close handling or are inaccessible in private houses'. The Egyptian collections at UCL were, on the contrary, intended to be accessible to students; each specimen dated as closely as possible, arranged by sequence of forms and available to be closely examined and handled by students. Petrie felt that a familiarity with certain types of commonly excavated material, arranged in this way, was fundamental to the vocational training of an archaeologist. 'At present the archaeological experience that should be acquired before doing any responsible work in any country ought to cover the history of the pottery century by century, the history of beads, of tools and weapons, of the styles of art, of the styles of inscriptions, of the burial furniture and of the many small objects which are now well known and dated' (Petrie, 1904: 4).

Petrie's share of finds from excavations in Egypt now came straight to UCL, and he began to collect, both by excavation and by purchase, for the purpose of teaching as well as for his own research. In 1907 he offered to sell his collection to the university. The way he phrased his offer shows that he valued it as a collection of type series, essential for 'study rather than for popular show':

> The most important sections of the collection are: scarabs with kings' and personal names, about 1200, a more complete series than any national collection; Beads, over 500 strings carefully selected; the only dated collection and by far the most varied and complete; Pottery, the only dated collection, and the largest. (The above are essential for practical study). Prehistoric, more varied than any other collection, except perhaps Oxford; Tools and Technical, of which I have secured every variety that I have seen; there is no similar collection; Weights, by far the largest collection yet made. And the general collection of statuettes, stone work, amulets &c, selected for illustrating variety of work and period.

(Letter from W. M. F. Petrie to Provost, UCL Managing Sub-Committee Minutes 5/11/1907 minute 10.)

Changing displays, growing ambitions

The university bought the collection in 1913 and by 1915 Petrie had arranged it, together with the Edwards library, in cases on the second floor of the main building, where it stayed until the Second World War. The museum was in a long room, with windows along one side. Petrie's first

CLASSES OF OBJECTS.

Adzes	856	Metal vases		280
Amarna work	620	Minerals		730
Amulets	450, 460	Moulds		880
Arab objects	500	Painting		393
Architectural work	780, 810	Palettes, carved		180
Axes	850	,, plain		60
Beads	1–30	Pottery		928–999
Bronze working	830	Prehistoric figures		190
Button seals	323	,, pottery	40-50	
Cartonnage	670	,, small objects	210	
Coffins and Mummies	640	,, stone vases	31	
Coptic objects	910	Rings and gems		440
Cylinder jars	150	Roman small objects	900	
Cylinder seals	322	Royal objects		321
Daggers	860	Scarabs		270, 324-8
Early dynastic	220, 230	Sculptures		520-560
Fish hooks	868	Sealings of jars		170
Flints, palaeolith	70	Shells		733
,, early dynastic	110, 120	Soul houses		680, 690
,, historic	130	Stamps		390
,, foreign	140	Statuettes		330-445
Foreign heads	380	Stone vases	250-60, 290-300	
Foundation deposits	890	Stone working		790, 800
Games	736	Terra cotta figures		576
Glass	610, 870	Toilet		720
Glazed pottery	630	Tools		840-869
Greek pottery	820	Toys		738
Inscriptions, small	570	Ushabtis		470-499
Iron Tools	840	Weaving		700-719
Ivory work	835	Weights		580-609
Knives	846	Wooden boxes		740, 770
Lamps	610, 910	,, tools		750-60
Measures	580-599	Writing materials		370

Fig.3. Layout of the Egyptian Museum, 1915 (Petrie, 1915b) (photo: Petrie Museum of Egyptian Archaeology, University College London).

consideration was lighting, about which he held strong views (Petrie, 1904: 131 and 1938: 341). He arranged the themes of the museum according to the requirements of the different object types for direct or oblique light (Fig. 3). The displays were arranged as type sequences, key reference collections serving as a basis from which to identify and discuss new finds. According to Petrie, the sequence of forms was based on the display arrangements at the Pitt Rivers Collection in Oxford, where objects were again arranged by type (Petrie, 1893). At this date, taxonomic displays were common even in more publicly oriented museums. The sole exception was a case devoted to 'the art of Tell Amarna', Akhenaten's city, excavated in 1891–2. This may have been treated archaeologically in recognition of its importance as a site, and of Petrie's excavation of it, or possibly because it was stylistically so separate it was almost a type of its own (Stephen Quirke, Pers. Comm.). Otherwise, although almost all the objects were dated, the displays did not illustrate context at all. Elsewhere, Petrie had berated colleagues in public museums for splitting site material. 'Tomb groups are hated by the museum curator because there is always something ugly, something too big, something untidy in the group: and so science may go hang, but the museum must look nice and contain objects all duly attractive to the ignorant' (Petrie, 1900: 526). Yet here the relentless type groupings were a deliberate choice.

71

Although it remained primarily a teaching museum, the purpose of that teaching shifted. The need for practical, trained archaeologists became less crucial and 'the promotion of research in the subject' was now the primary function of the Egyptology department (Annual Report, 1936–7: 63, 65). Cupboards were built around the sides of the gallery where the reserve collection, gradually being uncrated, could be stored in drawers. Tables within the museum provided some space where researchers could work (Fig. 5). Members of the public were not encouraged to visit, although there were 'always some pretties out', such as the faience from Amarna, in case they did (Eric Uphill, Pers. Comm.).

All post-war museum staff have worked within severe constraints of funding and staff time common to university museums. The museum has never had a budget for display and has always relied on volunteer help for major rearrangements. Barbara Adams, later the museum's curator, made further changes to the displays in the 1960s and 1970s. She altered the layout to give more weight to archaeologically contexted material, extending the sequence of site displays chronologically right through from Predynastic material to the Graeco-Roman site at Hawara. But the most critical constraint was that of space. The Standing Commission on Museums and Galleries commented on the museum's 'acute problems of housing' (Standing Commission, 1977: 11) and Adams described it as 'probably the biggest university collection of Egyptian material in the world – in probably the smallest building' (*Hampstead Express and News* 12/5/1978: 45).

Fig.6. The museum in 1999 (photo: Petrie Museum of Egyptian Archaeology, University College London).

By the 1980s the museum had developed a more ambitious purpose: 'to transform the collection from a departmental teaching aid into a modern museum giving full services to international scholarship' (Smith, 1988: 7). Further updating and relabelling was carried out, aimed at the Egyptian archaeology graduate, a knowledgeable, specialist visitor requiring detailed information about individual objects. This labelling, which is still in place in 2000, assumes that visitors know the dates of dynasties, or will be prepared to look them up in the guidebook, and that they may need to follow up bibliographical references. It is nevertheless considerably more informative than the labelling, for instance, in Petrie's displays. Space constraints leave little alternative to object-rich displays, and no room at all for extensive orientation, graphic panels or interactive elements

(Fig. 6). By the late 1980s the museum displays were being compared against the standards of public museums:

> The scheme of the Museum's display reflects its primary role for academic research and study. In spite of recent work the collections are still presented in a very traditional fashion that may limit their interest to the non-specialist museum visitor and general public, who are accustomed to more modern exhibition interpretations (Arnold-Forster, 1989: 16).

The modern museum to which my predecessors aspired could not be created without resources in such a tiny space. This is still the case and under these circumstances my colleagues and I have concentrated on audience research, marketing and outreach as we look for a better site.

Who is it for?

The process of identifying target audiences involves – as it would in any museum – looking in detail at the subject matter of the collection, assessing existing and potential audiences, discussion, experiment and evaluation. The Petrie Museum's target audiences are currently:

- UCL staff and students
- Academic and other researchers worldwide
- People of Egyptian and African descent
- Educational audiences from primary school to adult
- Londoners and visitors to London

The internal audience

The priority is implicit in the listing; the museum is still primarily for an academic audience, and its core audience is an internal one. At the time of writing, though, UCL staff and students use the collection much less than they might. The museum's collections cover an immense time-span from the Neolithic to the period after the Arab conquest of Egypt in 641 CE. They contain objects of relevance across a wide range of archaeological disciplines, and could certainly be used as a resource for teaching Anthropology, History of Art, History of Science and Fine Art. Museum studies and conservation students undertake occasional collections-based projects but there is so far little evidence of the cross-disciplinary use one might expect. At any rate, most of the teaching that takes place within the museum is conducted by the museum's former curator and assistant curator, both of them Egyptologists deeply familiar with the collection and easily able to access it. Looking back, although the museum's potential for teaching and research has been repeatedly extolled, its actual use has been patchy, subject to the personal enthusiasms and abilities of teaching staff.

Written records suggest that Petrie made every effort to facilitate use by students and researchers. As a self-taught and practical person, he was keen to open his teaching to a wide range of students, especially those we would now call mature students, in full- or part-time work. He planned his academic year to allow time to give Saturday afternoon lectures for the general public; he organised the Edwards Library for lending as well as reference, to help those students who could only study at home; and encouraged research at every level: 'someone may not be able to touch more than a minute subject, in a few spare hours, now and then; but let him do that fully and completely and every student will thank him' (Petrie, 1893).

From 1915 what was known as the Egyptian Museum and Edwards Library (they were used and spoken of together) were open to all staff and college donors from 10am to 5pm on weekdays and 10am to 1pm on Saturdays. Students and others could also visit the museum, but

only with a member of staff and on condition they signed a visitors' book. Staff could borrow objects for teaching or study elsewhere in college with the curator's permission (UCL Managing Sub-Committee Minutes 7/11/1913). The syllabus of a two-year diploma course leading to a certificate in Egyptology included practical classes in drawing and dating of objects (Annual Report, 1911–12: 37); one would assume that these took place in the museum and involved handling the collections. It is, however, difficult to establish exactly how and how much the collection was used for teaching in Petrie's day. One of Petrie's students in the 1930s remembers being asked to draw scarabs, presumably for one of his publications, and being taught by his assistant, Margaret Murray, how to draw a pot in profile. She cannot, however, recall Murray ever taking objects from cases or teaching hands-on sessions and is sure that Petrie did not; he was too busy with exhibitions and lectures (Margaret Drower, Pers. Comm.).

After Petrie's departure from UCL in 1933 the syllabuses suggest that object-based teaching increased. Classes on the dating of objects, technology, epigraphy and 'practical demonstrations on the restoration and preservation of antiquities' were taught in small groups (Annual Reports, 1934–5: 63 and 1939–40: 63). This is borne out by oral testimony (Margaret Drower, Pers. Comm). During the Second World War, most of the collection was packed and stored off-site, and it was only fully unpacked, in its new 'temporary' home, in 1965. Despite this tremendous hiatus, teaching with the collection resumed in 1946, when the beads were used in seminar work and Middle Kingdom papyri were made available to students (Annual Report 1946–7: 69). Museum-based classes focusing on identifying types of artefact took place through much of the 1950s and 1960s, largely conducted by those staff – Anthony Arkell, Harry Smith – who were practising archaeologists. Questions about objects appeared in exams (Peter Ucko, Pers. Comm.). Postgraduate use of the collections seems to have peaked during this period, and provision was made for researchers from outside college to study the collection. Yet its use was not universal even within the department; those Egyptologists who were primarily linguists usually taught with books and slides (Eric Uphill, Pers. Comm.)

The other factor affecting internal use of the museum has been its proximity to the departmental staff and library. Edwards and Petrie had conceived of the museum and library as one resource; they were located together, next to the professor's office. Even when the museum moved into its 'temporary' post-war premises, the library and departmental offices soon followed (Fig. 7). During the day, museum and library were overseen by a college security attendant, but postgraduate students had keys to the back door so that they could use the library in the evenings (the museum was in darkness). For security reasons this interrelationship ended in 1975, when a partition was built between museum and library. This meant that the museum could shut in the evenings while the library remained open, and indicated that members of the public could visit the museum but were not entitled to use the library (Barbara Adams, Pers. Comm.). The break with the library was reinforced in 1993 when the Egyptology Department was incorporated within the Institute of Archaeology (formerly a separate school within London University, but by now part of UCL). The Edwards Library, together with most of the academic staff, was transferred to the institute, a separate building three minutes' walk away.

In the past, use of the collections for teaching and research seems to have depended more on personality than policy. For anyone managing a university museum this makes it tricky to plan ahead. If the prime audience is an internal one, what should happen to the collections if, as has happened for periods in the past, teaching with the collection stops? Egyptology is now a minority subject, as defined by the Higher Education Funding Council for England. For long periods of the museum's history, it has been seen as a resource specifically serving that subject area. If UCL were to stop teaching Egyptology, should the collection be transferred elsewhere so that it might better serve another audience?

Fig.7. The Edwards Library with the museum behind, 1960 (photo: Petrie Museum of Egyptian Archaeology, University College London).

While Egyptian archaeology is still taught at UCL, our aim is to broaden and deepen use of our collections. The first step is to understand the barriers that may be preventing staff from using them. The Museum Association's national survey of university collections noted that these barriers might include lack of documentation, unsuitable displays, inconvenient opening hours, possessive staff attitudes, lack of publicity or published research (Museums Association, 1992: 8). Not all of these criticisms could be levelled at the Petrie Museum, but there may be other problems. Colleagues in the Institute of Archaeology are currently surveying all teaching staff to explore their reasons for using, or not using, our many different departmental collections and we hope this will be the starting point for the museum to encourage greater use. We suspect that this will be a slow process, building up working relationships with lecturers in other disciplines (Fig. 8). What has been called 'imaginative and energetic advocacy for objects' (Hamilton, 1995: 78) is, we feel, a key priority for the Petrie Museum.

External audiences

The external academic community is a natural extension of the university museum's core audience and for at least the past fifty years the Petrie Museum has provided study space, access to staff expertise and hands-on access to the collections for Egyptologists worldwide. Few

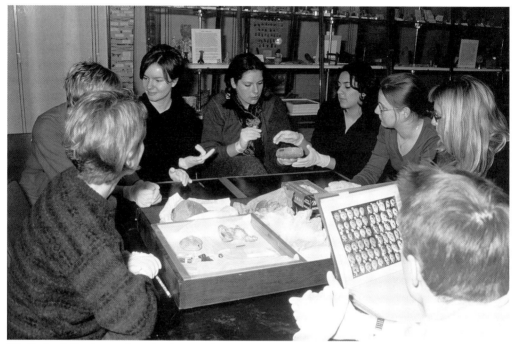

Fig.8. Dr Sally-Ann Ashton leading a classical archaeology handling session with students in the museum, 2000 (photo: Petrie Museum of Egyptian Archaeology, University College London).

would argue against this. But our decision to target much wider audiences, though in some respects controversial, also has precedents at UCL, and is in some respects a natural extension of the work of our immediate predecessors to open the museum to a wider public.

From his arrival at UCL in 1893 until around 1930, Petrie involved the public in the work of the department through the annual summer exhibitions. From the 1880s, his excavations in Egypt had been funded via the 'distribution system' whereby private individuals and institutions financing digs would get a share of finds. In the absence of state funding, private support was essential. Each summer, on the ground floor near the main entrance of college, Petrie would stage a public exhibition of finds from that year's excavations prior to their dispersal to those who had funded the digs. Sadly there are no records of visitors or visitor numbers, though some exhibitions were clearly extremely popular: several justified occasional evening opening until 9pm and at the Lahun exhibition in 1914, which included gold jewellery, three hundred 6p catalogues were sold in the first two days (Janssen, 1992: 18). The catalogues for these exhibitions appear to have been aimed at an interested but non-specialist audience and the exhibitions themselves sometimes included interpretative aids, such as site models, that Petrie would not have used in the university museum upstairs (Petrie, 1931: 199).

Clearly these temporary exhibitions served a completely different function to that of the main museum. They were high profile events that attracted press attention, public excitement, external funding for excavation and prestige for the College. As Petrie later put it, 'work in Egypt was not College business, though it gave vitality to the College in the public view' (Petrie, 1931: 145). It is

not clear exactly why these exhibitions stopped. Petrie retired in 1933 and although departmental staff continued to excavate in Egypt, government grants available post-war reduced the financial motivation for holding exhibitions (Stephen Quirke, Pers. Comm.).

In the early days the general public were never encouraged to visit the museum itself. Although it opened in 1915, and people from outside UCL were admitted provided they signed a visitors' book, the catalogue made clear that it was not 'intended to attract and interest general visitors' (Petrie 1915b: 4). The early visitors' books do not survive, but those from 1937 suggest that for decades external visitor numbers were never more than two hundred per annum. But from the 1970s the museum began to try to serve a more general audience, setting up a sales point, producing a guidebook (from 1977), establishing a Friends organisation (in 1988), and lending regularly to major exhibitions abroad. External visitor numbers, as recorded in the visitors' books, grew from 200 in 1970 to over 3,000 in 1996. As one source commented, outside visitors were 'generally amateur or professional Egyptologists. But its appeal should stretch wider than that' (*Hampstead Express and News* 12/5/1978: 45). Official recognition of the fact that the museum was now serving a wider audience came in 1987 when the museum received 'special factor' or 'non-formula' funding in respect of its services to a public outside academia. In 1998 it was given formal responsibility to serve a national audience when, thanks to the efforts of my predecessors, the government awarded it designated status as a collection of national importance.

Our current list of target audiences is intended to reflect these new responsibilities, and also to recognise the special appeal of the museum's subject matter. Outside academia, Ancient Egypt is anything but a minority subject. It is embedded in Western popular culture from Victorian gothic horror stories to Hollywood, is now an option on the English National Curriculum for History, studied by many primary schoolchildren, and is of significance for groups as diverse as New Agers and Freemasons.

There is debate about whether it is appropriate for a university museum to attempt to serve these audiences. Some university colleagues feel strongly that it is not our business to serve schools (children are perceived by some as inherently noisy and disruptive) and 'cranks'. Much of this is an understandable concern to protect a quality and level of service: the Museums Association survey of 1992 reported widespread fears that university museums would 'dumb down' in search of popular audiences. But it can also be argued that universities are essentially elitist institutions – academically elitist at least – and cannot easily accommodate the concept of broad public access.

The decision to target people of Egyptian and African descent was made in recognition of the fact that the collection may have a special significance for people who see their roots in Egypt specifically or Africa generally. Many black people regard Ancient Egypt as a culture that has been appropriated by Eurocentric archaeologists and historians. Some would say that an Egyptian museum such as the Petrie, with its roots in Western archaeological practice, has a duty to explore alternative views of its subject matter. If it succeeds in making its collections more accessible and relevant to these hitherto excluded groups, the Petrie may join a wider movement towards more inclusive and socially relevant museums (see Simpson, 1996, 7–71). A university museum has perhaps a particular opportunity to share new non-Eurocentric academic interpretations with the public.

The choice of the second group – educational audiences in a broad sense – reflects the role the museum can play in what is now usually called lifelong learning. The Ancient Egypt option on the English National Curriculum for History encourages the study of aspects of everyday life through archaeological evidence. There are hundreds of primary schools within easy reach of the Petrie Museum, and the British Museum Education Department cannot currently meet the

demand for school visits to its Egyptian galleries. The National Grid for Learning – a rapidly-expanding online educational network – also provides opportunities to serve schools outside the immediate catchment. At the other end of the age scale, the Petrie now has an established audience of older people undertaking short courses in aspects of Egyptology. From the evening classes in hieroglyphs and object dating run by the department from its early days to the thriving Friends organisation, which runs object-handling seminars and lectures, the museum has served this natural audience well.

The last of the target audiences, Londoners and visitors to London, reflects the feeling of staff that the museum could serve a wider general 'tourist' audience of people with an interest in ancient Egypt. This grouping could be criticised as a catch-all and probably needs to be further refined.

How can we best serve our audiences?

Understanding audiences

Having defined these internal and external audiences, it is now a priority to establish what they might require of the museum, its collections, displays and services. Market research currently underway focuses on existing and target audiences and aims to establish the nature of their interests and needs. Postal surveys have been conducted with primary teachers, Friends and UCL students. In-depth interviews have been carried out with a wide range of people interested in Ancient Egypt, including academics, New Agers, Afrocentrists, Egyptians and amateur Egyptologists. A series of focus groups has explored attitudes to Ancient Egypt among schoolchildren and adults, including some who have visited Egypt as tourists. At the same time, the museum has commissioned help in developing means of monitoring visitor responses to the displays, and to check whether it is indeed fulfilling its mission. It will be some time before the initial stage of this process is complete and useful results can be published, but this research is a fundamental part of the museum's plan. It has already brought forth very useful information, such as the fact that primary school teachers would value the opportunity for their pupils to handle ancient material above all other services the museum has proposed it could provide for them.

Marketing and virtual access

Concurrently with research into audience needs, the museum is experimenting with ways of maximising use of its services. This is not simply a numbers game; the current building cannot comfortably accommodate large numbers of visitors. It is a matter of improving the quality of the services offered to users of all kinds, and of balancing the sometimes conflicting needs of different audiences. This last is particularly challenging working in such a small space. In 1999 the museum changed its opening hours in order to accommodate different types of visitors – researchers, schools, students, general audiences – at different times of the day and week. A banner, new signage, a new leaflet with targeted distribution and a website have been the first steps towards helping all target audiences find the museum.

The website is currently very basic, but over the next three years it will grow to include the museum's full catalogue of 80,000 objects, with images. The catalogue will include conventional subject-indexing but the project also involves the creation of several virtual Petrie-excavated sites, which virtual visitors can explore as a means of understanding the excavated context and a medium through which to access the raw collection data. These virtual sites will also provide the means for linking data from sites where the finds have been widely dispersed. Finds from the Middle Kingdom town of Lahun, for instance, were distributed by Petrie to Jesse Haworth, one of his patrons who later used them to establish the Egyptian collections of the Manchester Museum. The new virtual site will provide an entry point for users to access

individual records of Lahun material in both the Petrie and the Manchester Museum. The top layers of these virtual sites will be embedded with questions and references designed to facilitate the use of the collections in teaching. The underlying digital catalogue and the virtual overlay together constitute an ambitious virtual access project. It is funded mainly through government support to help designated museums improve access to their collections, but also with money from the higher education sector, which is keen to develop digital resources for teaching and learning.

This project should bring benefits for all target audiences. The intention is to combine expert-led with learner-directed facilities. University teachers will be able to search the collections, gather suitable material and request museum staff to prepare it for teaching sessions, from their desks. Students will be able to find objects and topics that staff have identified as particularly suitable for projects or dissertations. Researchers worldwide will be able to search the collections in advance of, or instead of, visiting the museum to study the objects themselves, allowing their time in the museum to be far more focused. School teachers will have access, via the National Grid for Learning, to educational materials aimed at specific age groups – this could also serve as a base for other developments. A text-only version including Arabic translations could be available for those, including many Egyptians, without access to fast modems. And excavated material distributed throughout the world by Petrie and his colleagues could be reunited virtually to the benefit of international scholarship. Petrie wrote, in 1891, 'It has been a bitter sight to me, everything being so split up in England that no really representative collection of my results could be kept together' (Petrie, 1931: 133). He would surely approve of its virtual reassembly.

Improving services for specific target audiences

For space reasons alone it will not be possible on the current site to reunite the museum with its Egyptological library. However, we are currently considering whether it might be possible for the museum to increase its opening hours for students and researchers to match those of most of the university libraries. This would involve significant staff costs and its need will have to be researched and tested, but it could result in the museum being more heavily used and highly valued within UCL. The rediscovery of the links between museums and libraries is popular politically at the time of writing and is being explored by many UK local authority services. This would help to sharpen awareness of the strengths and weaknesses of different media, and would accord with Edwards' and Petrie's original intentions, to keep artefacts, books, photographs and archives together (Petrie, 1893).

Services for the wider educational market are already under development. Before 1998, visits by schools occurred only in response to requests. In 1998, a teachers' pack was commissioned and promoted to encourage primary school teachers to bring groups to the museum. The success of this has meant that sessions available for schools are now filled to capacity. It is not possible to expand this provision on site without prejudicing other audiences, nor is there space within the museum for a class of thirty to handle objects. Given teachers' expressed wish for this service, the museum now hopes to develop outreach sessions using freelance education workers to take handling collections to schools. Playschemes are encouraged to visit the museum in the holidays and the museum will this year, together with a local jeweller, participate in classes offering local teenagers and young adults the opportunity to make jewellery based on ancient examples. Meanwhile existing collaborations with adult education courses and summer schools are flourishing.

Much of the teaching and research currently carried out or proposed within the museum involves object handling, yet while there is much support for hands-on teaching, particularly

within the museum profession, there is little solid evidence for its benefits. Together with the Institute of Education, the museum plans to carry out a detailed study of the effect, for both primary and tertiary students, of handling ancient objects. The results should help the Petrie plan better handling collections and may be of benefit right across the museum sector.

Meanwhile services to the identified 'minority' audiences – people of Egyptian and African descent – have not yet really started. Two funding applications have been made with the aim of employing education officers specifically to help the museum develop services for these groups, but both have unfortunately been unsuccessful. Funding has been achieved, however, for a well-known Egyptian author to work with the collection, producing short stories based on objects in the collection for publication in English and Arabic.

Current projects to increase the museum's more general audiences include two exhibitions. The first is a site-specific installation (Fig. 9) which literally shows the museum in a new light. The installation is one of a series of Art and Archaeology projects taking place in UK museums during 2000, which aim to bring archaeology to new audiences and to make people think about archaeological practice, and it will be evaluated against these aims. The second is an exhibition of objects from the Petrie Museum, which will tour to public galleries in Croydon and Glasgow. This exhibition, *Ancient Egypt: Digging for Dreams,* aims to bring challenging ideas and recent research about Ancient Egypt to a wide audience. This too will be evaluated with audiences; the results should be useful in planning new displays and exhibitions when the Petrie Museum moves to a new location.

Dream schemes

At the time of writing there is a firm commitment to relocation and several possible sites are being considered. Until a specific building or site is confirmed it is still possible to dream about the ideal layout, to have a vision of how it might look and be.

The museum's history is peppered with dream schemes for which official favour and/or

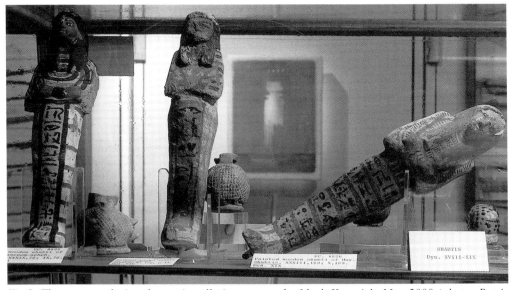

Fig.9. The museum during the art installation, traces, by Mark Karasick, May 2000 (photo: Petrie Museum of Egyptian Archaeology, University College London).

funding were never found. A century ago, Petrie was preoccupied with the problem of lack of space to house a growing archaeological collection, particularly on an urban site with the consequent cost of land. He put forward radical proposals for a national repository – The Sloane Galleries – to be situated in Kent or Sussex. There 'the great majority of specimens that are too bulky or unsaleable to be stolen' could be warehoused on open shelves (Petrie, 1900). Curators and security staff would live in an on-site village, all new acquisitions would be photographed as they came in and researchers could study the collections at leisure.

A much later and more practical scheme was put together by my predecessors, Barbara Adams and Harry Smith as part of a UCL centenary appeal in 1981 (Fig. 10). The proposed site was on the third floor of a building at the back of college and would have presented some of the same problems of public access and profile as its current 'temporary' home. It did offer considerably more space, however, and allowed for a rethink of the museum layout. The plan shows a division between a display museum and a working museum. The display museum would have contained more sparse displays of 'treasures', with graphic interpretation and space for temporary displays. The working museum was envisaged as further displays arranged either by site or type, with storage cupboards around the walls (Barbara Adams, Pers. Comm.). It is radical in that it shows no stores or non-public areas; everything is in the museum and is in theory available to be worked on and staff offices, the library and archive are positioned nearby to assist with research.

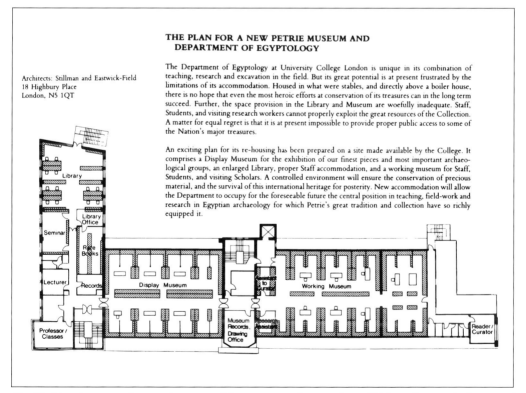

Fig.10. Plan for a new Petrie Museum and Department of Egyptology, 1981 (architects: Stillman and Eastwick-Field) (photo: Petrie Museum of Egyptian Archaeology, University College London).

A specialist resource with an open door

My own dream museum would be firmly based within the university, interconnecting with a specialist library, teaching facilities, seminar and cluster rooms for personal study. Academic staff specialising in related disciplines would work in and around it, the doors to their offices opening directly off the galleries; they would frequently be accosted by ordinary visitors. It would have a big front door to the main street, open well into the evening. Entry to the museum would be free; visitors would be asked for information instead of money. Special services, such as hands-on access to objects, or guided tours on particular themes, might be charged for. Most visitors would be members, and would identify themselves with swipe cards, recording the services they use (for example which objects they consult or photograph) in much the same way as a library card. The way the museum is laid out would encourage the visitor to progress along pathways (such as those already well defined within sports and arts development) from spectator through participant to performer/ teacher (Fig. 11). The greater the degree of access given, the more the visitor would be expected to give back (for instance, rapid publication of the results of destructive analysis). There would be no stores, only degrees of display. Student volunteers would be recruited for their abilities to help different types of visitor find what they need. The museum's core funding would come from the university, but at least half its income would be obtained from central government, the local authority, private sponsors, trusts and charges to users, reflecting the costs of serving internal and external audiences.

In this dream museum displays and programmes bring the fruits of academic research to the public *quickly*, in the way Petrie's public exhibitions and publications did. The museum is a front door for the university, an expression of the belief that knowledge is to be shared, not owned. 'Here the means of study and research will be provided as far as possible. The future lies with you' (Petrie, 1893).

LEVEL OF INVOLVEMENT	AWARENESS	OBSERVATION	PARTICIPATION	PROFICIENCY	COMMUNICATION
AUDIENCE	Non-visitor	Casual visitor	Learner	Researcher	Teacher
EXAMPLES	Member of target audience	Member of target audience	Schoolchild, undergraduate student, evening class student	Postgraduate, non-academic researcher, trained volunteer	Lecturer, guide, museum curator or educator
TYPE OF DISPLAY/ SERVICE	Outreach/ Marketing	Browsing displays	Teaching displays	Study areas	Teaching areas
REAL WORLD EXAMPLES	Poster, media coverage, school loan box	Changing displays featuring recent research on collections, controversial questions, provocative and eye-catching exhibits	Displays geared to undergraduate, postgraduate and other relevant taught courses and where appropriate to other educational use eg National Curriculum objectives and themes, access to teaching staff	Study collections, individual hands on access to objects, library and archival resources and specialist staff	Workshop space for handling sessions, experiments. Space for presentations, discussions and publications of all kinds.
DIGITAL EXAMPLES	Web site link, home page	Top level web pages, interactives	Resources and questions geared to use of collections as part of taught courses at primary, secondary and tertiary level. Online help with teaching enquiries.	Access to full museum catalogue with images, online help with research enquiries	Provision of online support advice and mentoring

Fig.11. Diagram of how a university museum might work.

Acknowledgements

I am very grateful to Barbara Adams, Paulette McManus, Nick Merriman, Stephen Quirke and Peter Ucko, who read, corrected and improved earlier drafts of this chapter. I should also like to thank Martin Burgess, David Dixon, Margaret Drower, Rosalind Janssen, Geoffrey Martin and

Eric Uphill for their memories of the use made of the collection for teaching at various times. Many thanks also to Hugh Kilmister for organising the photographs, to Tracey Golding for counting the figures in the old visitors' books, and to Stuart Walton and Carol Bowen who helped me to find what I needed in UCL Records Office.

References

Adams, B. 1992 Egyptian Archaeology in the Petrie Museum, London. *KMT* 3(1), 9–21

Arnold-Forster, K. 1989 *The Collections of the University of London. A report and survey of the museums, teaching and research collections administered by the University of London.* London: London Museums Service

Arnold-Forster, K. 1993 *Held in Trust: Museums and Collections of universities in Northern England.* London: HMSO

Catalogue, 1953 *Flinders Petrie Centenary Exhibition.* London: University College London

Centre for Cultural Policy Studies, University of Warwick 1999 *Partners and Providers: the role of HEIs in the provision of cultural and sports facilities to the wider public* April 99/25. Bristol: HEFCE

Drower, M. S. 1985 *Flinders Petrie: a life in archaeology.* London: Gollancz

Hamilton, J. 1995 The Role of the University Curator in the 1990s. *Museum Management and Curatorship* 14(1), 73–9

Janssen, R. M. 1992 *Egyptology at University College London 1892–1992.* London: University College London

Kelly, M. 1999 *The Management of Higher Education Museums, Galleries and Collections in the UK.* Bath: International Centre for Higher Education Management

Murray, D. 1904 *Museums: their history and use.* Glasgow: James MacLehose & Sons

Museums Association 1992 Museums and Higher Education. *Museums Association Annual Report* 1991–92: 5–14

Petrie, W. M. F. 1893 Introductory Lecture at University College London 14 January 1893 [quoted in full in Janssen, 1992: 99–102]

Petrie, W. M. F. 1900 A National Repository for Science and Art. *Journal of the Society of Arts* 18 May 1900, 525–36

Petrie, W. M. F. 1904 *Methods & Aims in Archaeology.* London: Macmillan and Co

Petrie, W. M. F. 1915a The Egyptian Museum, University College. *Ancient Egypt* IV, 168–80

Petrie, W. M. F. 1915b *Handbook of Egyptian Antiquities.* London: University College London

Petrie, W. M. F. 1931 *Seventy Years in Archaeology*. London: Sampson Low, Marston & Co

Petrie, W. M. F. 1938 Museum Plans. *Journal of the Royal Institute of British Architects* 45, 340–1, 557

Simpson, M. 1996 *Making Representations: Museums in the Post-Colonial Era*. London: Routledge

Smith, H. S. 1988 The Petrie Museum of Egyptian Archaeology. *UCL Bulletin* October 1988, 6–7

Standing Commission on Museums and Galleries 1977 *Report on University Museums*. London: HMSO

Ucko, P. J. 1998 The Biography of a Collection: the Sir Flinders Petrie Palestinian Collection and the Role of University Museums. *Museum Management and Curatorship* 17(4), 351–99

Roman Boxes for London's Schools: An Outreach Service by the Museum of London

Jenny Hall and Hedley Swain

Introduction

The Museum of London has developed a project intended for London's schools to improve the access to its nationally important Roman archaeological collections. It would like to provide a 'mini-museum' of Roman material, suitably packed and presented, to every state and special school in greater London – a total of over 2,000 schools. If the museum achieves its aim, it will be the largest ever deposition of museum artefacts to British schools and it is hoped that it will form a model for other institutions seeking to increase educational access to museum collections.

The Museum of London Archaeological Archive

The London Archaeological Archive holds the secrets to the lives of past Londoners. The museum views London as one big archaeological site and each individual excavation contributes a snapshot to the bigger picture. In all, the Museum of London holds the archives for over 3,000 individual excavations. A recent survey (Swain, 1998) has shown that the London Archaeological Archive (the accumulated remains from all London excavations) is over three times larger than any other in Britain. At present, it includes 120,000 boxes of artefacts, 4,000 environmental samples and 265 timber pallets of medieval stonework. These figures continue to increase annually (Swain, 1999).

In 1998 the archive moved from its rented store into the Museum of London's own resource centre. However, it is currently stored there in cramped conditions with only minimal access and no room for expansion. The museum is now planning a completely new approach to caring for the archive. It is faced with two main challenges: first, the effective storage of the archive to ensure its long-term preservation; secondly, and perhaps more importantly, the maximising of access to and the use of the archive. It is widely accepted that archaeology and the study of our past is important. However, it is very difficult to translate this into giving wide public access to some very complicated records and to box after box of flints and pottery sherds. Obviously much of the task of providing access falls to museum curators who study the material and explain it to the public through gallery displays, temporary exhibitions and books. However, it is the Museum of London's goal to provide a far more exciting level of access to this material. The school boxes scheme will be one element of this access initiative.

The museum's plans for the archive involve the creation of the London Archaeological Archive and Resource Centre (LAARC). This facility will be based in the museum's resource centre in Hackney, which currently holds the extensive social history collections not on display. The building will be enlarged to take current archaeological material and allow room for expansion as new sites are excavated. Public areas are also to be included and the museum is working closely with local archaeological societies, universities and other educational groups to design a programme of access and events in order to make LAARC the prime centre for archaeology in London. The project has received funding from both a public appeal and from the Heritage Lottery Fund.

The Museum of London's provision for schools

One of the museum's strategic aims is 'to make 100% of the Museum's core collections physically available and interpreted in an accessible and enlivening way' (Museum of London, 1999). The museum's current services for schools studying the Romans focus on the Roman London Gallery – the most popular gallery for school visits at the museum. The gallery visits are always fully booked and it is not possible to accommodate all the schools wishing to use the gallery. As many as 5,000 pupils are denied access each year. The museum's educational sessions on Roman themes and artefact handling sessions are also the most over-subscribed in its extensive educational programme.

Museum research has shown that, despite offering free admission for schools during term-time, trips out of school are too expensive for the poorest schools. The cost of travel prevents many from reaching the museum and as a consequence they cannot benefit from access to the collections. In addition, schools in London have only limited access to other sources of Roman material. The British Museum does not offer sessions for artefact handling and only a few of London's local museums have their own archaeological collections that are used for teaching purposes. Currently, the Museum of London's Roman sessions, mainly involving visits to the museum, are used by about 200 London LEA schools, barely 10% of the total of London's state primary schools.

A unique educational resource

It is widely accepted that there is nothing to compare with being able to touch real artefacts. If managed correctly, the first-hand experience of historic objects will greatly enhance a learning

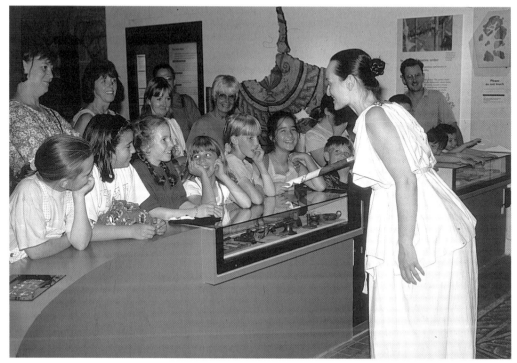

Fig.1. An education session underway in the Museum of London Roman gallery. These sessions are very popular and successful but vastly over-subscribed by London schools (photo: Museum of London).

experience (see, for example, Durbin *et al.*, 1990). To try to assist schools in studying the Romans, the museum has drawn on its expertise in working with children over the years and has assembled a series of artefact boxes for its teaching sessions. It is hoped that, by using actual objects in the classroom, London's schoolchildren will be better equipped to learn about the Romans. Classes study the Romans as part of the National Curriculum Key Stage 2 – Study Unit 1: Romans, Anglo-Saxons and Vikings in Britain. This is the stage in the National Curriculum when pupils are required to learn about the Roman conquest, its impact on Britain, everyday life and the legacy of Roman rule.

The development of the boxes project

The school boxes project therefore developed out of what proved to be several complementary factors:

• The museum wishes to provide greater and better access to its collections, and specifically access to its Roman collections to schoolchildren.

• The museum cannot satisfy the demand for access to its Roman London Gallery by schools.

• The museum holds the London Archaeological Archive which includes in its great bulk some material that is of limited academic value.

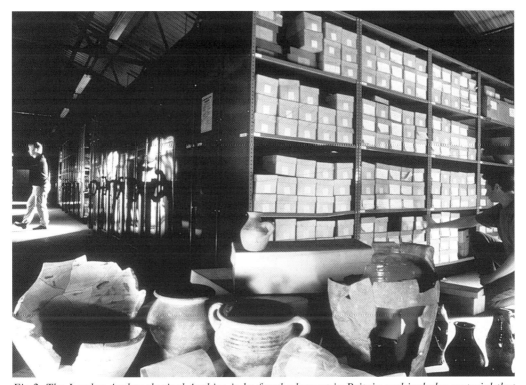

Fig.2. The London Archaeological Archive is by far the largest in Britain and includes material that can be used for the school boxes scheme (photo: Museum of London).

• The museum, through the ordering and management of the archive, will be able to identify archaeological material which does not warrant full curation within the museum, is of limited academic value and which is suitable for use in school boxes.

The idea was born to use material of no academic value from the archive to create boxes of material that could go out to London schools.

The design of the box

Detailed consideration was given to the appearance of the box. It was important that the box should both look good and be practical in its use as a mini-museum. During research for the type of box, project staff visited museums that run loan-box services to find out how they organised the services and the suitability of materials. They also talked to teachers. The following criteria were drawn up to assist in the final choice of the box:

• It needed to be bright and colourful.

• It needed to be made of durable material to survive the test of time.

• It needed to be strong and secure enough to protect the archaeological contents.

• It needed to be more than just a storage box so that it could double as a classroom display

A metal box was chosen because it was thought to be the most durable for classroom use. To get such a box made to order would have been prohibitively expensive and project staff then looked to see whether there was anything readily available. They found that metal boxes, made for craftsmen to keep their tools safe, were already on the market. These boxes had metal trays of varying depths and configurations with a top-opening lid. Approaches were made to the manufacturers (Talco plc) to see whether they would sponsor the project by supplying the boxes either free or at cost. The firm thought that the project was very suitable for sponsorship and were happy to supply the boxes at cost but with additions made to the drawer configurations to suit the project's needs. They also added a set of wheels to make the box more manoeuvrable and produced them in the chosen colour at no extra charge.

It had been decided that the objects to be stored inside the box needed to be securely packed. In museums, it is standard practice to store objects packed in inert foam or polystyrene boxes. To help teachers and pupils distinguish between real and replica artefact, the smaller real objects were to be packed into polystyrene boxes held in place in the drawers by foam (Plastazote). Instead of tissue, the artefacts were to rest on crumpled clear film (Cryovac) inside each plastic box. The replicas were to be set into shaped recesses cut in the foam. Again the team approached manufacturers of storage materials (The Stewart Company [crystal boxes for the finds], SJ Gaskets Ltd [foam packing]) and again manufacturers were very happy to help. Some were prepared to supply the materials at cost and others generously supplied materials free of charge as a form of sponsorship. As all the replicas were standard to each box, it was possible to approach a firm to get the shapes machine-cut, saving much time and effort on the part of the project team.

The inclusion of archaeological archive material from the museum's collections

Some still find the idea of using museum collections in this way difficult to accept. However the very particular nature of archaeological archives, particularly those from very old excavations,

does mean that there is almost always material which does not contribute to a museum's aims.

All the material for the boxes will come from the museum's archaeological archive held within the LAARC. The objects which are selected:

• will not come from accessioned collections

• will be clearly identified as owned by the museum

• will be fully recorded, before being selected

• will come from 'unstratified' archaeological contexts which make no significant contribution to the understanding of a site's history or from material for which no associated records survive

• will be of a mundane and repetitive type which has no intrinsic academic value.

Much material of this kind exists, and is indeed common to all archaeological assemblages. This programme fits securely with the current professional museum and archaeological debate about

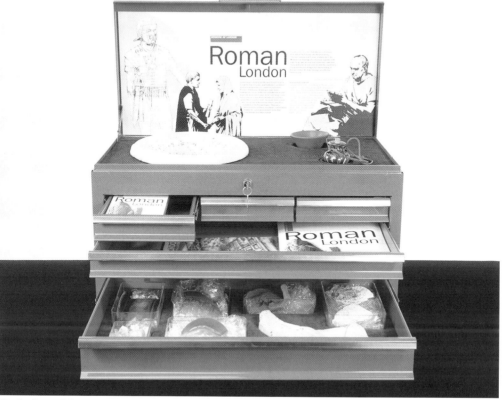

Fig.3. One of the Roman School Boxes. The bottom shelf contains the actual Roman artefacts (photo: Museum of London).

gaining maximum value from material while not retaining it simply through precedent (see, for example, Merriman and Swain, 1999). The process of deposition will include a clear record of the material, to be kept at the museum.

Legal ownership of the box

It had been intended to donate the box to a school but the issue of ownership of the archaeological material was raised as a problem. It was felt that the museum should retain ownership of these pieces, not so much because it might want them back at a later date but to impress upon the school that the pieces were, in their own way, a valuable part of the archaeological record and should, therefore, be kept safe and secure. The project team did not want see the material appearing on the antiquities market and the schools were also asked to confirm that they would not discard, hand on or sell any material that is deposited with them. Each piece of archaeological material has been numbered and a brief record made of what each box contains. Consequently, the schools were required to sign a deposit agreement in which it was stated that, if the school at any time no longer required the box, it should be returned to the museum.

The content of the boxes

Each box is designed as a Roman mini-museum with a graphic panel about the Romans, the Museum of London and archaeology displayed in the lid. It contains a mixture of real material taken from the Archaeological Archive and replicas of Roman objects. There are teachers' notes, classroom worksheets and a training and demonstration video to accompany the objects, all of which are designed to support the use of the artefacts.

The artefacts

The artefacts are the most important part of the box. They are high quality and reasonably large, chosen to be easily appreciated and understood when used for non-specialist teaching. Nearly all the items are ceramic, selected for their durability. Each box that has been distributed as part of the pilot scheme contains a carefully chosen selection of Roman pottery. All pottery sherds are clearly recognisable as being from pots, normally rim or base fragments so that the shape of the original can be appreciated. At least one large piece of pottery, of a more awkward shape, has been included and there is a deep drawer in the box to house it.

It would not have been possible to select identical sherds for every box but, in general terms, every box has two sherds of the red glossy tableware, samian, at least one of which had some form of moulded decoration, and an effort was made to select either sherds with either animal or figural decoration to enable children to describe the scene. To provide a balance, a fragment of plain locally made cooking or storage pot was chosen. It has also been possible to include a large fragment of mortarium, the Roman mixing bowl with a gritted interior, which was widely used in Roman kitchens. By including fragments of the abrasive surface, children can appreciate the technological reason behind its original design. Some boxes have a portion of amphora, the large containers that were used for transporting foodstuffs throughout the Roman Empire. Sometimes it may be one of the vessel handles, part of the rim from the top, or the spike from the bottom of the container that acted as a shock absorber.

In addition to vessels, fragments of ceramic building materials have been included. There is one piece of building tile and samples of flooring. The tile might be identifiable as a roof tile because of an upturned edge or might have an animal footprint impressed on the surface. The Romans are renowned for their decorative mosaic floors but there are many other different types of flooring found from Roman London. Two or three small cubes (tesserae) of clay from plain red tessellated floors are included. The only artefact included, that is not ceramic, is an oyster shell to introduce

the dietary theme. The selection of this real material therefore enables many of the themes in the National Curriculum Study Unit to be covered.

The replicas

It was decided that it was important to also include replicas in the school box. This was for two main reasons: replicas could enhance the learning potential of the partial remains of the original artefacts because they could assist the pupil in visualising the whole object; replicas could also illustrate themes in the Study Unit not covered by the real artefacts and could be made in materials that do not survive in sufficient numbers in the archaeological record to be included in the boxes. The replicas were chosen with care to ensure that they were as close copies as possible to original artefacts and that they were quality products. Some were actual copies of material found from Roman London and all (except for the coin packs which were already in general production) were commissioned especially for the boxes.

Two pottery replicas, a mortarium and a samian cup, help the pupils to understand the size and shape of the complete object, for which they have incomplete examples in the box. Also included is a replica clay Roman lamp, directly based on an example from the Museum of London collections, in the shape of a human foot wearing a shoe.

A replica bronze manicure set with tweezers, nail-cleaner and an ear-scoop and a replica glass bottle to hold perfumed oil for a trip to the public baths is included. A replica set of wooden writing tablets with a layer of wax set in the recess are hinged together by cord, which makes it possible for children to see how such documents could be sealed and sent. The implement used for writing on the wax is a stylus, a tool with a point at one end for writing and a flattened rectangular end at the other in order to smooth the wax for use as an eraser. A bronze example is included. A pack of two replica coins, one bronze and one silver, shows that coins were a means of communicating important events throughout the empire. Finally, it was decided to include a resin copy of a jet head of Medusa, the mythological creature who could turn people to stone.

The teacher's notes

Three booklets have been especially produced for the box. One provides background information on Roman London, covering such topics as Roman London's first settlers, the

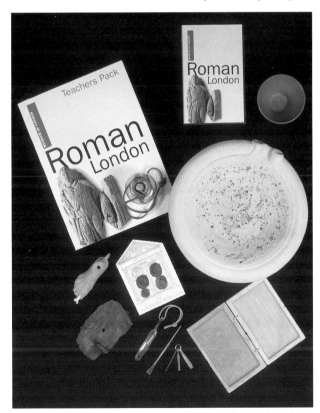

Fig.4. The teachers' information pack, video and replicas from one of the boxes (photo: Museum of London).

port and trade, people in Roman London, everyday life, religious life, homes and houses. A second booklet is solely about the Roman Box and its contents. It advises teachers on how to care for the box, gives information about the suppliers and replicas and then gives details and illustrations about all the objects, both real and replica, that are contained in the box. The third booklet, entitled *Using Objects – A Teacher's Resource*, is concerned with guidelines for teaching with objects. It provides a sample worksheet for children to help them learn to research objects and suggests activities, including cross-curricular activities, that teachers could use in combination with the Literacy Hour, mathematics, design and technology and art and design activities. Also included are copies of a booklet on Roman food, reproduced from the Roman London gallery, a sheet giving the chronology of events in Roman London and Roman Britain and a photocard pack, which had already been produced for teachers for classroom work prior to a school visit. The pack contains ten colour laminated photographs of Roman objects on display in the gallery.

The video

A video, produced to accompany the box, can also be stored in a box drawer. The video is divided into three parts. One section explains to the teacher how to use the objects in the box. The second section consists of a performance by an actress playing the part of a maidservant living in one of the Roman London's houses. It is a performance that, with prior booking, is presented to those schools visiting the reconstructed rooms in the Roman London gallery. She tells the children about her life and brings into the performance some of the replicas that are included in the box. The final section shows pupils how it is possible to find out about the Romans by the process of archaeology and looks at what materials may survive long-term burial.

The trial project

During the autumn of 1999, the boxes, storage materials and replicas were assembled in the museum's store in Hackney. It was then necessary to retrieve suitable material from the London Archaeological Archive, which was to prove a very time-consuming process. As it had been decided that the pieces had to be informative, there were many sherds that were deemed to be unsuitable. The material was also dirty, needing to be wiped clean and then marked with an identification number.

Two hundred boxes in the pilot scheme were delivered to schools in greater London early in 2000. Half of the schools were chosen because they regularly used the museum's education services and were invited to participate. The museum then approached local education authorities for suggestions of those schools less likely to volunteer to participate. The team wanted to be able to compare the differing uses that such schools might make of the scheme. This will be monitored during the evaluation process.

Before the boxes were distributed, a teacher from each of the schools was required to attend a training session. Two sessions were held at the museum's store in Hackney and attending teachers were allowed to choose and pack the contents of their own boxes. The project team decided that other sessions should be held at appropriate centres throughout Greater London to save teachers travelling distances. These sessions, held in museums in Croydon, Fulham, Enfield, Newham and at the main Museum of London building, consisted of a curator talking about the objects and replicas, a conservator who demonstrated how to look after the box and a museum educator who advised on how to use the objects for teaching purposes. The initial reaction of the teachers to the boxes was pleasing as they saw their teaching potential. Following the training sessions, all the boxes were delivered to the schools.

The boxes are now under trial and the evaluation process is underway. The boxes and their contents were expensive but it is hoped that they will withstand the test of time. The scheme has

also proved costly in staff time and would not have been possible without the generous sponsorship of the manufacturers. The Department of Education and Employment acknowledged it to be a prime example of increasing public access for schools and supported the pilot scheme with a grant of £41,000. The results of the evaluation will determine whether the museum seeks to raise the necessary sponsorship in order to proceed with its intention of furnishing every state primary and special school in greater London with its own mini-museum of Roman artefacts.

References

Durbin, G., Morris, S. & Wilkinson, S. 1990 *A Teacher's Guide to Learning From Objects*. London: English Heritage

Merriman, N. & Swain, H. 1999 Archaeological archives: serving the public interest?, *European Journal of Archaeology* 2(2), 249–67.

Museum of London 1999 *Museum of London Annual Report 1998–9*

Swain, H. 1998 *A Survey of Archaeological Archives in England*. London: Museums and Galleries Commission. (with contributions by Ash Rennie and Kirsten Suenson-Taylor)

Swain, H. 1999 Taking London Archaeology to Londoners, *London Archaeologist* 9(1), 3–5.

Written Communications for Museums and Heritage Sites

Paulette M. McManus

Introduction

I believe that the psychology of the writer is as important as the psychology of the reading visitor when you are considering the effectiveness of written communications at museums and heritage sites. The personal attitudes a writer has both to the subject matter and the task of composing texts for museums and heritage sites is the prime determinant of the interpretive success or failure of any label, panel, computer screen or other form of written communication with visitors. All the easily available advice on technical matters – line length, headings, font size and so on – will count for nothing unless there is a reflection of intentional writer energy and concern for audience in the writing.

Accordingly, in what follows I will focus more on what the communicative act of writing for informal educational audiences implies rather than the graphical presentation and production of the label seen as an object in the museum or visitor centre. A 'how to do it' behaviourist manual is not offered as I do not believe that there is a single formula for writing good text for all heritage audiences. However, there are some things which are best avoided, so reference will be made to common sense, practical, technical features of written products which I feel can obscure the communicative, educational function of written communications.

My aim is to emphasise that the combination of the ways you think about the act of writing for an informal education audience and the topic you are working with is likely to affect the communicative outcome when meanings come to be shared between you and the visitor – perhaps subtly, perhaps profoundly. Anyone about to begin writing informal educational texts needs to be encouraged towards developing a self-conscious working attitude to the act of communication which is embodied in the media of informal educational exposition. This is preferable to diving deeply into subject research straight away or becoming too fixated on strictures about syllables, word counts and such like before writing begins.

First, some reasons why written communications have become so important in all forms of display, and will become more so, will be discussed and I will describe how my own attitude to heritage text writing developed so that what follows can be placed in context and judged accordingly. Secondly, a recommended behavioural framework for text writers will be described and some general guidelines will be provided. Finally, as I agree with Blais (1995a: 26) that empiricism in the area of exhibition text is essential if we are to temper intuitive rules, trends and assertions, the feasibility and desirability of consultation with visitors during text writing will be illustrated with reports of three formative evaluation studies I conducted in 1999 on texts prepared for the British Galleries 1500–1900 Project, a major representation of collections at the Victoria &Albert Museum, London, due to open in late 2001.

Why written texts are now so important

Formerly, nearly all the language used in museums and at historic and archaeological sites was

spoken and conversational in tone. The collectors of the cabinets of curiosities which were the forerunners of museums talked conversationally with their friends and like-minded collectors about the things they had collected. They would have known the people they were communicating with. When public museums were established the items in them continued to be displayed as a collection. They were usually named, with little labels, according to taxonomic systems developed as a result of scholarly, academic and curatorial research. Often guides were employed to provide face-to-face interpretation of the objects on display because naming something is not the same as describing it or explaining its significance. This guiding function later developed more formally into museum education services.

In the 1940s some museum exhibitions began to explain the ideas and concepts developed as an outcome of research on collections. This development of the thematic exhibition (Sampson, 1995: 136) meant that objects were used to illustrate a narrative or story. Panels to introduce a story and explanatory labels to show how objects fitted into it became a part of museum exhibitions. Unfortunately, the written texts were often very technical and scholarly and the responsive characteristics of guided, spoken communicative interpretation were not very evident. Museum written texts can have a quite simple grammatical structure but be dense with lexical complexity. For example, words carrying puzzling content and concepts, such as *patination*, *socled* are packed into texts with lexical complexity. I recently came across these two technical words at the end of an otherwise easy-to-read museum text about the difficult-to-understand lost wax process for casing bronze statues. The last sentence read 'Finally, the statue is patinated and socled.' In contrast to lexically complex phrasings, the complexity in spoken language is grammatical because items such as *the*, *because*, *with*, *you*, which carry little content, facilitate the structure of the text in order to make it responsive to listeners. The puzzling sentence I read could have been expressed, with conversational, grammatical complexity, as 'Finally, the surface of the bronze is treated and the statue is mounted on a plain, low base.' Since the 1940s, museum texts have been moving towards a balance between lexical and grammatical complexity (Ferguson *et al.*, 1995: 33–4). It is likely that appropriate balances for labels, panels, pamphlets, screen delivered information and audio-tours, etc. will differ between applications and between venues.

From the time of the advent of the thematic exhibition the importance of the written word in informal educational environments gained recognition and today we can, sometimes, see educational exhibitions as mass communication media in their own right. Compared to other forms of mass communication such as, for example, books, newspapers and radio, the educational communication prepared for a mass educated audience at a museum or heritage site is a fairly new media still feeling its way forward into a widely recognisable format and some people still cannot resist writing very scholarly or technical exhibition texts. Hence the proliferation of 'how to write exhibit text' information in the professional literature. Some categories of museums, particularly art galleries, still present taxonomic displays based on categories, derived from collections research or scholarly studies, such as chronologies, schools and medium of execution. However, events such as the recent redisplay of the Tate Modern, London, and the Tate Britain, London, collections in themed exhibition spaces, indicate that the educational exhibition and the proliferation of responsive gallery text to support it has become a ubiquitous fact of museum life.

Historical and archaeological sites are harder to recognise as mass media instruments not least because, unlike museums, visitors must usually walk through the 'object' being interpreted. For conservation reasons, many historic buildings must pulse visitors through and they do so under the leadership of a face-to-face guide. Many archaeological sites, particularly in the Mediterranean region, provide no interpretation other than that delivered by face-to-face guides

who, it seems, still work in the traditional frameworks established for guiding at the times of the 18th century Grand Tour and the rise of middle-class tourism at the beginning of the 20th century. Quite often guides may work independently of the administration of a site, in which case there is no control over what is communicated. Just as some curators, in many instances because of their own perceived position as the sole source of expertise, were resistant to changes involving the introduction and development of explanatory texts, so professional guides can be expected to be resistant to forms of presentation other than the face-to-face encounter on which they depend for a living.

In an age of mass cultural tourism, face-to-face interpretation will always have a place but it cannot stand alone or adequately satisfy the modern informal education audience. For largely pragmatic reasons, it will lose dominance at historic and archaeological sites just as it did in museums. It will become a supplementary extra to written communication (even when the written words are heard as in an audio-guide). First, the volume of visitation at many sites mitigates against the face-to-face personal encounter and the personal response communication which might be thought to be desirable. There will not be enough guides and volume visitation is difficult to manage if it is all in large groups. Secondly, it is very difficult to monitor the content and level of presentation of a large troupe of guides and in these days of audit and accountability, this is not satisfactory for any publicly funded institution. Thirdly, informal education is free choice, open and dependent on unmanaged experience. What you will learn, why you want to learn it, where you will learn, who you will learn with and whether you have learned something or not is entirely up to you as an individual learner or a member of a small social group of visitors, and people like it that way. This pattern does not fit with being taken as part of a fairly large group of strangers on a shepherded and rapid perambulatory lecture of pre-ordained content. Self-guided tours with written and scripted interpretations provided by fixed panels, audio-guides, computer installations or hand-held pamphlets are more in keeping with the nature of the audience. Like museums, heritage sites cannot avoid a focus on communicative texts. However, as they are closer to the traditions of face-to-face conversational explanation, their approach may have much to offer museums.

Written museum text experiences

In the mid-1980s, I made a study of communications with and between visitors to the Natural History Museum, London (McManus, 1987a, 1987b, 1988). I observed the reading behaviour of 583 visitor groups and found extremely significant statistical relationships between reading behaviour, the use of interactive exhibits, duration of conversations, duration of visits and group type. I began to be alerted to the deep influence of texts in museum environments.

The linguistic analysis of the conversations of 167 of these visitor groups indicated a very close language involvement with the text writer (McManus, 1989a, 1989b) – 85% of visitors had paid a much-more-than-cursory attention to label texts in that they had either read or glanced at them, or the labels had been read out aloud to them by another member of their group. In fact, 71% of conversations imported the words, or paraphrased words, of the text writer into their talk so making the absent writer a party to their conversation. I dubbed this phenomenon 'text-echo' and it has since also been recorded in extensive evaluation studies at the Museum National d'Histoire Naturalle, Paris (Sampson, 1995: 145). My recordings also showed visitors reacting as if the exhibit writer was talking to them through exhibits and visitors talking back to the writer. With their active 'What is it?' and 'What does it say?' comments the visitors illustrated that the search for making meaning was the reason for reading in the museum – not that meaning making was the consequence of reading. The exhibition developers exerted

considerable topic control over museum conversations through the agency of the label texts – visitors attended to them as authoritative authors. Clearly, the relationship between visitor and exhibition team and writer was very close and (surprisingly) conversational in character.

Usually, books and articles on text writing for museums and heritage sites read like technical manuals with instruction about matters such as arrangement of text hierarchies and various genre text functions. Such literature may help with problems over the delivery of interpretation but not with problems over text conception and production. For this reason I prefer to refer to linguistically orientated writers on exhibition text such as the easy-to-understand Ferguson *et al.* (1995) and Jacobi and Poli (1995) and their colleagues writing under the editorship of Blais (1995a), since these writers share a view based on a modern understanding both of how language works and is processed, which they have focused on the use of language in the museum environment. Such writers explain, for example, *why* text hierarchies are important so that you can work out how to use, and not use, them.

After I had completed my research study I worked in an exhibition team as a researcher-writer and had lots of my text modified or cut by the editor because it was too scholarly or lexically complex. I was for a time deeply irritated and dismayed. Preparing exhibitions is a very involving, intensive and creative process with, ultimately, shared authorship at the end. This experience taught me that it can be a very emotional one too. It is very hard to let overwritten texts go. I began to understand the subject-dominated writer's position. I have since seen other people become really angry and distressed for a long time when their words are rejected. Part of such emotional responses to editorial behaviour is tied up with the sense of single authorship which can develop when the heritage writer works alone. When text is rejected it is as if the author 'loses the right to declaim from the soap-box'. In reality, most heritage interpretation involves three-dimensional visual communication in which things, design and words interplay with space, colour and lots of other perceptual influences – there can be no single authorship.

I then went on to carry out research for a series of educational TV programmes and I still tended to produce lexically rich script derived from written scholarly source material. But the other researchers spent lots of time on the telephone consulting the experts verbally and writing down responses verbatim. They were acting like reporters and producing grammatically complex scripts. Some time later, I project-led the development of *Science for Life*, an exhibition about modern medical research, for the Wellcome Trust. Texts for exhibit areas such as the human cell that people could walk through had to be academically accurate yet readable for a lay audience in a very novel environment. I employed an academic and a TV researcher to become second level 'in-house experts' after they had digested the very abstract concepts we were working on with our first level experts. We then developed a system where we interviewed each other about topics. Texts were based on the way verbal explanations were made and this helped to achieve a balance between lexical and grammatical complexities.

Experiences in talking to visitors during evaluations and in critical review of exhibitions have reinforced my understandings about writing communicative texts. Such activities can be undertaken by anyone working in the museum and heritage sector.

A behavioural framework for writers of communicative heritage texts

This behavioural framework depends on the prerequisite of an in-depth understanding of subject matter which will allow the writer to employ a high level of variety in approaches to interpretation. Following that, the full-time use of an interactive model of communication (McManus, 1991) is employed. Grasping the concept of the model will provide the motivation for going just that little bit further when thinking about subject matter.

Topic mastery

Try to fully understand the content, process, demonstration or activity you are writing about so that you can confidently explain it in many different ways to many different audiences if required. Reproducing a description or explanation from a research resource is not sufficient; reproducing your 'not-quite-there' understanding is not sufficient. Visitors must not be left with unanswered questions. Full understanding of your topic will give your explanations an intangible, confident, reliable air of authority. Evaluations, and the rewrites they engender, often reveal that the text developer did not really understand the material offered to the public.

The interactive model of communication

The interactive model involves accepting that both you and the visitor who is your future audience are working to share understandings about what is written (McManus, 1991). Contrary to what mid-20th-century models of communication might say, the task is not about writing messages which will be admitted unchanged into the mind of some mechanical 'receiver'. Both the writer and the audience must interrogate the communication situation in order to make shared meaning from it. We can conceptualise this interrogation as two sets of three questions from both parties to the communication situation. The more the questions are satisfied, the more likely are congruent understandings.

The text writer's questions
What do I want to say?

Whatever topic you want people to understand when they have finished reading your text is your 'key point'. Stick with the key point, especially in captions, and avoid confusing the visitor by adding other points further down the text. That is, avoid 'topic drift' in a unit of text. Put enthusiasm into the writing. Don't be afraid to show that you care keenly about what you 'say' – that you find it interesting enough to tell visitors about it.

Who am I saying it to?

Remember that you have a leisure audience which is on the move and that they may be reading your words in dimly lit or noisy conditions. Remember that most informal education visits take place in a social group and people will be wanting to pay as much attention to their companions as they do to your texts. This is not a subject-specialist audience. To help your audience, keep your text simple and easy to read. Be aware of any research on common misconceptions about the topic and deal with them at the beginning of the text so that you ease the path to shared understanding.

Am I reaching my audience?

As you sit in your office, it is difficult to imagine an audience which is distant from you in time and space, so it is important to imagine your future audience, drawing on all your understanding of, and readings about, visitor behaviour while doing so. When writing, concentrate on the effort to communicate.

The final audience's questions
Who is talking to me?

With this question, an audience judges the integrity and expertise of an author in order to assess how far new information can be trusted as reliable. This is why you must have authoritative mastery of the topic you are writing about. Most museum visitors trust the subject authority of museums. Alternative lay interpretations of heritage sites such as, for example, Stonehenge, are commonplace and widely accepted. Each alternative narrative challenges the other for authorial

authority. At Stonehenge, the audio-tour is given by several author 'characters'. It is not known whether visitors there accept the version of events given by the 'shepherd author' or the 'archaeologist author', or understand that both texts were written by a single author conceding that there are various points of view, or whether they are left confused.

What is the author's topic of communication?

When visitors ask this question they are looking for an immediate, clear indication of topic. This is best given clearly in the heading to your text and in the first sentence.

What they saying about the topic?

Here visitors are seeking for an indication of your approach to topic – the line you are taking – and an elaboration of the key point you are talking about.

Using the model

Think of how many visitors your museum or site expects annually and the projected life of your communication. Many thousands will read what you write and you will remain responsible for your text in these encounters. Be very careful in planning, drafting and rewriting your texts. Above all, keep the interactive model of communication in the forefront of your mind and try to make sure that all the questions embodied in it are answerable.

Suggested practical guidelines

Use text hierarchies

Well-prepared text provides a coherent intellectual framework for the visitor. It leads the visitor down a path which explains what a communication is about. The text hierarchy should articulate the intellectual framework you wish to provide for the visitor. For museums and visitor centres, a text hierarchy starts with the name of the institution and follows on down with the titles of exhibitions, titles of conceptual areas or sections within exhibitions, titles of subject panels and their contents, titles of exhibits and their texts down to both object labels and directions for activities. Informal education audiences tend to browse text and scan it while on the move. Hence, ensure that text at any level of the hierarchy can stand alone. Most other forms of heritage communication, especially those on-screen, follow a similar pattern.

Do not use development team jargon while you work

If you use development team jargon, or subject-defined technical expressions, for either exhibits or activities while you work on them this will not help you to mentally target your final audience. Early on, think of the visitor experience and decide on final titles within your text hierarchy and stick with them. The stage when floor plans or tour routes is decided is a good time to finalise topic titles.

Always use a conversational tone in your texts

Writing as you speak will help you to make contact with your 'off-the-street' audience. If you are having trouble writing a particular piece, read it aloud or record yourself explaining the topic to a friend. This will help to ensure that you use an everyday language register which relies on grammatical complexity. Do not be afraid to use 'you' and 'we' in your texts.

You can break the 'rule' about active tense

Most current text manuals say that labels should always be written in the active tense for a heritage audience. Conversational text, mentioned above, is in the active tense. But, if the

subject of a sentence calls for use of passive tense use it (Ferguson *et al.*, 1995: 16) but don't put all texts in the passive.

Remember the social context of your subject matter

Visitors are very interested in the social dimensions of exhibition and heritage communications. They like to know about the people who made, owned or used things. Satisfy their curiosity whenever feasible.

You don't have to provide words all the time

Language is the basis of most informal education communications but this does not always mean providing text. Sometimes the words can be used up by the development team in their work to discuss and select images, maps and graphical representations of concepts and to design pictograms and activities, all of which can carry communicative impact. Cartoons are also a very immediate way of keying into popular culture while illustrating abstract concepts. All visual representations should be self-explanatory and related to your key points.

Text and objects or sights

Your text should mainly refer to the things that visitors can see. It should point out concrete and specific things about the things seen, whether they are indoors or out. Labels should be placed as close to objects as possible – preferably so that label and object are seen by visitors as an interpretive unit.

Text and hands-on and screen-based interactives

Place instructions for hands-on, physical interactives where people will be putting their hands when using them. Naming parts of an interactive which must be constructed on the actual parts can be very helpful. This helps visitors to talk meaningfully about what they are doing when constructing rather than resort to portmanteau terms such as 'thingamajig'. Don't make instructions for hands-on or screen-based interactives too complex. This can happen when you break the activity down too far into itemised steps. Use common sense – the visitors will! Pictograms and their equivalent, screen icons, are very helpful when writing instructions for hands-on and screen-based interactives.

It is a good idea to put the plan of the architecture of a complex computer program on a panel and place it on the wall near the screen so that visitors can refer to it while using the program. A complex ICT program can be envisioned as an exhibition behind a screen with one exhibit on view at a time. The plan will help visitors to orient themselves through the program in a controlled way just as the physical layout of an exhibition floor helps them to orient themselves through the exhibition communication. Truly educational programs should grant their users a high level of autonomy and freedom to explore mindfully and providing a scheme of the program architecture, rather than have visitors try to remember it or work it out *if they can*, may help to achieve this.

Explain

Explain your reasons for any value judgements you might make, for example that something was 'good' or 'bad'. Explain any technical terms you cannot avoid using.

Be sensitive

Be sensitive to all parts of your audience and do not offend those who are not a part of it in front of those who are. This stricture applies to gender, ethnic, cultural minority and foreign language issues.

Paulette M. McManus

Vary text length and sentence structure

There are lots of 'rules' about these two items and communicative intent must be the guide in choosing to break them. However, it is a good idea to observe them most of the time and the three I think most important follow:

Keep sentences short but not all the same length – aim for around six to eight sentences every hundred words. If you find 'and' in the middle of a sentence you have probably joined two sentences together that would be better on their own.

Think of those who do not have English as a first language such as migrant residents in your country or visiting tourists. Heritage audiences are, increasingly, tourist audiences. Help them by using simple words and sentences without subsidiary clauses.

Vary the length of similar status texts as this strategy helps visitors to stay alert.

Readability tests are not obligatory

Readability tests only take account of the number of words and syllables in a sentence – not the meaning of the words or sentences, or the understanding the reader forges from those meanings. I do not recommend the use of readability tests (but many people do) because I feel that if you write with informed, committed communicative intent you will not need to use one. The fact that your computer has a readability test facility does not mean that it is a 'good thing'. If you do want to use a readability test, read all about what they do so that you can override the test with confidence. Many text writers use a test for an age range of 14 to 15 years – this is about the reading age of a tabloid newspaper. For a more detailed critique of readability tests see Carter (1993).

Think about the amount of text read in exhibitions

Visitors will not read all of your texts. They will browse and sample depending on what they already know and what interests them. Their motivation may depend on how tired they are and how much more they want to see. This means that your words must count and, also, support the general themes of the overall communication.

I once planned a comprehensive study of how a large exhibition about cultural relativism worked when in use. The study included seven distinct evaluation approaches. In response to an exit questionnaire asking what the exhibition was all about 97% of the hundred visitors interviewed clearly described the communication objectives which had been prepared when the exhibition was first planned (McManus, 1993a). This was a good indication of a successful communication. A separate tracking study of fifty visitors indicated that 88% of the visitors had stopped at between one and fifteen of a possible thirty stopping places (McManus, 1993b). This was strong evidence of the browsing and sampling behaviour often reported in tracking studies and it was concluded that browsing and sampling did not prevent visitors from forming a firm impression of what an exhibition communication is about. The same study indicated that the average time spent in the gallery was 6 minutes and 35 seconds with an average of 4 minutes and 50 seconds actually spent in front of exhibits and the rest of the time spent walking between them. Visitors can easily read texts high in a text hierarchy while they walk about. Even so, this was not very much time in which to pick up the main communicative threads of the exhibition. However, humans are excellent information processors and most people can read 250 words a minute. Taking data from both studies, and if it is estimated that on average around half the time in this gallery was spent reading, it can be surmised that the average visitor understood the intended messages after reading around 820 words. That is quite a lot of text but nowhere near the amount of text commonly available in a medium to large exhibition. To help visitors to read more, texts need to be easy to read and economical in length. Say what you need to say simply and do not overdo the information load. Texts which slow the visitor down are likely to shorten the reading word count.

Use formative evaluation

Formative evaluation is a flexible method of consulting visitors and shaping text during its development. Visitors are usually asked to read a text and then say what it was all about. If there are any problems in understanding they will be picked up early and visitors can also be asked if they can suggest improvements. Samples of from five to twenty visitors will help to reveal any communication problems which can then be put right and, if need be, re-tested. It is really important to test fully worked up text. Visitors should be used to polish any text the writer is worried about – not to do the work of development.

Text as gestalt: the importance of choosing a text house style

A text house style includes a myriad of graphic features from choice of font, point size to colour of ink and background and, also, matters such as paragraph length and positioning. Kentle and Negus (1989) present a very helpful and sound house style manual as used at the National Maritime Museum, London (and by many others). A text house style has communicative impact in itself. However, many of the elements employed within a particular graphic are difficult to isolate and evaluate for optimum characteristics because visitors will always read for meaning and will, therefore, quite often put up with a very inconvenient presentation of the combined elements. This means that no-one can perfectly isolate and decide on the ideal features of particular matters such as font or point size. Common sense and knowledge of your audience must be used in deciding on appropriate specifications for the combined use of elements within your particular text house style and for a particular audience. Good advice can be obtained from Kentle and Negus (1989); McLean (1993); Marquart (1995) and Anctil (1995).

 The important thing is to choose a house style and apply it consistently so that visitors can recognise patterns of where texts of differing hierarchies are likely to be placed and the way that information within them is laid out. This recognition helps in the skimming and scanning involved in visiting three-dimensional communications. But before that visitor activity can happen, labels and panels in exhibitions are seen first as things which are part of the three-dimensional scene – they are part of a gestalt the visitor forms in order to orient themselves physically and mentally in the communication space (Jacobi & Poli, 1995: 71). A gestalt is a patterning force which holds the parts of a perceived area together (McLean, 1993: 82). With regard to exhibitions, an obvious and consistent text house style which gives due consideration to positioning should be a strong feature of the patterning involved in gestalt formation. This recommendation is also likely to apply to the way-marking of interpretive routes outdoors.

Beware of compromises made on aesthetic grounds

A strong focus on appearance, whether from curator or designers, can be counter-productive as far as readers of all types of communication are concerned. Thinking of museums, art curators are said to dislike the competition which labels offer to the contemplation of art works. Designers can be very focused on the overall look of an exhibition seen as a display. How else can we explain labels printed in white on transparent backing and then fixed to glass so that they 'disappear' (and cast shadows behind)? How else can we explain labels tucked away out of sight or placed below knee level? I have even seen text printed in black on dark green board so that the labels blended in with a dark green damask wall covering. Screven (1995: 20–1) suggests that a failure to understand text labels and panels as objects integrated into an exhibition and a part of its information system occurs because designers and others see words and their supports as presenting a kind of conflict of interest as they are not artefacts or art. Remember communicative intent at all times when aesthetic demands are made.

Use an editor

Establish an editorial process before writing begins as editorial review takes much time (McLean, 1993: 110). An editor helps to ensure that any team-prepared communication speaks with one voice or, if the work was prepared by a single person, speaks in the style appropriate to a particular institution. So, an editor is a very important person and his or her decisions should be respected.

Three formative evaluations of text: using visitors to help make editorial policy

These three formative evaluations were undertaken during 1999 in the early stages of the development of the British Galleries 1500–1900 displays at the Victoria & Albert Museum, London. They were designed in order to assist in forming, or confirming, aspects of a text house style. As the topics being investigated were largely related to matters of perception and the use of texts, much larger samples were used than would be the case when conducting formative evaluations related to content or directions for activities. The topics investigated were: Ekarv structuring of text; whether texts on panels and labels encouraged visitors to look more closely at objects; and the preferred order of information on object labels.

Test of Ekarv layout

In the 1980s, Margareta Ekarv, a Swedish writer of easy-to-read books for adults with literacy problems, was asked to write the text for an exhibition at the Postal Museum, Stockholm. She used the writing methods she employed for her adult literacy books and in 1986 wrote a paper for the *Journal of Swedish Travelling Exhibitions* about the use of her writing style in museums. Ekarv's article was made more accessible to museologists outside Sweden when it was reprinted in the Leicester Readers in Museum Studies Series (Hooper-Greenhill, 1994) alongside two evaluations of the Ekarv method conducted by students. These publications aroused interest in the Ekarv proposals.

The main features of the Ekarv recommended methods for museum texts were not in themselves controversial. They involved common museum text requirements that: sentences be short and simply structured with subordinate clauses and adverbial modifiers avoided; active tense should be employed; text should be broken into paragraphs; a rhythmical conversational tone should be used; texts should relate to exhibits and that location of texts should be tested in situ. However, the recommendation that museum texts should be typeset so that the end of each line would coincide with the end of a natural phrase or idea (roughly, where you might take a breath when reading aloud), rather than run on as usual when standard left justified text is used, was unusual.

The student evaluations of the Ekarv method are interesting, although sample sizes are not often given (Gilmore & Sabine, 1994). Sabine wrote text for an Egyptian mummy display. Prior to beginning, visitors were asked to compare two texts on the same subject: one text was traditionally academic in tone and the other was written according to Ekarv recommendations. She found that the Ekarv text was popular. After the exhibition with its Ekarv texts was opened, interviews and written comments from fifty-two visitors indicated that 63% of the sample liked the Ekarv texts they were offered. Gilmore used Ekarv principles to produce text for a ceramics display. Using a variety of data collection approaches, she found that both adults and children found the texts accessible and that text-echo occurred. She also commented that the larger labels needed to accommodate the elongated Ekarv text (because of its variable line length) were not particularly practical, especially for small objects.

In the study conducted at the Victoria & Albert Museum, London, it was decided to isolate and test the layout of Ekarv texts as determined by line length adjustments to phrase lengths.

The aim was to see if the layout helped comprehension and readability in and of itself. Initially, a sample of twenty-one visitors was asked to read three full-size mock-up text panels about marquetry, Chippendale and chinoiserie. The texts had been prepared according to general principles of ease of reading in a museum situation and were placed near relevant displays. In general, the visitors reported that the texts were easy and comfortable to read. Then, after the Ekarv layout was discussed with them it was found that, in line with Sabine (Gilmore & Sabine, 1994), several visitors had not noticed the layout, others ignored it, some thought that it looked like a poem and others were critical of it, saying it looked like a series of bullet points and made the chinoiserie text very long.

It was decided that the way forward was to test, side by side, identically scripted chinoiserie texts, one left justified and the other in the Ekarv format and both on same size panels. The chinoiserie text was chosen because it had the most obviously unusual and varied line lengths and it had been the most criticised in the first test. It therefore provided a severe test of the Ekarv layout. The layout of the Ekarv text was as follows:

Chinoiserie was a form of decoration
inspired by Chinese materials and design.
It was most fashionable between 1745 and 1765.

Chinese goods had been imported into Britain
since the 17th century.
People admired them
for their rare materials and curious motifs
that conjured up a fantasy world.

British designers and craftsmen also imitated
Chinese furniture, lacquer and porcelain.
They often combined
Chinese figures and landscapes
with the forms and motifs of the rococo style.

Chinoiserie was mainly used in interiors
for bedrooms and small dressing rooms.
In architecture it was used chiefly
for small garden buildings.

The left justified 'standard' layout looked as follows :

Chinoiserie was a form of decoration
inspired by Chinese materials and design.
It was most fashionable between 1745
and 1765.

Chinese goods had been imported into
Britain since the 17th century. People
admired them for their rare materials and
curious motifs that conjured up a fantasy
world.

Paulette M. McManus

*British designers and craftsmen also
imitated Chinese furniture, lacquer and
porcelain. They often combined Chinese
figures and landscapes with the forms and
motifs of the Rococo style.*

*Chinoiserie was mainly used in interiors
for bedrooms and small dressing rooms.
In architecture it was used chiefly for small
garden buildings.*

For this second test, the sample size was 103. Half of the sample was asked to read the standard text layout and then the Ekarv one with the situation reversed for the other half of the sample. The procedure for visitors was as follows: read a presented text; remove the text from view; read the second text; say which was preferred and why; view both texts side by side during a discussion about their readability during which the principle of Ekarv layout was explained. Hence, both text were presented to visitors under similar conditions.

It was found that a majority of 66 visitors preferred the standard layout from a readability point of view, 35 preferred the Ekarv layout and 2 could not decide. Of the sub-sample of 35 visitors who preferred Ekarv, 50% (n=17) had English as a first language; 60% (n=21) rated themselves as fast readers, 17% (n=6) as slow readers and 23% (n=8) as average readers; and 79% (n=19) left full-time education after university level.

Of those 66 visitors who preferred standard layout, 65% (n=43) had English as a first language; 47% (n=31) rated themselves as fast readers, 5% (n=3) as slow readers and 49% (n=32) as average readers; and 67% (n=30) left full-time education after university level.

Regarding the sub-sample of 52 who rated themselves as fast readers, 60% preferred the standard text layout while in the sub-sample of 49 who rated themselves slow or average readers, 71% preferred the standard text layout. That is, this particular group of 103 visitors indicated that standard layout was preferred regardless of self-judgement of reading speed.

It is obvious that the entire sample, and each of the sub-samples within it, is highly educated and that they are likely to be very experienced readers indeed. This finding points to the need to suit presentations to a particular audience. As educational level is one of the main determinants of museum visiting, studies in other museum are likely to have similar findings to this one. Similarly, museums with a large cultural tourism audience, such as the Victoria & Albert Museum has as a national museum, will also have a highly educated audience and would be likely to have very similar findings.

Since reading is such a complex activity, 35 visitors is a small sample from which to derive reasons for preferring the Ekarv layout. With a bigger sample we might see a trend to those with an Ekarv preference being more likely than others to be highly educated, rate themselves as fast readers and not to have English as a first language. Some of the severest criticism of Ekarv layout came from the 53 visitors who were exposed to the Ekarv text first. Forty of them preferred standard text, some as soon as they saw it. Those who read standard text first were almost equally divided in their preferences. It was decided not to adopt Ekarv layout in the texts for the new galleries. A decision reinforced by comments such as:

Standard is easier – it's chunky and there are no cut-offs so you can go on reading. The other takes longer to read – it slowed me because my eyes were dropping down all the time. It's all very easy English anyway – you are going a bit over the top.

108

After the investigation I surmised that the Ekarv layout prevented readers from skimming down the centre of the text as they read for meaning. For fluent readers, from childhood on, reading is a deductive activity where anticipation functions as an intuitive system based on the probability and frequency with which words, categories and linguistic structures appear (Blais, 1995b: 86–7). The Ekarv layout may have disrupted the intuitive anticipation used when reading. It may also be the case that Ekarv layout is more helpful with the structures of written Swedish.

Does text encourage people to look more closely at objects?

The second piece of research is about the principles of text content. The aim was to establish whether the text provided in subject panels and object labels helped visitors to look at displayed objects with greater understanding. The displays investigated were about Chippendale, marquetry and chinoiserie, part of the temporary *Best of British* gallery. Each display had three or four pieces of furniture arranged on a plinth with small object labels related to them arranged along the front of the plinth. The chinoiserie display also had a case of smaller objects beside it. A temporary large format text panel, printed in black on heavy duty white paper, was placed next to each display. The texts investigated were produced according to in-house guidelines.

The total sample was 76 with 25 or more visitors in each topic sub-sample. Visitors were invited to 'Attend to this display for as long as you find it interesting and then come and answer a few questions about it'. The questions asked were:

What was the display all about – how would you describe it to a friend?

Did you look at the objects first or the labels first?

Was there anything you read that made you notice something you would probably not have noticed otherwise?

Were the little labels and the panel texts helpful?

When asked what the display was all about, most visitors responded with information gleaned from the subject panel – particularly if the text was about a person (Chippendale) or described the application of a technique which visitors could easily check visually (marquetry) – and 67% of visitors claimed that they looked at the furniture first before looking at any texts. By implication, this means that many visitors might be looking at the text to find out something about what they had already seen rather than the other way round (using the text to help them to look). Also, what happens if a potentially interesting object does not look very interesting? Will anybody start to read about it? In the survey, 71% of the visitors noticed something on or about the objects on display which they claimed that they probably would not have noticed if they had not read about it; 75% said that they found the large text panels helpful; and 67% found the small object labels to be so. Additionally, visitors commonly reported a to and fro situation where they looked first at an object, then a bit of text, then back to the object and so on. After this investigation it was decided to continue to produce text according to the in-house guidelines.

What is the best order of information on object labels?

The aim of this last investigation was to test visitor preferences for the order of information on object labels. It was, therefore, about the principles of text layout.

Four alternative text formats for presenting dates, material, artists or makers, large font commentary, acquisition details and museum details were prepared for four objects: a chinoiserie chair, a ceramic centre piece, an elaborate cup and cover and a bust of Charles 1. The four formats were:

A. 1. Title
 2. Large font commentary
 3. Date and museum details
 4. Acquisition details

B. 1. Title
 2. Date and material
 3. Museum details
 4. Large font commentary
 5. Acquisition details

C. 1. Title
 2. Museum details in large font prose
 3. Large font commentary
 4. Acquisition details

D. 1. Title
 2. Museum details, including date
 3. Large font commentary
 4. Acquisition details

The sample size was 106 with around 25 visitors in a sub-sample for each object. The four text formats for each object were randomly numbered from one to four to reduce evaluator bias. The four formats were presented side by side to visitors with a rotation after six interviews in order to reduce any influence which position in reading order might have on visitors. The texts were viewed by seated visitors in front of the relevant object. It was explained to visitors that the four labels in front of them contained the same information but it was, in each case, presented in a different order or manner. They were asked 'Which order of information do you prefer for the type of object in front of you?' A prompt, 'With an item like this, what information is the first you would look for? What is most important to you?' was also used. Visitors were then asked to read all the labels, make a choice and explain it.

Format B (four paragraphs detailing date and materials, museum details, large font comentary and acquisition details) was the strong first choice for all four items except for the sculpture where, although first choice, it scored slightly under half of all choices. Overall, 56% of visitors preferred format B, with 20% choosing format A, 13% choosing format C and 11% choosing format D.

The visitors valued format B for its ready supply of a date on the first line after the title. In this study, it was very notable that visitors were most anxious to be given dates. Comments like this one were common. *It's important to date the thing first and what it is made of. I like the general stuff after the details because it's just opinion really and it should have to wait till the specifics are given. Most of the time I read the bits but always the name, date and who made it.* Overall, the comments indicated that visitors appear to use the date to give themselves access to a personal conception of a period in history and I will investigate this issue as a separate research topic. The visitors also valued format B because it had four paragraphs (the others had three) and this gave them lots of freedom to skim and so helped them to select information. One-fifth of the entire sample chose format A because the large font, narrative commentary came before the hard information details.

It was decided to use an order of information based on the four-paragraph format B, with date and materials coming after the title and a narrative commentary, so favoured in format A. Hence the order of information decided on was: title, large font narrative commentary, date and

materials, other 'hard' information such as maker, place of manufacture, acquisition details and museum number. It was decided that the font size of 'Date and materials' should be enlarged so that it stood out more than the other 'hard' information.

In summary

These three investigations show that it is perfectly feasible to take the views of visitors into account in order to both satisfy visitor needs and to check professional assumptions about all sorts of features of written communications when preparing them. Undertaking such work helps us to know our visitors better and is an expression of care for them. Combining this approach with the use of the text writer's behavioural framework recommended here and a common sense approach to 'do and don't' advice should make text writing and presentation a much less fraught activity than it sometimes is. It should also help us to communicate better with visitors to museums and heritage sites.

Acknowledgements

Morna Hinton, in her role as Evaluation Manager for the British Galleries Project at the Victoria & Albert Museum, prepared and administered the evaluation program, part of which is reported above.

References

Anctil, R. 1995 Typographic legibility: definition and field of application in exhibitions. In: *Text in the Exhibition Medium* (ed. A. Blais), 251–78. Quebec: Societe des Musees Quebecois and Musee de la Civilisation

Blais, A. (ed.) 1995a Introduction. In: *Text in the Exhibition Medium.* Quebec: Societe des Musees Quebecois and Musee de la Civilisation

Blais, A. 1995b The reading process. In: *Text in the Exhibition Medium* (ed. A. Blais), 79–95. Quebec: Societe des Musees Quebecois and Musee de la Civilisation

Carter, J. 1993 How old is this text? *Environmental Interpretation* February, 10–11.

Ekarv, M. 1994 Combating redundancy: writing text for exhibitions. In: *The Educational Role of the Museum* (ed. E. Hooper-Greenhill), 201–4. London: Routledge

Ferguson, L. MacLulich, C. & Ravelli, L. 1995 *Meanings and Messages: Language Guidelines for Museum Exhibitions.* Sydney: Australian Museum

Gilmore, E. & Sabine, J. 1994 Writing readable text: Evaluation of the Ekarv method. In: *The Educational Role of the Museum* (ed. E. Hooper-Greenhill), 205–10. London: Routledge

Hooper-Greenhill, E. 1994 *The Educational Role of the Museum.* London: Routledge

Jacobi, D. & Poli, M. 1995 Scripto-visual documents in exhibitions: some theoretical guidelines. In: *Text in the Exhibition Medium* (ed. A. Blais), 48–78. Quebec: Societe des Musees Quebecois and Musee de la Civilisation.

Kentle, E. & Negus, D. 1989 *Writing on the Wall: a guide for presenting exhibition text.* London: National Maritime Museum

Marquart, L. 1995 Writing in space. In: *Text in the Exhibition Medium* (ed. A. Blais), 232–50. Quebec: Societe des Musees Quebecois and Musee de la Civilisation

McLean, K. 1993 *Planning for People in Museum Exhibitions.* Washington, DC: Association of Science and Technology Centres

McManus, P. M. 1987a *Communication with and between visitors to a science museum.* Unpublished PhD thesis, University of London

McManus, P. M. 1987b It's the company you keep … The social determination of learning-related behaviour in a science museum. *International Journal of Museum Management and Curatorship* 6, 263–70

McManus, P. M. 1988 Good companions … More on the social determination of learning-related behaviour in a science museum. *International Journal of Museum Management and Curatorship* 7, 37–44

McManus, P. M. 1989a Oh yes they do! How visitors read labels and interact with exhibit texts. *Curator* 32(3),174–89

McManus, P. M. 1989b What people say and how they think in a science museum. In: *Heritage Interpretation, Vol. 2, The Visitor Experience* (ed. D. Uzzell). London: Belhaven Press

McManus, P. M. 1991 Making sense of exhibits. In: *Museum Languages: Objects and Texts* (ed. G. Kavanagh). Leicester: Leicester University Press.

McManus, P. M. 1993a Gallery 33 Survey: Exit questionnaire. In: *Gallery 33: A Visitor Study* (ed. J. Peirson-Jones), 9–33. Birmingham: Birmingham Museum and Art Gallery

McManus, P. M. 1993b Tracking Study. In: *Gallery 33: A Visitor Study* (ed. J. Peirson-Jones), 37–54. Birmingham: Birmingham Museum and Art Gallery

Sampson, D. 1995 Reading strategies used by exhibition visitors. In: *Text in the Exhibition Medium* (ed. A. Blais), 135–54. Quebec: Societe des Musees Quebecois and Musee de la Civilisation

Screven, C. 1995 Preface. In: *Text in the Exhibition Medium* (ed. A. Blais), 19–24. Quebec: Societe des Musees Quebecois and Musee de la Civilisation

Archaeology Outdoors:
Site Interpretation
and Education

Heritage Marketing in the Not-for-Profit Sector: The Case for Branding

Carol Scott

Abstract

As we enter the 21st century, museums find themselves struggling to maintain audiences in competition with an increasing number of leisure attractions (Nightingale, 1999). How can museums position themselves to appeal to leisure consumers while distinguishing themselves from theme parks, amusement arcades and other entertainment venues? Effective branding offered valuable insights and solutions at the Powerhouse Museum in Sydney, Australia.

Introduction

The Museum of Applied Arts and Sciences was established in 1879. In the 1980s plans were approved to redevelop and relocate the museum and, in 1988 it opened on the site of an historic power station. Taking inspiration from the site, the museum was renamed the _Powerhouse._ The new museum opened to acclaim for its architecture, contemporary exhibition design and innovative use of interactive computer technology. Each year, it welcomes up to 600,000 local and international visitors.

Notwithstanding its successes, in 1998 the museum decided to reassess its position and undertook a brand audit. The reassessment was motivated by a combination of internal and external factors that required resolution. These factors included problems with overall branding, increased competition and 'taking stock'. While the marketing of specific programs at the Powerhouse had been successful, with major campaigns attracting excellent attendances and high media profile, positioning and promotion of the overall brand of the Powerhouse proved more difficult. Two issues were particularly challenging.

Under its generic title of the Museum of Applied Arts and Sciences, the museum had acquired a diverse collection. This very diversity, which encompasses science, industry, technology, social history, transport, decorative arts and design, proved to be a challenge when trying to create a meaningful, overall brand and to position this brand in the minds of the public. A year-long visitor study undertaken at the Powerhouse in 1996/7 provided evidence of how difficult that task was. The study revealed that both local and tourist audiences anticipated an interactive science centre when they visited the museum. While local residents familiar with the museum were marginally more aware of the fact that programs covering social history, decorative arts and design were offered, the major expectation was for exhibitions about steam engines, trains and planes, science, new technologies, inventions, innovations, power and electricity (Environmetrics, 1997). In the minds of museum staff and management, there was often a question about whether the name, the _Powerhouse,_ contributed to these expectations.

In addition, the Powerhouse recognised that it was operating in an increasingly competitive leisure market in which both local residents and tourists can choose from a wide variety of places offering interest and entertainment. Between 1988 and 1991, a further three new museums opened in Sydney. Cinemas, theme parks, state and national parks, aquaria, zoos, cultural precincts, gardens, quays, beaches, spectator sports, concerts, restaurants and a host of performances vie for

consumer attention. The museum decided that, in a leisure environment where options were multiplying, strategic positioning was becoming increasingly essential.

Finally, the brand audit coincided with two important milestones. The museum was celebrating its first decade in operation and the approach of the new millennium was on the horizon. The timing was right to take stock, to review and to make decisions about the place that the museum wanted to occupy in the future. Reviewing the overall corporate identity of the museum became a key direction in the museum's strategic plan for 1998/9. The brand audit was identified as a major strategy to commence this review.

The role of a brand audit

A brand is an engineered perception (Mukerjee, 1998) made up of the name of an organisation and the personality that goes with it. The personality is a combination of the organisation's products, services and perceived attributes. A brand can be engineered to achieve a specific marketing positioning. A brand audit explores the history, origins, associations, products, services and communications of a brand to discover what it stands for from the customers', stakeholders' and general public's point of view. This intelligence is used to identify what position the brand occupies in the marketplace relative to competition. An optimal positioning is then recommended and a strategic plan developed to implement the positioning (Berstrom & Bresnahan, 1996).

In marketing terms, there are three types of brands. Two of these – corporate brands and product brands – are familiar while the third type is a *values* brand, of which museums are an example (Kiely & Halliday, 1999). A values brand has an enduring core purpose, which creates a long-term bond with those sectors of the population sharing the same values.

There are two other important dimensions of a values brand. First, there is a desire for the lasting future of the brand because of customer allegiance to the brand's underlying values. Secondly, the permanence and stability of a values brand does not preclude flexibility. The brand is free to move into other areas as long as the core principles can be discerned in any new ventures. In auditing a values brand, therefore, particular care is taken to probe beyond a simple awareness of products and services. Emotional, as well as functional attributes of the brand are elicited through words and images, associations and personal experiences, permissions and constraints. The Powerhouse brand audit also emphasised the important need for context. The study was constructed to explore perceptions of museums within the overall environment of leisure choice.

The purpose of the exercise was to decode the Powerhouse Museum brand and distil this into a brand positioning that would resonate both internally and externally.

Brand audit methodology

Responses from three major groups (repeat visitors, external and internal stakeholders and the general public) were sought. In addition, a complete audit of the museum's communication materials, including advertising and marketing campaigns and other publications such as books, CD-ROMs, brochures, flyers, posters and annual reports, was undertaken.

From the repeat visitors, stakeholders and members of the general public, five aspects of the brand were canvassed:

- a description of the essence of the brand in words and images;

- emotional and functional attributes of the brand;

- awareness of the brand's products and services;

- permissions and constraints associated with the brand;

- positioning of the brand within a competitive set.

Internal and external stakeholders

A series of interviews with stakeholders sought to find a common thread between internal and external perceptions of the museum's core purpose and values.

A careful selection of museum interviewees ensured that the sample included a variety of staff and management across departments. Curators, designers, human resource personnel, educators, information technology staff, property managers and administrative assistants all contributed. External stakeholders included members of the Board of Trustees, senior policy staff from the institution's major funding agency, sponsors, educational representatives, media critics and senior management from the state tourism body. These stakeholders were asked to comment on their personal relationship with the museum. In the case of staff, questions focused on why they chose to work at the museum; what they valued about their job and the reactions they experienced from others when they revealed where they worked. External stakeholders had an opportunity to describe what they valued about their own museum visits and what aspects of the museum they felt merited improvement. They were also asked to comment on their professional contact with the museum.

The interview explored the values and culture of the organisation and its perceived strengths and weaknesses. Words and images that described the museum's key attributes and its essential character were also canvassed. The identification of competitors and how the Powerhouse was differentiated within this competitive field was discussed. Finally, respondents were asked to describe their ideal future for the Powerhouse, key directions for the museum to pursue and obstacles that it might face in realising this future.

Focus groups

Besides stakeholders, focus groups were held with repeat audiences (loyal customers) including young people, culturally active adults, members and family groups. The table below outlines the selection criteria for the groups.

These focus groups examined the museum experience within the general context of leisure participation. Initial discussions explored the ways in which visitors spent their leisure time and what they sought from leisure. The position of museum visiting within this framework of leisure participation was subsequently introduced, with questions on frequency of museum visits, motives for choosing a museum visit from among an array of leisure options and the perceived value of the museum experience for the visitor.

The social purpose of museums was considered and the specific role that the Powerhouse Museum occupied in the community was also discussed. Included in this part of the proceedings was the issue of *permissions* and *constraints*, in which the parameters of the institution were verified. The positioning of the Powerhouse in relation to other competitors was also compared. In this section of the discussion, profiles of the types of people that were associated with different venues and attractions were developed and the attributes linked to the Powerhouse Museum identified. Intellectual relationships to the Powerhouse brand were canvassed through surveying visitor knowledge of the range of exhibitions, programs, facilities and services. Emotional associations focused on the feelings that visitors took away with them as the result of a visit and their anticipated response if the museum was threatened with closure.

GROUPS	RECRUITING CRITERIA	DEMOGRAPHIC INFORMATION
Parents with children under 15 years	a) Live in Northern suburbs, Eastern/Inner West and Southern suburbs; b) Have children under 15 years; and c) Have visited the Powerhouse twice in the last two years.	a) 30% of PHM audiences live in the Northern suburbs, another 30% live in the Eastern and Inner Western suburbs and a further 14% live in the Southern suburbs. Participation from the Southern suburbs is increasing particularly during holiday periods and especially from family groups; b) Family tickets account for approximately 25% of all admissions; c) The family audience is shared between four major institutions (PHM, ANMM, OzMus, Taronga ZOO); d) Of NSW residents with children who visit the PHM, 40% have made 2-3 visits in the last five years, 17% have made 4-5 visits in the last five years, 11% have visited 6-10 times and 9% have visited over 11 times.
Youth 18-23 years	a) Live in the Northern, Eastern and Inner Western suburbs; b) Have made a visit to the museum either as part of a tertiary study group, with friends, alone or with a family group within the last three years; c) Group requires gender balance and a balance between tertiary students and young people in the workforce.	a) Youth in this age group often do not make a voluntary visit to the museum; b) However, they have been attracted by youth specific programs such as the exhibitions *Real Wild Child* (1994-6), *Star Trek* (1997-8), *Cyberzone* (1997-8) and the public programs *Virtual Reality* (1992) and *Hot Summer Nights* (1994-5) and will probably be attracted by the new computer exhibition, the *Universal Machine* (1999). c) This age group can also be accessed through tertiary design courses and may make visits as part of a tertiary study group in this field.
Members	a) 4 participants who represent *families* with children; have had a Powerhouse membership for 1-2 years and have also had a membership at another cultural institution which they have joined because of the children; b) 4 participants representing *loyal supporters* who have had a membership for 5+ years and who may also belong to a membership sub-group (Friends of Fashion or Friends of Music) and have memberships with other cultural institutions.	a) Powerhouse members cover families, loyal supporters (often similar to culturally active adults), schools and corporates; b) However, unlike non-member families and culturally active adults, members visit more frequently, have access to special programs related to new exhibitions and other aspects of the collection and are generally, as a result, more *embedded* in their understanding of the work of the museum and its range of programs; c) They are also generally *members* of other cultural institutions as well, and can, therefore, offer informed comparisons.
Culturally active adults	a) Live in the Northern, Eastern and Inner Western suburbs; b) Have visited the Powerhouse twice in the last two years; c) Make regular visits to other cultural institutions; d) Age = 45+	a) Adult tickets account for 32% of admissions; b) Culturally active adults who visit the Powerhouse also visit Darling Harbour (61%), The Rocks (53%), the Botanic Gardens (43%), Art Gallery NSW (47%) and live theatre (30%); c) These visitors are mainly professional/managerial, in paid work and with a university education; d) There is evidence from our last visitor study that there is an upward age shift in this group.

Finally, impressions of the name and the logo as major signatures that communicate the essence of the museum were examined.

The public survey

In the next stage of the brand audit, 357 face-to-face interviews were conducted with a demographic sample of the general Sydney population. The purpose of this stage was to canvass perceptions of two other sectors:

- infrequent visitors (occasional customers);

- people who had never visited the museum (those who do not buy the brand).

The outcomes of the focus groups had provided the team with an indication of key areas to explore in this part of the study. As a result, the survey was able to clarify details of leisure participation, explore the reasons for leisure favourites and attribute specific characteristics to the Powerhouse Museum.

For example, respondents were offered a wide range of options and asked how often they undertook any of these leisure activities. Taking into account the importance of emotional factors in making choices, people were also asked how they *felt* when they were undertaking these activities. The survey then focused on cultural venues as a type of leisure activity. Questions were asked on frequency of participation, the emotions associated with the respondent's favourite cultural venue, and the reasons for that choice.

In addition, however, respondents were also asked to nominate 'attributes' associated with their *ideal* leisure venue. These attributes were in the form of statements such as ' it's challenging and thought provoking', 'it's modern', 'it's an adventure', 'it allows me to touch the past'. A total of 28 statements, elicited from the outcomes of the focus groups, were provided to survey respondents. These attributes were then applied to a discrete competitive set of cultural venues, including the Powerhouse. This enabled distinctions to be made between characteristics attributed to the Powerhouse and those assigned to other cultural venues within the competitive set. Feelings associated with visiting each of the venues in the competitive set were also identified.

Finally, a series of statements about the Powerhouse arising from the focus groups were presented. Each of the respondents was asked the extent to which they agreed or disagreed with each of the statements on a six-point scale. The statements sought to confirm or deny knowledge, awareness and attitudes to products, activities, services, collections, advertising, audience, location and quality of the museum experience.

The findings about museums and leisure

One of the most significant findings from the audit was the place that museums occupy in relation to other leisure options. This part of the study had two dimensions. The first was information about the frequency of participation in a range of leisure activities. The second identified the attributes related to the ideal leisure attraction and compared these with the attributes associated with museums (Boomerang!, 1998).

The 357 respondents selected from the general Sydney population who were asked the frequency with which they participated in a range of leisure activities on a scale from *at least monthly* to *never* provided some interesting results. Visiting art galleries and museums was a frequent (i.e. monthly) leisure pursuit for only 5% and 3% of the population sample respectively. The activities in which respondents participated most frequently (i.e. monthly) were:

- Going to restaurants and cafes 66%

- Exercising and playing sport 64%

- Shopping for pleasure 59%

- Visiting pubs and clubs 52%

- Visiting parks and gardens 46%

- Going to the theatre/movies 41%

- Going to the beach 35%

- Attending sporting events 34%

Moreover, when asked to specify the attributes that characterise an *ideal* leisure venue, these respondents identified:

- a relaxed atmosphere

- entertaining

- a good place to take family and friends

- friendly

- fun

- an exciting place to be

- great value for money

- plenty of room to move

- a place where you can get lost in another world

There is something in these attributes of a trend to the *depthless* leisure experiences described by Rojek (1995) in describing leisure in a post-modern society. In *Decentring Leisure* (1995), Rojek depicts a pattern of superficial encounters with a large number of activities pursued at a greater pace. Further, he suggests that, in a post-modern society influenced by rapid change, fragmentation, increased flexibility and a rejection of traditional structures and order, people seek leisure activities that lack intellectual commitment. The brand audit provided some evidence to support this.

Museums, however, were not perceived to share these 'ideal' leisure attributes. In fact, quite a different set of attributes was applied to museums. These included *educational*, *places of discovery*, *intellectual experiences*, *challenging*, *thought provoking*, *absorbing*, *fascinating*, *innovative* and *places where you can touch the past*. In fact, museums appeared to be the opposite

of 'depthless'. It would seem that museums are perceived to be in a different field of activity to leisure. Secondly, this museum 'field' is an intellectual and educational experience requiring some of the mental engagement and commitment that is becoming less attractive in today's world.

The museum attributes are positive and worthy. But the important issue in a time of increasing competition is the lack of alignment between what people are looking for in an ideal leisure attraction and what museums are perceived to offer. Interestingly, many museums would legitimately argue that they are offering what the leisure consumer is seeking. Museums are *fun*, they are *exciting*, they are *good places to take the family* and they offer *great value for money*. However, it appears that museum marketing is failing to capitalise on these attributes to demonstrate the valid synergy between what consumers want and what museums have to offer. The opportunity exists for museums to include in their branding, not only the attributes that they meaningfully own, but also the attributes associated with an ideal leisure experience (i.e. GREAT VALUE FOR THE WHOLE FAMILY – DISCOVER THE FUN OF *PIRATES* AT THE NATIONAL MARITIME MUSEUM!).

The findings about values brands

In addition to maximising the marketing potential for museums by using the attributes of an ideal leisure attraction, another major outcome of the study related to effective values branding. Positioning a values brand is a creative challenge. The positioning needs to communicate both a core identity based on timeless and unchanging principles as well as elements of extended identity such as new products or ways of doing things. This has special importance for museums. With a strong brand identity, museums should be able to promote their changing products (exhibitions and programs) linked to the essential core elements and attributes associated with the long-term purpose of the museum. These core elements can serve to differentiate museums from other activities.

Specifically, the study revealed that the Australian Museum in Sydney, a museum with both natural history and ethnographic collections has the key attribute of 'offering educational opportunities'. This is not surprising given its long tradition in research and scholarship. Effective values branding would promote a recent blockbuster exhibition, 'Life and Death in the Age of the Pharaohs' as, AT THE AUSTRALIAN MUSEUM LEARN ABOUT *LIFE AND DEATH IN THE AGE OF THE PHARAOHS*, thus linking a core and timeless attribute of 'education and learning' with a temporary product. Similarly, the Powerhouse Museum in Sydney has the attribute 'a place of discovery'. Linking this core attribute with a changing exhibition in a meaningful way, the promotion could state, AT THE POWERHOUSE MUSEUM YOU CAN DISCOVER *STAR TREK*.

More generally, however, museums offer an experience that is uniquely differentiated because it is associated with authenticity and social value.

Differentiation

Social value is ... *the attachment of meaning to the things which are fundamental to personal and collective identity* (Johnston, 1992). Personal and collective identity is fostered both through the traditional role of the museum as a preserver of material cultural heritage which

> ... incorporates not only objects but, more importantly, the intellectual heritage, the history, values and traditions of society; it also emphasises continuity by suggesting the requirements to preserve what is valued from previous generations so that this may be inherited by the descendants of present members of society. (Dept. of Finance, 1989: 24)

and the recognition of contemporary issues and the role that museums can play in forging identity in a post-modern world.

In response to the 'fracturing' experienced by many in post-modern society, the emergent museum literature cites policies of 'inclusion', of outreach and of developing partnerships with communities through addressing their communal needs (AAM, 1996). It highlights the potential of museums to offer personal and collective meaning-making experiences (Silverman, 1995, 1997) and celebrates the museum as one of the few 'safe' forums for debating and discussing ideas (Heuman Gurian, 1996). It suggests that museums offer opportunities for the type of personal engagement with a subject that is optimal for learning (Csikzentmihalyi, 1995: 35–7). What museums can offer differentiates them from other leisure options in ways that have the potential for long-term personal and collective value.

Conclusion

Positioning museums effectively in the 21st century may become a matter for survival. Although the 1970s and 1980s saw an unprecedented boom in the establishment of museums throughout the industrialised world with attendance numbers attaining new highs, the 1990s began to witness evidence of declining attendances (Kirchberg, 1998; Australian Bureau of Statistics, 1999).

More leisure options, less time (Australian Bureau of Statistics, 1998), more individualised and home-based leisure (Pronovost, 1998), the ageing of the 'baby boomers' (Peterson *et al.*, 1996), the impact of technology (Maggi, 1998) and a resurgence in cinema are all cited as contributors to dwindling attendances. However, recent leisure theory also suggests that the pace of leisure is speeding up and, as an antidote to increasing pressure in the workplace, people are seeking *depthless*, less *committed* forms of leisure that promise *fun*, *entertainment* and *time out* at the expense of education, *learning* and *intellectual experiences* (Rojeck, 1995; Jonson, 1998).

If this is the case, then museums are going to have market themselves very strategically to attract audiences and maintain a position in the future. In terms of positioning, museums must do three things:

1 align themselves with the attributes of the ideal leisure experience to maximise audiences;

2. differentiate themselves from other leisure activities so that they are regarded as unique;

3. emphasise that museums are a value-added experience as the result of the combination of 1 and 2.

In aligning themselves with the ideal leisure experience, museums can legitimately claim and promote the attributes of being places which are *fun*, *entertaining*, *value for money*, *a great place to take friends and family*, *comfortable* and *safe*. Moreover, they are also *exciting* places where one can *get lost in another world*. It is these two attributes from the field of leisure participation that may provide the bridge across the divide of what is perceived as a leisure experience compared with what the museum has to offer. For, though the 'excitement' of the museum is less about a physical experience and more about the excitement that comes with *intellectual* discovery, and the 'new world' is likely to be *a realm of knowledge* or *exposure* to a different culture, argument or point of view rather than a ride through simulated reality, both attributes can legitimately be claimed as part of the museum experience.

In addition, the museum is differentiated from other leisure experiences in that it offers two things that are unique:

- it is an authentic experience;

- it a value experience.

In a museum, one can *touch the past* and *discover new worlds* through contact with actual objects. More importantly, one can do this in the company of others, thus sharing collective memories and making new meanings together. Museums as 'institutions of memory' which 'store, collect and pass along our past' can contribute to our collective well-being as a society through providing a forum for what Heuman Gurian (1996) calls 'congregant' behaviour. This is a type of value experience not available elsewhere. Contemporary positioning for museums requires that these differentiating attributes are also part of our marketing.

Finally, when considering the 'ideal' leisure experience that one can have in a museum in combination with a 'unique' experience not available elsewhere, then it must be said that the museum experience is a value-added one. When people come to a museum in the 21st century, they truly get the lot!

References

American Association of Museums 1996 *Museums for the New Millennium*. Washington, DC: Centre for Museum Studies/Smithsonian Institution

Australian Bureau of Statistics 1998 *How Australians Spend Their Time: 1997*, Cat. No.153.0. Canberra: ABS

Australian Bureau of Statistics 1999 *Attendance at Selected Cultural Venues*, Cat. No. 4114.0. Canberra: ABS.

Bergstrom, A. & Bresnahan, J. M. 1996 How banks can harness the power of branding. *US Banker* 106(3), 81–2

Boomerang! Integrated Marketing and Advertising Pty. Ltd. 1998 *Powerhouse Museum Brand Audit and Positioning Options*, in-house report prepared for the Powerhouse Museum

Csikzentmihalyi, M. 1995 Intrinsic Motivation in Museums: What Makes Visitors Want to Learn? *Museum News* 74(3)

Department of Finance 1989 *What Price Heritage*? Canberra: Department of Finance

Environmetrics 1997 *Year Long Visitor Study 1996/7*, in-house report prepared for the Powerhouse Museum

Heuman Gurian, E.1996 *A savings bank for the soul*. Paper presented at the 1996 Museums Australia Conference, Sydney

Johnston, C. 1992 *What Is Social Value? a discussion paper*. Canberra: Australian Government Publishing Service

Jonson, P.1998 *Leisure in the 21st Century*. Paper presented to the Evaluation and Visitor Research in Museums Conference: Visitor Centre Stage-Action for the Future, Canberra, 4–6 August 1998

Carol Scott

Kiely, M. & Halliday, M. 1999 Values: New Brand for the Millennium. *Executive Excellence* (Australian Edition) 16(3)

Kirchberg, V. 1998 *The Changing Face of Arts Audiences. The Kenneth Myer Lecture*, Arts and Entertainment Management Program, Deakin University

Maggi, M. 1998 *Advanced Museums/Innovation on Museums*. Italy: Fondazione Rosselli

Mukerjee, K. 1998 Faceless in the Crowd; the importance of branding. *National Business Bulletin* January

Nightingale, J. 1999 Cultural Therapy for Sale. *Museums Journal* May, 39–42

Peterson, R. A. *et al.* 1996 *Age and Arts Participation with a Focus on the Baby Boomers*. California: Seven Locks Press

Pronovost, G. 1998 *Trend Report: The Sociology of Leisure*. Thousand Oaks: Sage

Rojeck, 1995 *Decentring Leisure: Rethinking Leisure Theory*. London: Sage

Silverman, L. 1995 Visitor Meaning-Making in Museums for a New Age. *Curator* 38(3)

Silverman, L. 1997 Personalising The Past: A Review of Literature with Implications for Historical Interpretation. *Journal of Interpretation Research* 2(1)

124

Peopling the Past: Current Practices in Archaeological Site Interpretation

Elaine Sansom

Costumed interpreters are used increasingly in archaeological site interpretation This paper will look at current practice in England. It is not a comprehensive survey, nor is it a 'how to' guide to the various techniques as this has been done elsewhere (Binks, 1988; Risk, 1994). Instead it will provide an introduction to costumed interpretation methods (as opposed to modern dress presentations) presently used with the general public and proceed to question their value in the task of 'peopling the past'. Although archaeology is a long established academic discipline, that of on-site interpretation to a broad public is still relatively young and it is much in need of research into its impact on the public.

The growth of the medium

Growth in the use of human interpreters on archaeological sites in Britain may be attributed to a number of influences not least of which is the increasing interest of the public in their origins and the desire to establish some kind of historical context for themselves. This interest has been variously ascribed to the breakdown of family and social units and to modes of living which separate people from life processes. Whatever the reasons, it is a trend which has coincided with two other major influences: widespread acceptance of the concept of people-based interpretation and the need to increase public understanding of archaeology whilst increasing income at interpreted sites.

Writing in the 1950's, Tilden, the 'father of heritage interpretation', firmly believed that people-based interpretation was the highest and best form of interaction, the most desirable and best use of the visitor's time (Tilden, 1977). His ideas have had far reaching impact and many accept his writings on the subject largely unquestioned. Despite changes in technology, public understanding of 'interpretation', and the sophistication of audiences, the assumption that people-based interpretation is best remains. Lewis, for example, accepts Tilden's views as orthodoxy when questioning whether people-based interpretation is necessarily the highest or best form of interpretation in museums. He refers to his own views as a 'seeming heresy' (Lewis, 1994: 333). Four decades on from Tilden, Uzzell's modern principles of interpretation do not make the same claim for human interpreters. Instead he argues for variety of interpretive technique. Exhibitions, audio-visual demonstrations, costumed interpreters, trails, events, panels, guided walks, leaflets, themed catering and themed children's play equipment may all have a role, with the choice of techniques at any one site being dependant on 'what is being interpreted, for whom and for what purpose' (Uzzell, 1994: 300).

The second major factor encouraging the use of human interpreters on sites has been the need to improve the public image and understanding of archaeology, with resultant commitment to funding and preservation (Fowler,1981), coupled with the necessity for sites to generate income (Smith, 1989). Site managers now need to attract new visitors, generate return visits, inculcate visitor loyalty through membership schemes, and increase secondary spend at shops and cafes on sites. To achieve this they have redefined their basic product from being the

ruins or remains themselves to being an 'edutainment experience'. English Heritage refer to the move as being 'from ruins to tourist attractions' (English Heritage, 1994: 20). A variety of interpretive media, including costumed interpreters at special events, is now considered necessary (Griffin, 1994).

Thus in recent years the combination of public interest in the past, a 1950s interpretive approach and the financial exigency of the 1990s has done much to put human interpreters on to archaeological sites. The reasons behind the growth of human interpretation on sites are relatively easy to see. More difficult is any attempt to evaluate the 'impact' of human interpreters on visitors. Interpretation should create a response in the visitor that either advances understanding or creates an emotive reaction encouraging the person to want to know more. The assumption is that human interpreters create such responses. However there has been virtually no research in to the efficacy of employing them on sites, other than from a marketing perspective. There is some evidence from the related fields of museums and visitor centres on which to draw, but its value when applied to archaeological sites is essentially unproven. Given the fact that interpreters are expensive and interpretation budgets are limited, it would seem essential that some measure of their effectiveness as communication tools on archaeological sites should be made. Without such information, the value of costumed interpretation can only be argued in terms of visitor income generation. This assigns it firmly to the context of 'promotion' rather than 'interpretation'.

The content of the message

The problems, validity and even desirability of interpreting 'the' past have often been debated (Lowenthal, 1985; Molyneaux, 1994; Potter, 1992; Hewison, 1987) and it is now accepted that all historical reconstruction is an imperfect product of our time. From this starting point it can be argued that site interpretation should concentrate on factual reporting of finds and structures. However, as Fowler has pointed out, if archaeologists do not provide 'coherent images' of the past, there are others who will (Fowler, 1981: 65). Film, television, books and even games are all prepared to provide a completed picture and to give an unsubstantiated human story. These media exploit well the interest that the human condition attracts and stimulates. Archaeological site interpretation cannot ignore this interest nor, indeed, Uzzell's principles for heritage interpretation which are based on the experience of the last four decades and emphasise the need for 'strong human interest themes'. 'People are interested in people' states Uzzell, and 'if it is felt important to tell the architectural history of a place, then it should be told through the people who were involved in commissioning, designing, constructing and using the buildings' (Uzzell, 1994: 299).

Costumed interpreters have the opportunity to develop the human story of a site. They can 'flesh out' the archaeological remains with the meanings and motivations of past occupants to provide the much sought after 'coherent image'. More importantly (from an archaeologist's viewpoint) they have the opportunity to explore a variety of alternative images that result from different interpretations of the same evidence. Unfortunately, it is not clear that either outcome is happening. The fact that a costumed interpreter is being used does not automatically mean that they are developing the site's human story: a person in 'Celtic' costume turning a wood lathe is ultimately only a person in fancy dress demonstrating a craft; a costumed guide describing the architectural developments of a site is only someone recounting building phases. Such interpretation may be presented by costumed interpreters but it fails to have the 'strong human interest themes' advocated by Uzzell. In the area of providing alternative histories, the use of interpreters also seems to be having little impact. Archaeologists and interpreters providing guided tours or living interpretation are best placed

to give these alternative realities, but they represent a relatively rare and expensive form of human interpreter. The casual visitor will more often encounter the re-enactment society or special event theatre performers, neither of which may have the will or knowledge to describe alternative realities.

Concerns about authenticity and the desirability of presenting fictitious, stereotypical and sanitised versions of the past are often voiced (Hewison, 1987; Lowenthal, 1985; Porter 1991; Bennett, 1988). Whilst not denying the validity of such arguments, they do raise the practical issue of how to ensure that 'truths' acceptable to archaeology are given by human interpreters on sites. It is pointless for archaeological excavation and interpretation to produce alternative 'realities', only to find that they are ignored in public interpretation. Guide books, panels and displays are likely to be written, or at least vetted, by archaeologists but the same controls may not be in place for other methods of site interpretation. Compare the concern amongst the archaeological community over the accuracy of the pictorial reconstruction of sites (James; forthcoming) against the almost total indifference of archaeologists to the content of re-enactment programmes, even though the latter may reach a far larger audience. Presumably, the 'special event' is seen as the remit of the marketing department, the realm of the market-orientated 'heritage' professional, and as such is viewed as a financial imperative that has to be endured for the sake of a site's future, but is apparently outside the control of archaeology. This, in part, can be attributed to the low academic status of popular archaeological communication which is considered by some archaeologists as inherently non – or even anti-academic. However, if human interpreters do prove to have a greater impact on the visitor than panels, guide books and tape tours, then, by failing to provide the same rigorous controls on content, sites will become the venue for the reinforcement of stereotypical views of the past rather than for 'interpretation', with all its connotations of provocation and revelation (Tilden, 1977).

In the USA and Canada a very different approach has been taken to costumed site interpretation. The pioneering work of the American National Park Service and Parks Canada in interpretive planning, as part of overall management plans, has resulted in the establishment of precise objectives for each element of interpretive programmes (Knudson, 1995; Sharp, 1982; MacLean, 1995). This approach, coupled with a strong commitment to the need for research and training to underpin interpretation has resulted in some of the most informed site interpretation by costumed interpreters in the world (Anderson, 1984; MacLean, 1995; Knudson, 1995). In Britain comparable rigorous research and training of costumed interpreters is encountered in their use within museums. This includes their use at open air museums such as Beamish and the Black County Museum, and at the industrial site museum of Blists Hill, Ironbridge (Lewis, 1994).

Peopling the past: A taxonomy of approaches

Although potentially very different media, demonstration, first and third person interpretation and re-enactment are considered sequentially as they are often combined in archaeological site interpretation. All have been loosely referred to as 'living history', 'live interpretation', 'historical re-creation' or even as 'historical drama'. After discussing these methods I shall consider the use of drama and story telling.

Demonstration

The term 'demonstration' is usually used when processes or skills from the past, such as pottery making and firing, flint knapping, smelting, hunting, and so on are shown. Demonstrations may be given in modern day clothes or in period costume (when the event is

often referred to as 'third person interpretation'). As a communication method demonstration has the advantage of attracting visitor attention, allowing for the questioning of the demonstrator, and it may also involve active participation by the audience. Any of these activities may increase interest and cognitive learning (Field & Wagar, 1982). In terms of interpreting the site, however, demonstration has its limitations as the visitor is focused on methods of artefact production and use. Although this is a legitimate subject for interpretation on many sites, and indeed it is perhaps one of the few areas that archaeologists are fairly certain about, it does little to contextualise the process within the society that populated the site. The fact that demonstrators of crafts and technology are often artisans rather than archaeologists or interpreters means that the emphasis is firmly on the process.

First and third person interpretation

Costumed interpreters may also demonstrate processes and skills but, more importantly, they develop the interpretation to include the full range of the site's human story. All aspects of the human condition can be considered, from the mundane daily toil through to beliefs and attitudes, 'the intangibles of life' (Summers: 1993, 16). Costumed interpretation falls in to two main groups – first and third person interpretation. The National Park Service defines the first person style as 'living history' and the third person style as 'costumed interpretation' (Knudson, 1995). A more useful approach may be to consider the functions performed by such interpreters.

A *'first person'* interpreter adopts the role of a historically documented or fictional character who lives in the past. The adoption of a role is often referred to as 'role playing' and some use this term rather than first person interpretation. For some practitioners this method allows for no knowledge of the present (Malcolm-Davies, 1990; Summers, 1993) whilst others concede the value of acknowledging that the visitor is in the present, and that it is the interpreter who is from the other time (Bicknell, 1993). The interpreter may also use the language of the time although for most archaeological periods this would be either impossible or inappropriate if the intention is to communicate. For example, the use of Latin by interpreters on Roman sites shows only that people spoke differently in the past (Leon, 1989; Seaman, 1993).

'Third person' interpreters function as interpreters of the past rather than representatives from the past. They may dress and act as if they are living in the past but they do not adopt an historic role (Anderson, 1985). Risk usefully sums up the difference as being the 'they were, they did' style of presentation as opposed to the first person's 'I am, I did' (Risk, 1994: 324). As with an uncostumed guide, the third person interpreter can introduce the visitor to the concepts of historical perspective, archaeological processes and cultural determinism in their interpretation of the past.

As a method of communication, costumed interpretation has its advantages, in theory at least. The broad subject of the interpretation is set, but the direction and level in which it develops can be tailored to meet the knowledge and interest of particular visitors. Visitors can interrogate the subject actively through questions and information is given verbally by a person – a method by which most learning is initiated. The flexibility of first and third person costumed interpretations in responding to individual needs score them highly compared to other means of interpretation. However, costumed interpretation cannot be provided cheaply and the quality of research and training necessary to ensure a high standard of first person interpretation should not be underestimated. First person interpretation requires considerable research, practice and skill (Alderson, 1976; Knudson, 1995; MacLean, 1995).

Both techniques do much to help visitors visualise the physical occupants of the site. However, the mere presence of a costumed person has a limited interpretive value and easily

falls into the role of demonstrating 'how they dressed'. Reservations have been expressed about first person interpretation in relation to the process itself, interpretive value, and the true level of interaction it allows the public. Some visitors find the process of interacting with a character from the past difficult. Malcolm-Davies, a proponent of first person interpretation, admits that it can leave visitors feeling ridiculous and frustrated (Malcolm-Davies, 1989). This 'embarrassment' may be a particularly English phenomenon (Griffin, 1994) not encountered in the USA and Canada. The archaeologists Potter and Leone believe that the problems are much more serious and that first person interpretation, rather than being interactive, pushes the visitor in to the passive role of receiver of information.

> A costumed worker, in character, can tell visitors that he learned how to build a tobacco barn from his father, but such a worker cannot tell a visitor how to conduct research into tobacco farming – which is more or less how the interpreter knows what he knows. The interpreter is empowered, and the visitor is left with nothing to do but listen. (Potter, 1992: 479)

This view compares dramatically with those of Seaman who, working in the museum education field, believes such interpretation can encourage intellectual access to the past.

> Through the use of first-person interpretation history is transformed into a forward moving narrative where the outcomes are not yet determined. Judgmental hindsight is set aside in favour of interaction in which dilemmas must be faced and decisions made. (Seaman, 1993: 13)

Research in this area has tended to be based in museums and, surprisingly, given the rapid growth in this relatively expensive communication medium, very little has been published. Available research shows a high rate of public approval, at around 95 per cent of visitors, for costumed interpreters in museums (Canadian Museum of Civilization, 1992; Bicknell, 1993; Bicknell, 1994; MacDonald, 1995). However, such approval is qualified by the detailed questioning of some surveys. This indicates that some groups, in particular lone males and older age groups, feel less comfortable with it, and there was an assumption amongst them that such interpretation was aimed at children (Bicknell, 1993: 40). The large numbers of visitors to living history events at English Heritage sites suggest that a similar outline approval on sites can be expected. This view is supported by a survey carried out at Hampton Court Palace which found that 88 per cent of visitors thought that the costumed interpreters brought the Palace more to life, and 91 per cent found them enjoyable (Summers, 1993).

More interesting, in communication terms, are the findings relating to the effect of the costumed interpretation on the visitor. At the Science Museum, London, a wide variety of evaluation techniques led Bicknell to conclude that contact with the interpreters in the galleries 'evokes strong emotions which in most cases seem to encourage a desire to find things out and seems to provide vivid memories of the event, i.e. some of the elements of true learning' (Bicknell, 1993: 42). In a survey at the Canadian Museum of Civilization 78 per cent of people thought they had learned something new from first person interpretation (Canadian Museum of Civilization, 1992; MacDonald, 1995). At Colonial Williamsburg in Virginia, America, the survey evidence on the first and third person interpretation of the Wetherburn Tavern indicated that the ability of the public to 'recall and understand most of the [interpretation] objectives was impressive' (Graft, 1989: 137). These three reports focused largely on visitor behaviour and their reaction to the process of the interpretation. However their conclusions relating to the 'impact' of live interpretation suggests a starting point from which the value of such media can be argued in communication terms rather than purely those of marketing.

First and third person interpretation has become increasingly common on reconstructed and historic sites in America, so much so that, 'you can easily make a case for living history as the 'American way of history' (Anderson, 1985: 5). Its use is central to many site interpretation strategies and full-time first person interpreters are employed (Leon, 1989). The Canadian Museum of Civilization review of live interpretation in North America concluded that the discussion was no longer whether to use it but how to use it effectively (Canadian Museum of Civilization, 1992). In Britain, such interpreters are used relatively little on archaeological sites, though they are becoming an established communication medium in museums (Malcolm-Davies, 1989; Malcolm-Davies 1990; Positive Solutions, 1991; Bywaters, 1993). This difference, perhaps, relates to the nature of the American and British sites being interpreted to the public. Those in the UK are rarely reconstructed domestic or military sites. Many are geographically large sites from pre-industrial and prehistoric societies with little in the way of their original structures remaining. Such sites do not have the relatively easy prop of a recognisable human context in which interpreters can be based. Without such a context, interpreters, in museums at least, can seem 'marooned' (Bicknell, 1993), though Seaman has argued that the lack of context can actually liberate the interpreter (Seaman, 1993), and on an archaeological site the site itself provides a very direct context.

A more influential factor in the British case is that public interpretation of sites is often only an element within the overall goal of site preservation. In the American re-constructed site museum the primary goal is public education, whereas the interpretive role on UK sites is often a combination of 'hard management' and marketing functions relating to physical site preservation and the promotion and funding of the organisation responsible for the site (Uzzell, 1989). There are cheaper and more effective ways of meeting these goals than the employment of first person interpreters (Griffin, 1994).

First and third person interpreters are not unknown on sites in Britain but, where they do occur, they are more likely to be re-enactment groups employing 'living history' techniques or members of archaeological trusts, at special events, rather than full-time interpreters employed as a central interpretation technique. There are, however, a number of freelance, location-free, professional independent costumed interpretation companies working in Britain that supply occasional site interpretation. For example, Time Travellers, one such company, were employed at the Arbeia Roman Fort, South Shields, to provide an interpretive programme for schools (Nurse, 1994).

The Arbeia Fort is typical of many preserved Roman sites in this country in that it consists largely of the masonry bases of buildings standing to a level of one to two feet, though it does also have a reconstructed fort gate. Little remains in terms of an easily recognisable physical context against which the interpreters could be set. This circumstance allowed the interpretation to focus on the people of the site rather than on the structures. Two costumed first person interpreters developed the characters of Ritona (a female Celtic clan leader and farmer) and Sarrius (a male Roman potter) to illustrate the changes and effects that Romanisation of the area had had on the Celtic population. This was, indeed, a case of interpreting the 'intangibles of life'. Neither character demonstrated a process nor relied on a simulated context against which to perform. Through the use of language, with the props of costume and the site itself, the well informed interpreters provided an interpretation of the human story of Romanisation in the north east. Time Travellers staff are all 'qualified in history, archaeology, education or performance' and pride themselves in their content, 'our programmes are information driven and we ensure that the information we convey is up to date and valid' (Time Travellers' promotional leaflet, 1994). When commenting on this programme's effectiveness, Nurse noted that the interpretation not only appealed to the main

audience of children, but that parents and on-lookers found it entertaining (Nurse, 1993: 51). She went on to state, 'I find it disappointing to learn (from Time Traveller's Director) that there is a lack of demand for these realistic programmes because of competition from voluntary groups offering 'exotic' yet often historically misleading re-enactments. For once, we have the portrayal of a 'realistic' female figure set in a context that rings true on an individual and historical level' (Nurse, 1994: 51).

Re-enactment

Referred to as 'historisist hooliganism on Bank Holidays' (Hewison, 1987: 83), the form of costumed interpretation known as re-enactment has probably had the most influence, in recent years, on archaeological site interpretation in Britain. Sites tend to be large, interpretation budgets small. A large re-enactment society may well be cheaper, more impressive, and attract more visitors than a professional first person interpretation. Griffin and Giles, from the special events unit at English Heritage refer to them as a 'cost effective resource' (Griffin, 1994: 331).

Re-enactment is variously defined and the term is often used in the same broad way as 'living history' to encompass all forms of historic recreation. From America, a more specific definition which limits it to the 'simulation of a particular historic event' is provided (Anderson, 1985: 460). On the face of it this is a very narrow definition, but it is intended to include not only re-enactment of specific historical events, such as a documented battle, but also the processes by which something occurred. For example, the definition would cover the enactment of a fictitious skirmish to show the tactics and methods of Celtic tribes at war (Blackmore, 1991: 9). Thus re-enactment has similarities with both performance theatre and demonstration. In its pure form re-enactment does not allow for interaction with the public and so provides a 'coherent image' of an event from the past. Such an image can be accepted or rejected but not interrogated. As Blackmore says 'It differs only from film and video because of its live nature' (Blackmore, 1991: 9). However, many re-enactment groups have evolved a number of methods enabling interrogation by the public so that some so called re-enactment groups are now better retitled as living history presenters because they do not re-enact events or portray associated processes at all. Other groups provide first and third person interpretation away from the set re-enactment pieces, for example in villages or encampments, where they can explore many aspects of the period rather than just an event. Yet others use intermediaries to act as interpreters between the re-enactment and the visitors (Malcolm-Davies, 1989).

Overall numbers of re-enactment groups continue to grow in Britain though individual societies come and go with time. Members of the societies are all volunteers and their standards of dress, training and research vary considerably. Some societies are well established, have good reputations for historical accuracy and attract members from the archaeological and museum world – others do not (Malcolm-Davies, 1989, Blackmore, 1991). In recent years societies have been encouraged by archaeological organisations to improve their research and authenticity (Malcolm-Davies, 1989; Griffin, 1994; English Heritage, 1992) but the differing fundamental aims of site interpretation and re-enactment groups remain to give cause for concern. Whilst not denying the real interest in the past that many re-enactors share, the societies clearly have a social role for members. This role may often take precedence over the accurate portrayal of history as desired by the archaeologist and the site manager. Whatever the concerns relating to authenticity and the desirability of presenting fictitious pasts (Hewison, 1987; Lowenthal, 1985; Porter, 1991; Bennett, 1988), the real question for discussion here concerns the value of these events in communicating archaeology to the public.

Do amateur groups of 20th century people in costume on archaeological sites add to the public perception of people who lived in the past and, subsequently to an understanding of the site? Unfortunately, little research has been undertaken in relation to re-enactment and where it is done it is often from a marketing perspective and not a communication one. It is not known what impact re-enactment has in interpretation terms, though we do know that large numbers of visitors attend such events and that they find the media absorbing. It may be conjectured that, as with first person interpretation, the human element in re-enactment has a considerable impact in stimulating interest and possible information retention by its audiences.

On the basis of the American experience, Wallace argues that 'special events' can be an integral part of site interpretation but that in Britain they fail to do so as they are often irrelevant to the site (Wallace, 1990). During 1995 there were a wide variety of such events performed by re-enactment societies. A 'savage battle between the Saxons and the Vikings' could be viewed at the 11th century Kenilworth Castle in Warwickshire (English Heritage, 1995: 4); Napoleonic Soldiers could be seen in an 'authentic encampment' at Dover Castle, Kent (English Heritage, 1995: 4); and the Vikings were providing the opportunity to 'meet the King, buy a slave and witness the thrill of battle' on the Bronze Age site of Flag Fen, Peterborough (Flag Fen promotional leaflet). Whether the public were aware of the lack of relationship between these presentations and the sites is unknown. A belief commonly encountered by museum curators is that dinosaurs and people coincided – a belief supported, for example, by the film *One Million Years BC* featuring Raquel Welch. It will be unfortunate if similar misconceptions arise from anachronistic site events paradoxically being sold under the title of *Bringing History Alive* (English Heritage, 1995).

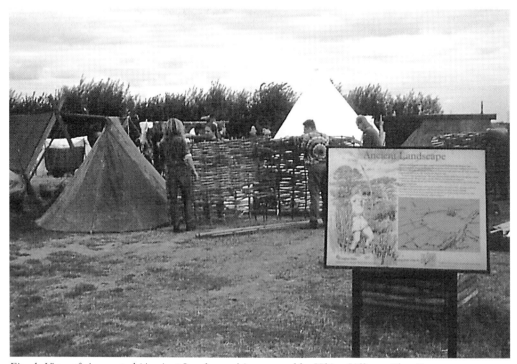

Fig. 1. View of signposted 'Ancient Landscape' is removed by Viking Village, Flag Fen.

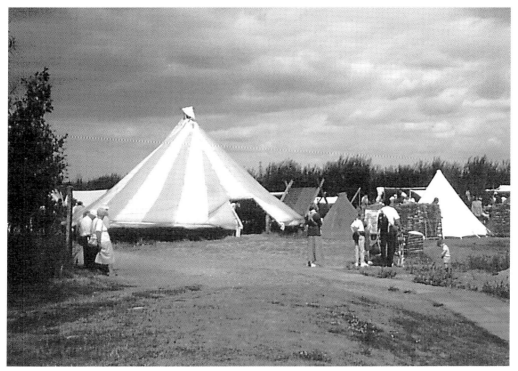

Fig.2. Viking Village adjacent to reconstructed Iron Age roundhouse (left), Flag Fen.

For those who have not attended such 'special events', it is worth briefly considering two that were held over the August bank holiday of 1995. As income generators they may both have been significant. As instruments of site interpretation their value is at best questionable and possibly counter educative. They establish a whole new range of 'coherent images' that may have nothing to do with archaeology or the sites on which the event occurred.

At Flag Fen, Cambridgeshire, a three day event involved *The Vikings* re-enactment society. This multi-period site, with evidence from the Bronze Age to the Romans, is still being excavated in places. The main focus of site interpretation is the evidence it provides for Bronze Age settlements in the fens, with associated farming activity, tracks and droveways. It is a relatively difficult site to understand, but the interpretation is well thought out. Entry to the site is normally via the visitor centre, where a video helps develop an understanding of the nature of the human occupation. This can then be followed by a guided tour of the on-going excavations, a visit to the site museum or a walk in the park with its Roman road, reconstructed Iron Age roundhouse, and carefully reconstructed Bronze Age landscape.

Unfortunately, the large audience anticipated over the three days of the special event ordained that visitors were asked to enter the site from the rear. Thus their first view of the site was of the modern day encampment for *The Vikings*. The visitors then proceeded past the demonstration area, used by *The Vikings* for battles and archery shows, to the 'Preservation Hall' and 'Research Excavation Area' containing Bronze Age excavated site and on-going excavation respectively. After that, the visitors encountered *The Viking* village of canvas tents

133

Elaine Sansom

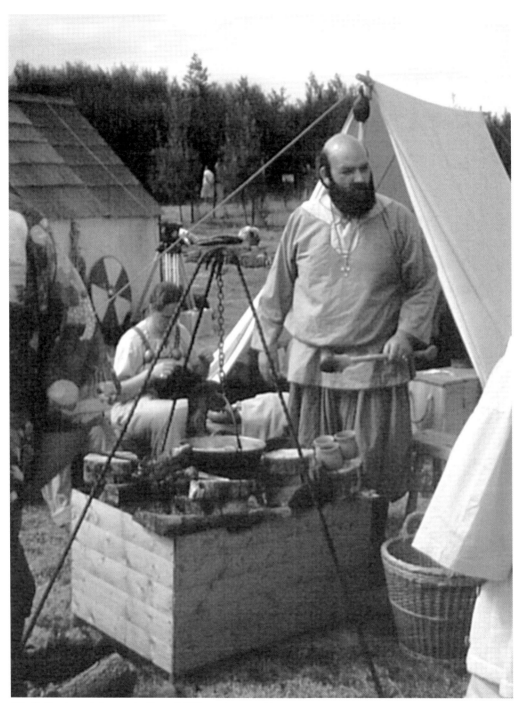

Fig.3. Costumed demonstration of 10th century cooking processes.

134

Figs. 4/5. Participative activities for visitors in Viking Village.

next to the site's reconstructed Iron Age roundhouse. Finally the visitor reached the visitor centre where, due to 'everything else that is going on', the introductory video had been removed.

The event had both costumed interpretation and re-enactment elements. *The Vikings* re-enactment society had made an effort to orientate their programme to the region, basing it on the contest for the throne of Wessex between Athelwold and Edward which had occurred in the area. The costumed interpretation was provided in a re-created Viking canvas village where, in the absence of central characters, costumed society members largely took on the role of demonstrators to show processes such as cooking and crafts. Visitor activities such as 'paint a shield' were also available, and modern beads and jewellery could be purchased. At set times the village was used to stage events related to the overall theme of the interpretation. For example, at 1 pm visitors were encouraged to 'visit the village and see how Oscetyl (Viking settler to the fens) deals with the many problems that an English Army on his land cause. Meet the various members of his family and friends' (The Viking Re-enactment Event Programme, 1995). The pure re-enactment elements consisted of the recreation of an 'archery competition' and a 'friendly combat competition'.

However authentic, or otherwise, their re-enactment and living history elements, the fundamental problem was that *The Vikings* were not interpreting either the relevant archaeological period nor the particular site on which they were placed. The archaeology and its related human story had become not only incidental but actually a confusion for the story being told by *The Vikings*. The visitor who, on entering the Iron Age Roundhouse reconstruction, remarked that this *Viking* had a lovely tent could well be forgiven. Though obviously of a different style and construction technique, the roundhouse was next to the tents erected for the event and there was a *Viking* in there selling jewellery. I could also identify with the visitors who stood in front of a site panel in apparent bafflement. The panel pointed out features relating to the Flag Fen site but what they could see from their vantage point was a rather strange group of *Viking* tents.

An event held at Old Sarum, Wiltshire, had more content legitimacy in terms of the site. The Iron Age hill fort with some Roman use became the venue for a two day event involving two re-enactment groups, *The Ermine Street Guard* (Romans) and *Brigantia* (Celts). Unlike that at Flag Fen the event was largely a commentated performance – it could be said that the *Ermine Street Guard* gave a 'costumed demonstration' of military manoeuvres, whilst *Brigantia* provided a 'performance drama'. In many ways the event was a classic example of good practice. The re-enactors did not re-create, or create, a skirmish between Celts and the Roman Army which may or may not have happened on this particular site, and a member of English Heritage's special events staff set the context for the re-enactment in relation to the site's history prior to handing over to *Brigantia's* 'Druid' and then to a commentator from the *Ermine Street Guard*. This does not, however, mean that all the components of the event were necessarily effective communication media.

I found that having the two different groups perform helped to highlight some of the problems and advantages of such displays as a method of site interpretation. Leaving aside issues of authenticity of dress and behaviour, it was clear that *The Ermine Street Guard* had a far easier interpretation role. The Roman army were renowned for their constancy of action throughout the Empire. What was being demonstrated were manoeuvres that would have been used in the taking of the area if not in the taking of Old Sarum itself. *Brigantia*, however, based their performance loosely on a documented Irish/Welsh skirmish which occurred between two groups meeting to arrange a marriage. Presumably this choice was determined by the survival of Celtic sources but the story was not immediately applicable to the site of Old Sarum.

However, the group did introduce in a memorable way concepts, such as issues of Celtic kinship and honour, which are normally difficult to explain in static displays or process demonstrations.

In the absence of any research it is impossible to gauge the communicative impact of either performance at Old Sarum on the public's understanding of the site, the Roman military or Iron Age society. I can only report the reactions of the bank holiday crowd sitting around me. Prior to the event people were talking about the Roman Army and what they already knew about their techniques and uniform. When the Celts arrived, and before the performance got into full stride, many could be heard still talking about the Romans. To some extent the Celts, who were not dressed too differently from the holiday crowd, appeared confrontational. They were not stereotypical people from the past doing preordained and prescribed manoeuvres as 'the Romans' might do, and for a while there was an element of hostility from the crowd towards what appeared to be shouting ruffians under the influence of alcohol.

The audience, largely families, were relatively quiet as the story of the meeting between the two tribes unfolded until the Celts started to kill each other. As the site began to fill with dead bodies (all of whom 'died' fully stretched out on their backs, and some of whom then leant up in order to watch the proceedings) an element of farce crept in and laughter began to sweep the audience. When the Druid asked the audience to point out who had done the first killing which had resulted in the bloodshed, the ringing shouts of 'Behind You' put the event firmly into the realm of pantomime. The performance was completed to the sound of cheers from the audience as the protagonist, who had been declared 'dead for all time' by the Druid, got to his feet and rejoined the group to give a final demonstration of Celtic fighting methods. A slightly disconcerting start had finished to public satisfaction with the performance pigeonholed into the understandable category of farce with all its established stereotypes in the British theatrical tradition. However, the message behind the presentation was complex and perhaps more interesting than the straightforward, if well researched and performed, demonstration that many of the audience had come to see. The fact that the message was let down by the medium does not negate the method, but this example does indicate some of the problems associated with its effective use in archaeological site interpretation.

Drama

Costumed drama has many similarities with other forms of human interpretation, and from the account of *Brigantia* at Old Sarum described above it is clear that to categorise it separately is to some extent false. The division is here if only because some practitioners see it (Positive Solutions, 1991). One way of defining the differences between them is to imagine a continuum with historical evidence at one end and human attitudes, values, customs and behaviour at the other. Costumed interpreters, such as those described above, and actors using drama may make use of both ends: the difference comes in the techniques employed, the emphasis and in the intended effect. The interpreter is more likely to interact directly with the visitor, to concentrate on the activities of the past, and to want to impart 'facts'. Drama is more often used to engage the viewer at an emotive level, providing a 'feeling' for how a period or incident *may* have been experienced through the portrayal of human conflict, dilemmas, change and emotion. There is, however, a continuum and it does not prescribe that drama can not educate and that interpreters can not inspire (Alsford, 1991; Positive Solutions, 1991; Canadian Museum of Civilization, 1992). However, the very nature of drama and story telling means that these forms of presentation are oriented towards the human story.

As communication methods, drama and story telling, which is discussed below, are generally considered to work initially at an emotive level rather than a cognitive one. This notion is

borne out to some extent by a Canadian Museum of Civilization survey which found that 78 per cent of visitors at first person interpretations said that they had learned something new from the performance, compared to 63 per cent where visitors had experienced drama performances as well (Canadian Museum of Civilization, 1992). This survey does not, however, shed any light on the long-term impact of the different techniques.

Drama can be defined in many ways, but in terms of site interpretation it may be useful to simply divide it in to *'performance'* drama, where the primary product is a show of some form performed in front of an audience, and *'process'* drama where, if there is an end performance, it is incidental to the main function of learning through active participation in writing, movement and acting.

Performance drama, more than any other form of drama, is likely to be encountered on archaeological sites by members of the general public, though it is likely to be incidental to any interpretation of the site. In the summer of 1995 the British public could attend a large number of theatre performances at heritage sites, including *The Merry Wives of Windsor, The Bard's Best Bits* and *Hisses, Kisses and Misses: a show of Victorian melodrama, music, comedy and mayhem* at Fountains Abbey, Portchester Castle and Wenlock Priory respectively (English Heritage, 1995, National Trust, 1995). One of the rare examples of a location specific performance was commissioned by Colchester Museum in Essex. The play, *Boadicea The Movie,* 'explored the myth and reality surrounding the Celtic leader whose forces destroyed Colchester in AD 60', and was performed in Castle Chapel prior to touring more generally within Essex (Seaman, 1993: 23).

It is notable that a relatively cheap variant of performance drama, son-et-lumiere, which is used to great effect at sites around the world, has not been developed in archaeological site interpretation in Britain.

Process drama on archaeological sites can range from relatively simple events led by a school teacher through to complex drama integrating the performances of professional actors and interpreters with the participants (Woodhead, 1994; English Heritage 1988a and b). Process drama is particularly suited to community-based projects. At Bancroft Roman Villa, Buckinghamshire, a relatively elaborate project incorporating process drama was developed (Blockley, 1994). The site, although preserved and interpreted by traditional means, was not valued by the local community and had become vandalised. Working with schools, the Archaeology Unit taught local children the processes of archaeology in general and the findings of archaeologists on the Bancroft site in particular. Not surprisingly they uncovered the human story of the site's occupation and excavation. This led to the children developing a script and the ultimate performance of 'The Villa Thriller' at the site. Blockley had no doubts of the value of this site specific approach to interpretation, '... rather than buying in an off-the-peg living history performance, the project was produced by the children (and the families) of the local community. The process of producing and understanding the interpretation enabled locals to see their familiar park in a new light' (Blockley, 1994: 368)

Story telling

At a simple level the public can participate in drama through events where aspects of the past are recreated through 'using period tools, or by dressing up, or by having them behave as people of the period' (Binks, 1988: 43). Listening to stories is one way in which the public can 'behave as people of the period'. Prior to the use of the written word, story telling was an important way of maintaining histories and cultural traditions, and throughout the past people would have sat around fires listening to stories. In the American National Park Service, with its strong tradition of interpretation, the campfire programmes given by rangers are a well

established interpretation medium (Risk, 1994). In Britain there is less evidence of story telling to the public on archaeological sites though the practice is encouraged with schools (Maddern, 1992). At the Early Technology Centre, Dorset, reconstructions from a variety of archaeological periods are used as venues for story telling to both schools and the general public. The manager there is convinced of the power of stories to inspire listeners: 'It is impossible to imagine the past, but through stories it is possible to get a sense of the mystery and the fears of past times' (Keen, 1995).

An integrated approach to the use of costumed interpretation: an example of good practice

The West Stow, Suffolk, site, consisting of seven structures and associated crops and animls, has been reconstructed on the site of an excavated Anglo-Saxon village which housed three or four families. As a result of the reconstructions it is similar to, if smaller than, sites such as Plimouth Plantation and Colonial Williamsburg in America which are renowned for their use of costumed interpretation as an almost exclusive method of public interpretation. Rather than follow the American route, the interpretation at West Stow makes use of a mix of media which focus on the site's human story, of which costumed interpreters are just one element (Baxter, 1995).

Visitors approach the site via the visitor centre where they are recommended to view the video *In Search of the Anglo Saxons*. The video introduces the village, and early Saxon life in the area and also gives brief details about the excavation and reconstruction. Villagers, portrayed by members of staff, are seen in silhouette and at a distance. Although done for financial reasons, this strategy creates a clear message: the people are no longer here but they are central to the story of the site. Visiting school groups may well have seen an extended version of the video in which, using professional costumed interpreters, individual characters are developed through a series of short stories. The individual characters appearing in the show are given names, such as 'Saxwulf the slave' and 'Emma the oldest person in the village', and appear elsewhere in the site interpretation.

On a normal day, the visitor then moves on to the site with a personal audio-tour. The tour is narrated by a modern guide but in places the characters, already encountered in the video, are overheard. The audio-tour provides a significant amount of information about the excavation, changing interpretations of house construction, and the evidence on which the reconstructions the visitors are looking at are based. The main emphasis, however, is on the people who lived on the site and subjects ranging from cooking practices to beliefs are explored. There is also a second tape tour, *Reconstructing the Past*, narrated by Dr Stanley West the archaeologist responsible for excavating the site, which can be requested by those wanting a more archaeological interpretation. On the approach to the site there is an information point with interpretation panels, but in the village itself there are no panels. The visitor is left to imagine the past with the aid of the tape narrator and the characters that they have seen on the video.

Throughout the year there are a series of special events for the public at West Stow. The interpretation provided changes, though it retains the characters encountered on the video or tape. For example, activities are based on the child character of Aelfwynn in *A Day in the Life of Aelfwynn: an activity tour of the Anglo-Saxon Village looking at how a Saxon child would have spent her day*. The annual springtime *Saxon Market* event allows the visitor to meet characters from the video and tape tour in a first person interpretation. At other times in the year the site characters can be found providing costumed process demonstrations of pottery production, wood working and so on. Non-costumed guided tours are also used throughout the year to interpret different aspects of Saxon life. In 1995 these tours were on the theme of

Anglo-Saxon crafts, farming, fireworks, and 'who was the most important person in the village' (West Stow promotional leaflet, 1995).

Ultimate responsibility for the archaeological content of the interpretation lies with the West Stow Trust, which includes archaeologists and academics, and with Dr West who has been retained as an archaeological consultant. The staff of the West Stow Country Park and Anglo-Saxon Village include two ex-archaeologists and a manager with museum and education training. They provide the guided tours and other interpretive activities. Costumed demonstrators and interpreters are hired for special events. The former are predominantly crafts people with an interest in the past, whilst the later are professional interpreters from the Longship Trading Company which was also used in the making of the extended video. Both costumed demonstrators and the professional interpreters adopt the villager roles developed for the video.

The only other costumed people on site are the Volunteer Villagers. This sub-group of the voluntary society 'Friends of West Stow' occupies the village a couple of times a year on Volunteer Days. Volunteer Days were introduced as a way of channelling the desire of the public for participation in the interpretation process in such a way that it could be controlled in terms of clothing and content. Other forms of participation are offered to the general visitor through demonstration programmes and, also, guided tours which may include a story telling element or the telling and solving of Anglo-Saxon riddles in the Hall.

Baxter states that one of the reasons for not previously reporting the interpretive strategy for West Stow is that it is continually developing (Baxter, 1995). Indeed, the methods of interpretation have changed over time. Large scale first person interpretive events were used in the past but were found to be staff intensive, costly and 'difficult' for participants. They did, however, inspire the characters that were subsequently developed in the video, tape and events programme, and a book for children *The Children of Stowa*. Similarly, the use of re-enactment groups on the site was abandoned seven years ago. This was done because of the inability of the staff to control the content of performances and also because the events did not contribute directly to the interpretation of the actual site.

There has been no formal evaluation of the effectiveness of the West Stow site's interpretation strategy. Staff do note all verbal comments made to them and the white board, on which visitors are asked to write comments, is recorded daily. This form of evaluation cannot indicate the impact of the interpretation on visitor understanding, but it does indicate that people are affected by it at an emotional level. In particular, it is the audio-tour, with its characters, music and readings from Beowulf that appears to effect the visitor, 'Closing my eyes, with the smell and the warmth of the fire, you are sent back in time' (recorded visitor comment).

The West Stow site has inherent advantages which are not available to those interpreting hill forts and ruined masonry. The reconstructions are of domestic dwellings which visitors can readily identify with, and they provide an immediate context for costumed interpreters. However, the site's value as an example stems from the fact that the interpretation is totally focused on the human story of this particular site. From standard visits in the winter, with their reliance on the 'humans' of the video and tape, through to the special events of warmer months, using costumed demonstrators and costumed interpreters, everything is aimed at interpreting the site of West Stow. The message there is not confused by inappropriate events as the human interpreters, costumed and uncostumed, are controlled by site management. However debatable archaeological truths are, the site management at West Stow has attempted to ensure that the content of presentations by demonstrators, professional interpreters and volunteers are based on archaeological research and are broadly acceptable to an archaeological consensus.

140

The future

The discipline of site interpretation is still relatively young. As with most evolving activities many avenues have to be explored before informed choices can be made. The various techniques available, from the guide custodian through to the large scale re-enactment of a battle, all hold possibilities for communicating the essential human story of the people who created, lived and died at a site. However not every avenue will prove useful as a communication tool, and at present decisions to use the various methods are largely based on fashion and the financial imperative. This does not belittle the efforts and integrity of some practitioners of costumed interpretation who are trying to evolve the medium in the face of spurious historical representation by film and television, and professional distrust by some academics, curators and archaeologists. It does, however, serve as a reminder that in archaeological site interpretation, at least, it appears that it is the marketing function, rather than those of communication and education, that is driving most of the use of live interpretation.

 In future it would be useful to have some principles of site interpretation that are based not on assumptions, but on their real communication value. Indeed it may be that with evaluation of the impact of certain techniques of live interpretation on public understanding (also their impact on the site itself and on true levels of income generation) such methods will be refined, re-labelled or rejected. The importance of getting it right should not be underestimated. As Pearce put it 'the presentation of open air sites is one of the most important interfaces between the committed archaeologist and the public, and it needs to be treated with a corresponding degree of serious attention' (Pearce, 1990: 180).

References

Alderson, W.T. & Low. S. P. 1976 *Interpretation of Historic Sites.* Nashville: American Association for State and Local History

Alsford, S. & Parry, D. 1991 Interpretive theatre – a role in museums. *Museum Management and Curatorship:* 10, 8–23

Anderson, J. 1984 *Time Machines: The World of Living History.* Nashville: American Association for State and Local History

Anderson, J. 1985. *The Living History Sourcebook.* Nashville: American Association for State and Local History

Baxter, A. (Manager of West Stow Country Park and Anglo Saxon Village), 1995 Personal comment

Bennett, T. 1988 Museums and 'the people'. In: *The Museum Time Machine* (ed. R. Lumley) London: Routledge

Bicknell, S, & Mazda, X. 1993 *Enlightening or Embarrassing? An Evaluation of Drama at the Science Museum.* London: Science Museum Interpretation Unit, National Museum of Science and Industry

Bicknell, S. 1994 An evaluation of the provision of drama in the Science Museum, London. In: *Manual of Heritage Management* (ed. R.Harrison), 376–78. Oxford: Butterworth-Heinemann

Binks, G., Dyke, J. & Dagnall, P. 1988 *Visitors Welcome.* London: HMSO

Blackmore, D. 1991 *The use of reenactment in the interpretation of military collections.* Unpublished MA Dissertation, University College London

Blockley, M. 1994 The Bancroft Villa Thriller. In: *Manual of Heritage Management* (ed. R.Harrison), 365–8. Oxford: Butterworth-Heinemann

Bywaters, J. & Richardson, P. 1993 Breathing life into exhibits. *Museums Journal:* October, 30

Canadian Museum of Civilization, 1992 *Evaluation of the Live Interpretation Program.* Unpublished internal document

English Heritage, 1988a *Living History – the Kenilworth project* (video)

English Heritage, 1988b *The past replayed – Kirby Hall* (film)

English Heritage, 1992 R*evised Draft Guidelines for Historical Societies and Performers. No.1: Authenticity and Presentation*

English Heritage, 1994, Marketing the past – from bare stones to Tosca's leap. *Conservation Bulletin* 23: 20–1

English Heritage, 1995 *Events 1995 Bringing History Alive*

Field, D.R. & Wagar, J.A. 1982 People and Interpretation. In: *Interpreting the Environment* (ed. G. Sharpe) 52–73 Washington: John Wiley and Sons

Fowler, P. 1981 Archaeology, the Public and the Sense of the Past. In: *Our Past Before Us. Why Do We Save It?* (eds D.Lowenthal & M.Binney), 56–70. London: Temple Smith

Graft, C. 1989 Incorporating evaluation into the interpretive planning process at Colonial Williamsburg. *Visitor Studies:* 1989(2), 133–9

Griffin, J. & Giles, H. 1994 Bringing history alive: special events at English Heritage. In: *Manual of Heritage Management* (ed. R.Harrison), 331-332. Oxford: Butterworth-Heinemann

Hewison, R. 1987 *The Heritage Industry: Britain in a Climate of Decline.* London: Methuen

James, S. Forthcoming. Paper contributed to *The Archaeology of Visual Representation* (ed. B. Molyneaux)

Keen, J. (Manager of the Early Technology Centre), 1995 Personal comment

Knudson, D.M., Cable, Ted, T. and Beck, L. 1995 *Interpretation of Cultural and Natural Resources.* Venture Publishing Inc. PA

Leon, W. & Piat, M. 1989 Living History Museums. In: *History Museums in the United States* (eds W. Leon and R. Rosenweig) Chicago: University of Illinois Press

Lewis, P. 1994 Illustrations and observations from Wigan and Beamish. In: *Manual of Heritage Management* (ed. R.Harrison), 323–4. Oxford: Butterworth-Heinemann

Lowenthal, D. 1985 *The Past is a Foreign Country.* Cambridge: Cambridge University Press

MacDonald, G.F. & Alsford, S. 1995 Museums and theme parks: worlds in collision? *Museum Management and Curatorship* 14 (2): 129–47

MacLean, T. 1995 *Loisbourg Heritage From Ruins to Reconstruction.* Novo Scotia: University College of Cape Breton Press

Maddern, E. 1992 *A Teachers Guide to Storytelling at Historic Sites.* London: English Heritage

Malcolm-Davies, J. 1989 Living in Interpretation in Museums, *Heritage Interpretation:* 43, 12–14

Malcolm-Davies, J. 1990 Keeping it Alive. *Museums Journal:* March, 25–29

Molyneaux , B.L. 1994 The represented past. In: *The Presented Past* (eds P.G.Stone and B.L.Molyneaux). London: Routledge

National Trust, 1995, *Centenary Events*

Nurse, J. 1994 *The Elusive Women of Roman Britain.* Unpublished MA Dissertation, Nottingham Trent University

Pearce, S. 1990 *Archaeological Curatorship.* London: Leicester University Press

Porter, G. 1991 Partial Truths. In: *Museum Languages: Objects and Texts* (ed. G. Kavanagh). Leicester: Leicester University Press

Positive Solutions, 1991 *What's the Catch: report on the first UK conference on the use of drama in museums.* Liverpool: Positive Solutions

Potter, P.B. & Leone, M.P. 1992 Establishing the Roots of Historical Consciousness in Modern Annapolis, Maryland. In *Museums and Communities* (eds I. Karp, C. Mullen Kreamer & S. D. Lavine) 476–505. Washington: Smithsonian Institute Press.

Risk, P. 1994 People-based interpretation. In: *Manual of Heritage Management* (ed. R.Harrison), 320–330. Oxford: Butterworth-Heinemann.

Seaman, B. 1993 *Not Magic, But Work. Dramatic Interpretation in Museums.* Unpublished MA Dissertation, University of Leicester

Sharpe, G. 1982 *Interpreting the Environment* Washington: John Wiley and Sons

Smith, S. 1989 Funding our heritage. In: *Heritage Interpretation* Vol.2 (ed. D. Uzzell) 23–8. London: Belhaven Press

Summers, R. 1993 Professional education or amateur dramatics. *Museum Development* April:14-17

Tilden, F. 1977 *Interpreting Our Heritage*. Chapel Hill, NC: University of North Caroline Press

Uzzell, D. 1989 The Visitor Experience. In: *Heritage Interpretation Vol.2* (ed. D. Uzzell). London: Belhaven Press

Uzzell, D. 1994 Heritage interpretation in Britain four decades after Tilden. In: *Manual of Heritage Management* (ed. R. Harrison), 293–302. Oxford: Butterworth-Heinemann

Wallace, M. 1990 The value of special events as interpretive tools. *Heritage Interpretation:* 44

Woodhead, S. 1994 Young National Trust Theatre. In: *Manual of Heritage Management* (ed. R.Harrison), 335–7. Oxford: Butterworth-Heinemann

Conservation 'As Found': The Repair and Display of Wigmore Castle, Herefordshire

Glyn Coppack

Wigmore Castle, *caput* of the Mortimers, was one of the last great castles in England to survive unconserved, a natural ruin in a setting of decayed woodland pasture, high on a ridge in the north-west corner of Herefordshire (Fig. 1). Its condition has been of concern throughout the 20th century: the editor of the Woolhope Society's *Transactions* claimed in 1908 'what was once the home of one of the most powerful nobles of the March-land … is fast disappearing from the face of the earth' (Anon 1908: 14); in 1963 Pevsner described the site as 'one of the largest castles along the Welsh border, but badly preserved and badly looked after' (Pevsner 1963: 321). Its condition remained perilous in 1987 when it was described in *Rescue News* (Shoesmith 1987: 3), and in 1988 there was a major fall of masonry on the south curtain wall. The castle was a scheduled ancient monument in private ownership, and had been identified as being at risk by English Heritage. In a survey of English Marcher castles on the Welsh border it was seen as the most important of a substantial group, and the one which should be the first target for repair (Streeten, 1993).

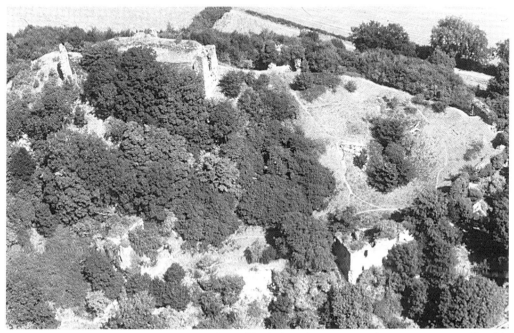

Fig.1. Wigmore Castle seen from the south in 1995 before the site was taken into state guardianship (photo: English Heritage).

The problem with Wigmore Castle was the fact that it remained in private ownership but that repair was only possible with the input of substantial public funds, estimated in the region of £1m. The owner, who had acquired the site in 1988 in the mistaken hope that it would provide him with an income, was not in a position to be able to guarantee future maintenance, and had strong views on how the castle was to be repaired and presented, leading to substantial concern that repair was not feasible. The result was protracted negotiation while the castle continued to decay. It was not until 1995 that English Heritage persuaded both government and the owner that state guardianship was the only way that the castle could be safeguarded in the long term.

The high ground coming down from Radnorshire between the rivers Teme and Lugg converges towards the east where it forms a ridge bounded to the south by a steep, narrow valley and the north by the *more* or marsh of Wigmore. The castle comprised three wards or baileys (Fig. 2) set on this ridge to the west of Wigmore and separated from the high ground to the west by an immense ravine or ditch which is apparently man-made. The site is a scheduled ancient monument (county monument number: Hereford 6), but only the middle and inner wards with standing masonry are in guardianship. The inner and middle wards are essentially an earthwork motte and bailey castle with a stone shell-keep on the motte and a curtain wall, gatehouse and four towers enclosing the bailey. Between this and the outer ward is a barbican with four half-round towers set between two deep ditches and reduced to earthworks (Fig. 3).

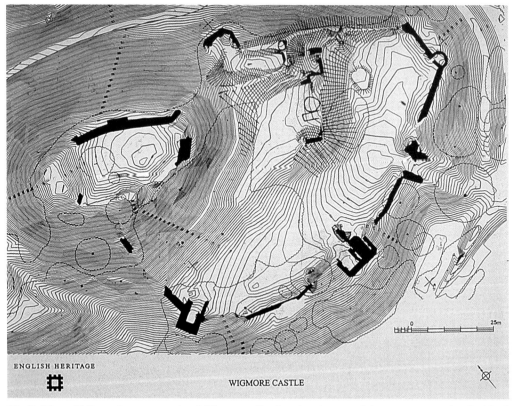

Fig.2. The middle and outer wards of Wigmore Castle, showing surviving masonry ruins in black against the topography of the site (photo: English Heritage).

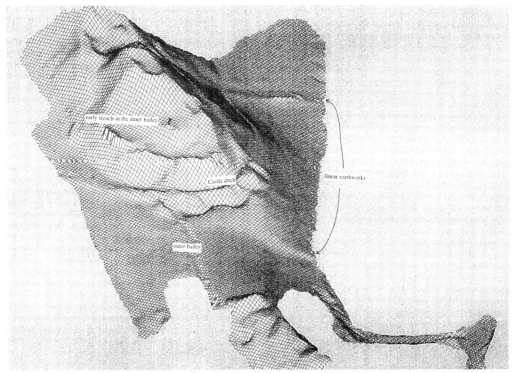

Fig.3. The morphology of the castle at Wigmore, seen from the east and showing the scale of the earthworks on the ridge (photo: English Heritage).

The condition of the site

Although there has been a castle at Wigmore since about 1068, the structures that are visible date predominantly from the 13th and early 14th centuries, the period of the Mortimers' greatest power and the castle's greatest extent. The castle was ruinous from the late 16th century, and was partially dismantled to prevent its fortification in the Civil War of the 1640s. Allowed to decay naturally for four centuries, it remained a spectacular and romantic ruin, a remarkable archaeological resource with buildings buried by their own collapse to first floor level or above. The building stone was a soft, local mud-stone, dressed with a soft sandstone from the Forest of Dean, both of which were originally protected by an external skimming of plaster, most of which has been lost to erosion. Many parts of the site had stabilised naturally, and the wall-tops were protected by a dense mat of vegetation which contained a number of rare species including the western polypody fern but also briars and small trees which in some areas were starting to destabilise the masonry. Other parts were remarkably unstable, the result of earlier stone robbing at the base of walls and around openings, and threatening imminent collapse. Most were covered with dense ivy, which had been cut at ground level in an attempt to kill it but which had rooted itself firmly into the masonry at a high level. The ground surface within the castle was rough grass, though the lack of grazing in recent years had led to large areas being colonised by nettles, blackthorn, and brambles. Some areas were eroding where visitors had climbed on them, while others were covered with screes of loose masonry. In most areas the earthworks of buried

buildings were at least partially obscured, and the site was difficult to 'read', even by specialists. Around the castle, the hillside was managed as woodland, the heavy tree cover obscuring the ditches but providing an important sense of setting for the ruin which was visible above the tree-line.

There had been no earlier conservation. Indeed, what made Wigmore so important was that it had not been modified by repair and display, a proper ruined castle that provided a real sense of discovery for visitors.

The philosophy of repair
Theory
So often, the repair of an ancient monument is constrained by what has been done to it in the past. Because Wigmore Castle was untouched, it provided a rare chance to develop a philosophy of repair at the outset which was suited to its particular needs, and one which reflected current developments in conservation practice (Coppack, 1999). This had begun, in fact, long before an agreement was concluded on guardianship, with attention paid to both the archaeology and ecology of the site. All repair of historic fabric is destructive of archaeological evidence, and the traditional method of conserving masonry by stripping off its natural protection and replacing it with a stone and mortar capping is damaging not only to archaeological features but to the setting and ecology of the site. From the very beginning, it was decided that repair should cause the minimum intervention possible, and that the delicate ecology of the site and its setting should be preserved. Essentially, Wigmore Castle would be conserved 'as found'. The policy of 'conserve as found' is an old one, dating from the period before World War I when Sir Charles Peers and Sir Frank Baines were codifying conservation policy for the Office of Works, but it has been interpreted differently by each subsequent generation, to the extent that 'conservation' is often little more than replication with some if not all of the original elements, and 'found' reflects the expectation of the time or the idiosyncrasies of the conservator. What it has never meant is the leaving of a monument as close to the state in which it was originally found which is consistent with its long-term stabilisation and public access. This, however, was the treatment that Wigmore seemed to need.

At Wigmore, the site itself provided the basis of the repair strategy, its state and component parts the only factors that controlled the approach adopted. Immediately before the site was taken into guardianship, a full photographic survey was made of all the surviving masonry, followed by a fully digitised photogrammetric and rectified photographic survey which formed the basis for all subsequent work. A topographic survey, again digital, was made of the whole of the site, including outworks not in guardianship. The ecological survey made some years earlier for the owner was updated. It was apparent from the outset that the surviving elements of the castle were not as fragile as they looked, that they contained a vast amount of archaeological data, and that they supported an extensive and important ecosystem that was more fragile than the ruins. It was also obvious that there were serious structural problems that might require massive intervention including extensive ground disturbance unless a more sensitive approach could be developed. Wigmore presented an interesting challenge if its repair was not to damage significantly its 'soft' and natural appearance, the flora and fauna it supported, or the archaeological evidence it retained and buried evidence it contained, all the criteria that made it important in the first place. Techniques of repair and presentation needed to be the least intrusive possible, but they had to work effectively and represent value for money. They also had to be sustainable and capable of monitoring. In short, Wigmore Castle presented a unique opportunity to experiment with modern techniques of repair on an immense scale, and if successful to set the standard for future repair of ruined structures elsewhere.

Practice

Repair was to be done by contract, which required the preparation of a full specification of works before the site could properly be examined, hardly an ideal situation. Most of the higher masonry was obscured by ivy which could not be removed without destabilising the ruins and only limited access to examine the upper levels was possible. The only way in which work could be specified was to identify a series of appropriate treatments, which included perhaps more taking down and resetting than was actually going to be required, and applying these as it seemed appropriate to the photogrammetric survey by examining what could be seen of the masonry from ground level. This approach requires a great deal of experience if it is to be at all meaningful and a close and trusting working relationship is needed between curator, architect, and civil engineer, the senior members of the project team at this point. It also requires constant attention to detail in the course of the conservation contract and a willingness by both the contractor and the project team to modify their approach as the true nature of problem becomes apparent. In this case it also required the understanding and support of both the commissioners and senior managers of English Heritage who were being asked to support a different kind of conservation to the one they understood. The first was achieved quite easily, the second could only develop through time, and the third was at times quite difficult to achieve, but once accepted support was total.

To ensure that the specification was realistic and to identify more precisely what problems would be encountered in the course of the works, a section of the east curtain wall was scaffolded, stripped of ivy, and used as a test-bed for different conservation techniques. The area chosen seemed fairly typical, with a fragile wall-head, exposed core, and a well-preserved and very visible outer face. Whatever work was done on this trial area, it could be reworked in the main contract. This allowed the opportunity to experiment with mortars and replacement stone, the use of additional core-work to support and protect fragile areas, and the removal and replacement of the soft capping on the walls. It permitted mistakes and experimentation, allowed for the refining of the specification, established the level of archaeological recording necessary, and provided the first understanding of how complex the structures of the castle were likely to be.

Archaeology

The decision to preserve the castle's archaeology undisturbed was taken long before the site came into guardianship and had been a central plank in English Heritage's protracted negotiations with the owner. Some excavation was unavoidable, required to inform the civil engineer about stability and levels, and to provide access for repair and underpinning, but that was to be kept to the absolute minimum consistent with good archaeological practice. The two areas excavated were designed within an archaeological research strategy that maximised the capture of information to aid interpretation while avoiding the reduction of ground levels which would expose fragile and unweathered masonry.

Excavation began four months before the repair contract in 1996 with a deep section inside the south curtain wall which revealed some 9m of buried deposits, identifying a timber castle of the early 12th century, early 13th-century rebuilding in stone, and an early 14th-century rebuilding on top of that. Although the purpose of the excavation was to determine the stability of the standing ruin, it demonstrated dramatically the potential of the site for serious archaeological research. Wigmore is an ideal site on which to study both castle development and decline. This immediately began a debate among commissioners as to whether the preservation of the archaeology in situ was the correct approach. It was right that the debate took place but unfortunate that it took place at that point. The point at issue was that the standing ruins were desperately in need of repair, and that archaeological research was not the first priority. As it transpired, it proved possible to define

a research agenda that would incorporate the excavations required for the urgent repair works but which can be pursued at any time in the future to place Wigmore Castle in both its regional and national contexts. A second area was excavated in the course of the repair works, the east tower which was detaching itself from the curtain wall for reasons which were not immediately obvious. Excavation revealed that although it appeared to be a 14th-century tower it was a 13th-century structure which had been partially rebuilt. The rebuilding had been to correct the movement of the tower which was subsiding into a massive 12th-century ditch. Not only was the reason for the subsidence found, the excavation provided access for substantial underpinning and repair. Both excavations provided evidence for substantial buildings against the curtain wall which were not apparent on the surface, confirming the depths to which the latest buildings are buried.

The main thrust of archaeological research at Wigmore was the recording and analysis of the surviving ruins, carried out immediately in advance of conservation and using the same scaffolding. From the outset, it was decided to produce a fully digitised survey using a methodology in part developed by English Heritage at Windsor Castle but refined in the course of the Wigmore project. Deciding on the level of recording required, always tricky on a site where it is often difficult to decide where one stone stops and another starts, and where all the masonry is eroded, was determined before the main contract began by experimentation on the east curtain wall, to different levels and standards. The importance of this experimentation cannot be overstated – it determined how long it would take to record the fabric in advance of repair and had a direct effect on the timing of scaffolding within the repair programme, and it set the level of recording for the whole of the site at the outset. The surviving ruins were particularly rich in structural evidence, some of it fugitive and most of it difficult to identify and even the lightest raking and pointing of joints was likely to destroy or damage it, and thus the record had to be comprehensive. It was in fact the recording and interpretation of these data that informed the method and extent of the repair undertaken, as well as providing the interpretation of the buildings for future display and publication. The archaeologists who recorded the masonry before repair were also responsible for providing the 'as built' record of the site against which the effectiveness of repair can be monitored. Comparison of the two records shows the extent of intervention and the amount of archaeological data lost or damaged.

The repair of masonry

Because the surviving ruins at Wigmore were the product of a continuing process of stone robbing and collapse, many parts of the site remained unsupported and unstable, and if not restrained would ultimately fall. Most of the serious damage resulted from two causes: Civil War slighting to make the castle undefendable, and trees growing on the walls. In the 1640s, sections of curtain wall were destroyed either by mining or explosives, leaving stress fractures in the surviving structures which had widened with water penetration. More recently, tree roots had been the problem, though many of the trees were felled after they had done the damage. As their roots had rotted out, water again was able to penetrate the core. This was the cause of the collapse of the south curtain wall in 1988 and of some of the instability in the east tower. Stone robbing had removed large areas of the inner face of the curtain wall, again exposing the core. Elsewhere there had been desultory robbing of quoins and dressings, and the undermining of walls which were left to fall through frost action and gravity. Remarkably, large parts of the structure were reasonably sound, the original mortar survived well, and only the wall-tops were friable, the result of four centuries of root penetration.. The ivy, though rooted into the upper walls, had in fact preserved more than it had destroyed, including areas of external plaster render.

Minimum intervention requires the client to accept that masonry will not be entirely repointed and capped to run off water. It also means that there will be a continuing need to monitor the site and carry out small-scale repairs as they are needed. The processes adopted at Wigmore were

designed to slow further degradation, not stop it in its tracks. Central to all of the work was the requirement to minimise disturbance to historic fabric. Where support was needed for overhanging masonry it was provided by underbuilding with new stone in preference to building in support. Where walls had cracked, reinforcement was provided by a lattice of stainless steel Cintech anchors, drilled through joints at the face but angled into the core, and grouted in. Where the outer face of the south curtain wall had fallen, it was rebuilt to protect the exposed core, and was literally hung off Cintech anchors that resisted any future outward movement. Where eroding corework was unsupported because a door or window-head had been robbed, stainless steel supports shaped to the profile of the corework were used to provide support to fragile masonry in preference to the speculative restoration of such features for support. Where evidence for the precise form of robbed detail was available, for instance the robbed reveals of windows in the south tower that had led to severe cracking, the stone was reinstated to its original size and profile using the evidence of the stone sockets themselves and unrobbed detail in adjacent windows. None of this was unusual – regular techniques were used to deal with easily recognised problems.

It was at the wall-head that Wigmore presented particular problems. The original specification had allowed for the taking down and resetting of up to 1m of the wall because of its likely state of decay, and while this was seen as a maximum, there were likely to be some areas where such drastic work was unavoidable. The experimental stripping of the east curtain wall demonstrated that parts of the parapet and wall-walk survived, well protected by the vegetation which had colonised the site from shortly after its abandonment. It was remarkably sound, and only the top two or three courses could be described as 'loose', even after strenuous cleaning to remove penetrating roots. It could be preserved as it was found, but only at a cost in terms of presentation. Even after repair it would be too fragile to leave exposed. The soft capping, which had preserved it so well, would have to be reinstated, hiding archaeological evidence but supporting the site's ecology and retaining its natural appearance. The alternative would have been extensive rebuilding, presenting features which were no longer historic but didactic. Consistency required that it be left as it was

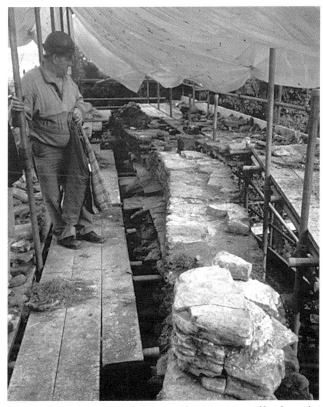

Fig.4. The parapet of the south curtain wall after the removal of its natural soft capping but before repair (photo: Glyn Coppack).

found, its grass and fern capping replaced, and its form can now only be seen in the archaeological record. Experience developed throughout the repair contract, as the repair of the south curtain wall demonstrated (Figs 4 and 5). Plants were removed from the wall-head, stored and maintained in a nursery area, and reset in new turf which was laid on the soil, broken stone and mortar which had been removed from the wall when it was stripped. The turf itself would not come off in large enough pieces to reuse, and in time the team grew sufficiently in confidence not to remove it but simply to peel it back where repair was needed. In this way, 95% of the wall-head of the shell-keep was left undisturbed, though in the middle ward all the walls had been stripped, some of them probably unnecessarily.

Perhaps typical of the work undertaken was the repair of the south tower (Fig. 6), an early 14th-century residential tower on two stories over a partially vaulted basement that houses a small but growing bat colony. Most of the cut stone had been robbed from the lower quoins of the tower and the internal splays of the windows, and several live vertical cracks ran through the structure, literally from window to window. Its coursed rubble walling was otherwise remarkably sound, and required only minimal repointing. Where pointing mortar was sound and could not be scratched out with a wooden spatula it was left alone and only failed mortar and voids were to be repointed, using a lime putty mortar matched closely to the original. Where stone had failed, as it had in some areas,

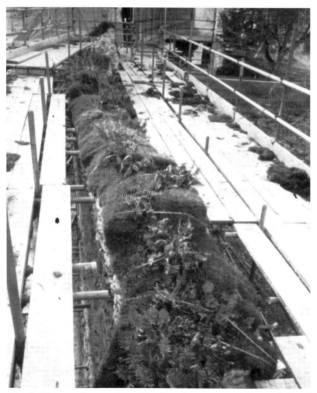

it was to be replaced with new matching stone from a local quarry, laid in matching bed-heights. To stabilise the structure, it was decided to replace the partly robbed reveals and rere-arches of the windows rather than pack the voids with coursed slates or corework to reintroduce the necessary support. The wall-top was treated in the same way as the curtain wall, with minimal repair and replacement of the soft capping. The evidence of wall-walk, roof, and waterspouts can still be found in the archaeological record, but it is no more visible now than it was before work started.

The vaulted basement of the tower, perhaps the most interesting feature of the site to many visitors, was virtually intact. Access, however, was restricted by the presence of a small bat colony and the incipient collapse of the side walls of the stair that led to it. Here, it was decided to protect the bat colony at the expense of public access, not simply because of our obligation to protect the bats but because this was a potentially dangerous area on

Fig.5. The south curtain wall after the repair of the wall-head and restoration of its soft capping. Note the replanted polypody ferns and the jute string securing the turf cover (photo: Glyn Coppack).

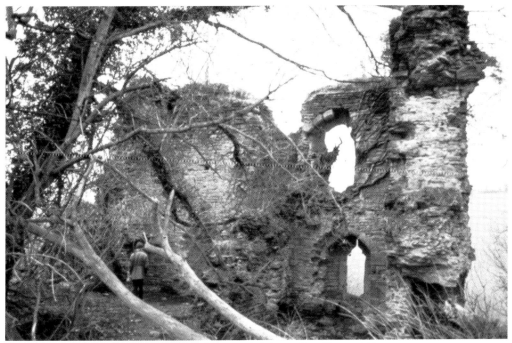

Fig.6. The interior of the south tower before repair (photo: Ron Shoesmith).

an unmanned site. A grille in the basement door would have been continually vandalised, the staircase to it was dangerous, and the repair of the staircase walls would have seriously compromised the archaeology of that part of the site. After recording the basement and stair, the vault was supported on permanent scaffolding, the door blocked to within 150mm of its lintel, and the stair backfilled to support its walls.

The east tower, which had serious settlement problems, was treated in the same way. However, once the superstructure had been conserved, the interior of the tower and an adjacent part of the middle ward was excavated to provide access for underpinning. Repair was complex but successful, but the civil engineer wanted to reduce the weight that the tower carried. Thus, the excavated area was backfilled to a level over a metre below the surface we had found in 1995, the only instance of active intervention revealing buried features.

The soft landscape
Although it was the stability of the masonry that required urgent attention at Wigmore, most of the site comprises earthworks which define the buildings of the castle (Figs 2 and 7), set within a landscape of relict woodland pasture which had developed by the early years of the 18th century, but which has not been managed or grazed for a number of years. Although most of the mature trees had been felled before the site came into guardianship, many semi-mature trees and saplings remained within the castle, and outside the guardianship area the owner was developing an area of woodland that complemented commercially managed woodland on the higher ground to the west. The setting of the castle (Fig. 1) is very emotive and very fragile, and the treatment of the landscape setting was as difficult as the treatment of the masonry.

There were also competing uses for this area: public access, archaeological survey and research, and nature conservation, as well as the working space required by the conservation contractor. The soft landscape at Wigmore protects the buried elements of the site as well as providing substantial, if slightly confusing, information about the planning of the castle. A balance had to be found between preserving the landscape 'as found' and providing reasonably easy public access on a site conserved at public expense and accessible to the public at any reasonable time.

The castle occupies a central location in a substantial area of managed landscape, and the reintroduction of a management regime to the part in guardianship that was consistent with the areas surrounding it was the starting point for developing the site and its setting. The existing tree cover would have to be maintained and managed effectively, some of the young saplings being retained to strengthen the existing planting and provide for the future, the very same policy that the owner had adopted for his land surrounding the castle. The first requirement, advised by the project team's ecologist, was to recover the coarse pasture land from the invading scrub which has resulted from a fairly lengthy period of non-management. Both the trees and the pasture had also to be protected from damage in the course of an 18-month repair programme during which the contractor had access to the site and during two periods of excavation when substantial spoil-heaps had to be endured. A works compound was established off-site with a temporary road up the hillside on the north side of the castle. This continued along the outer barbican bank which was protected by a surface of railway sleepers, allowing scaffolding and stone to be brought up as close as the gatehouse. Within the castle, access routes were identified

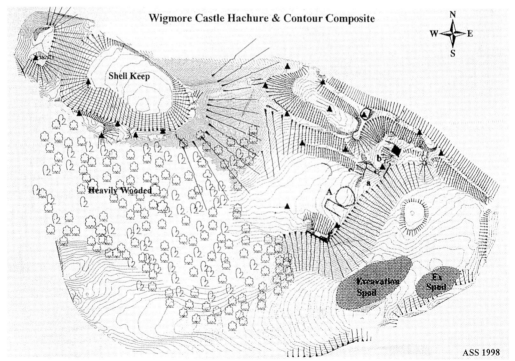

Fig.7. Archaeological survey located clear evidence of buried buildings within the middle ward, the hall and chamber block of the 14th- century castle on their own terraces (photo: English Heritage).

154

for the contractor's use, ensuring that damage was limited, any wear being countered by spreading bark which was easily recovered, or by moving the track in exceptional cases.

Blackthorn and nettles abounded inside the castle, and in many areas served a useful function. They kept people away from dangerous areas and were far less intrusive than fences which would otherwise be required. It did not take long for the team to realise that careful planting of blackthorn would aid the circulation of visitors while protecting fragile areas and preventing erosion of, for instance, the slopes of the motte which were covered with loose screes of fallen masonry. New planting requires protection while it becomes established, which means in the short term that chestnut palings appear in some areas where the visitor needs to be excluded, but this is a temporary feature of the site which will last three years at most. The visitor route around the site had already been established, well-worn routes from the gatehouse led to the south-west tower, the east tower, and up the motte. On the steeper ground, deep gullies had already formed, a combination of visitor wear and erosion from run-off water. Because they followed the easiest route to the inner ward or shell-keep on the motte, and because they had already caused damage to the shallowest archaeology of the site, they were chosen to be the permanent access routes. After considerable debate, which had as much to do with ecology as archaeology, it was decided to lay timber steps in the scarring, bedded primarily in the topsoil and following the profile of the slopes. Although an archaeological watching brief was carried out, no archaeologically sensitive deposits were revealed, let alone damaged, by the careful setting of the steps. Perhaps more importantly, the neutral colour of the steps and their laying in existing scars prevented them from being visible in distant views of the site and they are barely perceptible from the middle ward. Hard surfaces were avoided, though it was accepted that some would undoubtedly be needed. It was decided to review the situation after the site had been open for six months, and deal with problems as they arose rather than trying to impose a solution at the outset. Perhaps not surprisingly, wear patterns repeated those recorded before the conservation project began, and only slight modification was needed. A private (and unbriefed) visit from the Secretary of State for Culture, Media and Sport (the site's official guardian) in the middle of winter when the site was hardly at its best resulted in a request for the 'judicious use of gravel' to aid the visitor, and not a request for paths along the visitor route, a certain indicator that our approach was working and that the natural state of the site was properly appreciated.

The castle is, of course, only one element of a wider whole, and it was treated as such. To the east, the village of Wigmore is a planned town with an important pre-conquest church, while to the north are substantial remains of Wigmore Abbey, the Augustinian house established as the Mortimers' mausoleum. It is also part of a much greater whole, the frontier with Wales and one of the principal bases for the English colonisation of that country. Its conservation must be seen in that wider context and it must not be separated from its context by modern intervention. The decision to leave the site very much as it was found was carried into its wider landscape. There is no car park or visitor centre at the castle, which has to be approached on foot. Disabled access is virtually impossible and would be even with major intervention. However, intellectual access is provided both within the parish church and in the village centre, and car parking developed within the village can only help with the regeneration of Wigmore itself. Thus the castle ruins can remain a central and uncluttered feature of the wider landscape. It remains a site which still has a real sense of discovery, a 'proper' ruin which is now stable and safe, perhaps understated but preserved without serious damage for posterity.

Postscript
The conservation and basic display of Wigmore Castle was completed in July 1999, and at the time of writing it has been open to the public for eight months, sufficient time for opinions on its

success or failure to become apparent across the conservation community. Generally, it appears that the approach is well accepted by conservation professionals, many hailing it as the standard to be set for future work on major field monuments. By using techniques which were not new but which had never before been used on this scale, it was possible to show what was achievable, and by producing a detailed record of the work undertaken it will be possible to monitor its effectiveness for some time to come. Others are already looking at Wigmore Castle as an example to follow, as much to establish a philosophy of repair as to examine the methodology used in this particular case. Others, though, have been critical, some severely so, underlining the missed opportunities for archaeological research or making the site more 'visitor friendly'. Not surprisingly, criticism comes primarily from archaeologists and castle scholars who would have liked to have seen more information recovered. Visitors, however, are much more supportive even though Wigmore represents a major change in culture from the traditional approach to the conservation of ruins. It is very different from either Goodrich Castle or Montgomery Castle, sites which have been extensively excavated and conserved as something they never actually were, ruins without the product of decay, but not so different from the dozens of unconserved castles of the Welsh March like Clifford or Kilpeck that people rarely visit with such expectations (Shoesmith 1996: 77–9 and 145–51). In time, as the natural state of Wigmore recovers, visitors and scholars alike will start to appreciate it for what it really is, an essay in conservation in its widest sense.

References

Anon, 1908 Editorial. *Transactions of the Woolhope Naturalists' Field Club*, 14

Coppack, G. 1999 The Conservation of Wigmore Castle. In: *Managing Historic Sites and Buildings* (edsG. Chitty & D. Baker), 60–71. London: Routledge

Pevsner, N. 1963 *The Buildings of England: Herefordshire*. London: Penguin

Shoesmith, R. 1987 Neglect and Decay: Wigmore Castle – Home of the Mortimers. *Rescue News* 421, 3

Shoesmith, R. 1996 *Castles and Moated Sites of Herefordshire*. Little Logaston: Logaston Press

Streeten, A. D. F. 1993 Medieval Castles in the Central Marches: an Archaeological Management Review. Unpublished paper presented to the Ancient Monuments Advisory Committee. London: English Heritage

Audio-tours
at Heritage Sites

Brian Bath

This paper reviews the use of audio-tours to interpret heritage sites in the early 1990s, briefly looks at how auditory stimuli link with other communication channels, provides some basic rules of tour development, reviews the technology then available and the ways in which it has been applied to interpretive strategies at a number of English Heritage sites.

Overview

Visitors to heritage sites now expect high standards of interpretation comparable to those now in place in many museums and heritage attractions across the country. However, most heritage sites pose significant problems in fulfilling these expectations due to the sensitivity of either their landscape setting or the necessary restrictions imposed by the conservation of their historic fabric.

New visitor centres to meet this interpretive need are not always either desirable or an effective solution. Interpretive media that least intrude on the setting or fabric of a site are therefore increasingly sought after, and audio-tours have proven themselves to be a useful solution at many sites.

Audio-tours are widely used as a cost effective, informative and entertaining method of interpreting heritage sites. English Heritage now use audio-tours at more than 40 sites, including Stonehenge, Wiltshire, and Battle Abbey, Sussex. Over the last few years the technology for delivering audio-interpretation has developed significantly with the introduction of random access CD players and solid-state wands, and reliable solid state audio-replay which can be computer programmed with other effects.

Such technology offers great scope for interpreters of the past, but it also involves making the right choice of equipment in the first place. Part of the interpretive value of almost all heritage sites is their atmosphere, and this, coupled with the need to preserve the historic fabric, can often pose a significant problem when considering ways to interpret the site.

Audio-tours offer a relatively cheap and effective method of providing considerable amounts of information in sensitive settings as they generally have no permanent presence there – visitors bring their information sources with them from the site entrance and take it away when they leave. The same can be said of guidebooks, but a number of research projects at English Heritage show that most visitors do not use them extensively on-site, and sales expectations that an average 10 per cent of visitors buy them demonstrate that the vast majority of visitors will get no information at all from this source.

Alternative forms of site interpretation

In a simple test of knowledge gained by audio-tours and guide book users on site (Willis, 1990), a small scale study of 55 audio-users and 60 guidebook users we conducted showed that more information was gained by audio-tour users than guidebook users. This finding may not reflect anything more than that the audio-tour users, (using personal stereo cassette machines) could not avoid the information, while the guidebook users had to search for theirs and may not have chosen

to do so. It could also reflect, however, the more memorable quality of the audio message which is often given in dramatic scenes rather than narrative, and, sometimes, by historic characters who act as 'guides'. The ability to identify the character of the information giver may be of significance as the identity of the author is rarely evident in guidebook texts. However, given the circumstance that the majority of guidebook sales are made at the end of a visit, rather than the beginning, they do not appear to be the perfect means of on-site interpretation.

The percentages of respondents finding the audio-tour very informative (74 per cent) and very enjoyable (48 per cent) was high in comparison with guidebook user satisfaction (29 per cent and 7 per cent respectively).

The study by Willis also noted that other sources of information on site were available to both audio-tour users and guidebook users, and suggested that the exhibitions, videos and museums were used by an average of 92 per cent of respondents. This finding indicated strongly that other media could not be removed from the final interpretive mix.

Display panels, using reconstructed views and short descriptive texts, are very popular as a source of information to visitors at our sites (Ashworth, 1988). The study by Ashworth looked at where visitors were getting information on site and sought to establish an 'ideal' media mix. On-site display panels appeared far more valuable than large expensive exhibitions in terms of visitor satisfaction (although it should be remembered that as attractions exhibitions still play a vital role at any site). A further study at five English Heritage sites in the following year (Franklin, 1989) found results similar to those of Ashworth. At this time audio-tours were not yet part of the established media mix, and there was considerable suspicion concerning their use by potential purchasers.

Ordinarily, on-site display panels should be correctly orientated in relation to the part of the site illustrated so that the illustration itself can help the viewer 'reconstruct' the site in their own mind – the text simply providing further detail to the illustration. Again, illustrations with people, demonstrating the function of space rather than just its structure, appear to generate more interest, as they carry more information. The main drawback of display panels is that, if too many are used, they may intrude unpleasantly on the overall appearance of the site. A sensible balance must be found.

Integrating audio-tours with other forms of communication

At Hailes Abbey, Gloucestershire, the use of display panels with audio-tours was found to be a highly successful combination. The audio-tour links the areas illustrated by the panels with a guided tour by one of the monks of the abbey. But, of course, in the same way that a display panel would be tedious if only text, an audio-tour would be dull if only narrative. A range of sound effects, from background winds to orchestral works, can be used to create whole soundscapes, effectively re-creating an interior or a landscape in the audio-tour user's mind, just as the reconstruction drawings on a display panel would. The role of the audio-tour producer is much the same as that of the radio-play producer, but with the added benefit that he or she knows where the listener is, and can link the soundscape to the surroundings. Walkman and CD stereo systems are ideal for this, with high sound quality and even the ability to create '3-D' sound effects. This means that sound can be used to effectively fill an empty ruin with party-goers, or bring back the clash of battle to an empty field.

The Hailes Abbey audio-tour is also available in a form suited to wheelchair users, exploring those areas where access is possible, as well as in forms for partially-sighted and basic language tours. Each of these tours uses the same techniques as the standard tour but is written specifically for its intended audience. The basic language tour is valuable both for children and for those with learning difficulties.

At Etal Castle, Northumberland, an audio-tour was used in combination with display panels on site and an introductory exhibition. This arrangement had the benefit of introducing large scale artifacts and illustrations into the media mix. Some research at English Heritage (Ashworth, 1988) has suggested that visitors prefer short introductory exhibitions as a prelude to visiting a site rather than extensive, information intense exhibitions. While an exhibition can easily be an attraction in its own right, visitors to heritage sites have most often come to see the site itself, and do not wish to have to spend 30 minutes of what may be only an hours' visit in an exhibition. At Etal Castle, we were able to dispense with most exhibition text and use the audio-tours to guide visitors through the display which gave background information on the border wars and the battle of Flodden and put the significance of Etal Castle, of which relatively little remains, into context. On leaving the exhibition, visitors are then guided around the site to various display panels showing reconstructed views. At the end of the audio-tour, they leave the site via a further exhibition on the village of Etal which provides a present day context for the castle.

Audio-tours on personal stereo machines can be very effective at sites, such as those described above, with relatively low visitor volumes. In 1994-95 Etal Castle received 12,757 visitors and Hailes Abbey received 18,715. In practice, the limit for these systems seems to be about 30,000 visitors per year, unless staff can be made available specifically to hand out and take back machines.

Audio-tours at complex sites with large numbers of visitors

Sites with larger visitor volumes than those above could find it difficult, both in staffing and in the space requirement for equipment, to provide cassette audio-tours to all visitors.

Battle Abbey, Sussex

Battle Abbey used to offer cassette based tours, both for special needs and in a range of languages. However, because of space limitations, the audio-tour was offered as an option. It was only taken up by about 3 per cent of visitors, despite being well received by its users. The tour included the Battle of 1066, as does the site introductory video and the guidebook, but most of the interpretive materials and the exhibition in the gatehouse of the abbey emphasised the abbey and its history, rather than the battle.

A new marketing strategy recognised that most visitors were coming to the site because of its association with the Battle of 1066, in which the Norman king, William the Conqueror, defeated the Saxons, and not to admire the remains of the Abbey. At the same time, the development of the English Heritage Battlefields Register drew attention to the need to more effectively interpret battlefields in general.

Following investigation into a range of possible interpretive solutions, the approach adopted was to use a solid state interactive wand, and to link its use to a series of new display panels around the battlefield. These machines operate on the principle of the visitor entering a number to obtain a specific piece of information related to that number. Any number of numbers can be given at one position. A vast new range of interpretive possibilities are therefore opened up.

At Battle Abbey, a video introduction is given which follows the battle from the points of views of a Norman and an English knight. The audio-tour takes up this theme and allows the visitor to choose to hear of the battle from any one of three characters, a Norman knight, a Saxon, or Edith Swanneck, the common law wife of Harold, the Saxon King. These three characters are introduced by a touchable model of the site which gives the numbers associated with the images of each character. As the visitor moves around the battlefield they can choose which character they want to listen to – or they can hear them all, as many do. In this way a degree of choice is given to the visitor so that they can, in effect, create their own tour. Additional numbers and symbols also give

access to specific topics such as Arms and Armour, Norman Battle Strategies and so on.

The numbers are given on cast aluminium panels depicting scenes from different stages of the battle. The panels are in relief, so partially sighted visitors may gain something from them, and have no text. It was felt that, given the number of languages required, the panels would become unwieldy if texts were provided in all the languages used at this site. However, the wands can easily relate both to the site and display panels in any language with which they are programmed. Because of their solid state construction, the wands can be re-programmed in another language in only 3.5 seconds, so extra wands in a particular language can be provided very easily. This means that if, say, a tour group of 30 Japanese visitors arrives, extra interactive audio-wands can almost instantly be provided. The same applies for special needs tours.

The wands made it possible to link the battlefield with the abbey conceptually simply through the addition of cast metal labels to various locations around the abbey. A very interesting effect of providing information options seems to be that most visitors want to listen to all the options, judging by the extra time they now spend on site. The equipment has the facility to remember how it has been used each day, building up a record of which sections are accessed and when, so hopefully there will be data to demonstrate range of use on site. A great benefit of this wand system is that it could fit into the limited available space at Battle Abbey and be managed by existing staff without undue pressure on their other responsibilities.

While improvements to the Battle Abbey scheme have already been identified as necessary (such as full consistency in the use of characters at each stopping point and the need for better orientation), it is interesting that Battle Abbey achieved the highest visitor satisfaction rating for amount of explanatory material (8.8, max score =10) of all English Heritage sites assessed in 1995 (First Report 1995), while the average for all sites was 7.5.

Stonehenge, Wiltshire

The same system as that used at Battle Abbey has also been provided at Stonehenge, where daily visitor volumes are often over 5,000. Stonehenge has been poorly interpreted in the past, relying on a guidebook and three aged graphic panels. The panels have now been replaced by seven small number panels, each of which, on the wand, provides access to a basic narrative, a myths and legends option, and more considered archaeological options. The myths and legends are discussed by a shepherd and his mother and the archaeological view is narrated by Dr Geoffrey Wainwright, Chief Archaeologist of English Heritage. Where last year visitors to Stonehenge rarely stayed on site for more than 25-30 minutes, they now stay for longer, apparently listening to all the options. They also now walk all around the site to the Heelstone whereas last year the majority of visitors only walked to just beyond the end of the tarmac path in front of the monument.

The system can theoretically manage itself at Stonehenge, with visitors taking wands from racks, and replacing them in trolleys. In practice, having a member of staff available to hand out and take back wands has proved valuable. When changes to the tours of Stonehenge are required, or when additional tours are provided, it will be a relatively simple matter to change the data and re-programme all the machines in their racks. Equally, when more special interest tours are available, visitors will be able to re-programme their own machines.

Initial indications from market research (First Report, Stonehenge, 1995), although based on a small sample, suggest that visitor satisfaction with the amount of explanatory material is above the average for all sites surveyed at 8.

Ambient soundscape interpretations

Another variation in the use of interactive audio-wands has been developed for Dover Castle, Kent, where, in the Underground Hospital, they are triggered by infra-red transmitters in the

tunnels at specific points. The wands are only offered to overseas visitors, or the hearing impaired, as the main tour uses ambient audio-techniques. This last is a novel technique rarely possible at heritage sites, but the location of the tunnels, and their repair and reconstruction allowed ambient sound to be used as a vital part of their interpretation.

In this case, following a video introduction, visitors are guided round the tunnels by a member of staff for safety reasons. In the Underground Hospital, many rooms have been fully reconstructed, mostly with original artifacts of the period, and dressed in such a way as to look 'lived in'. The audio-component of the tour consists of various background sound effects, and conversations between various members of staff of the hospital, linked by a storyline of an injured pilot entering the hospital, being assessed and undergoing an operation. The storyline is not essential however, as the characters reinforce the function of the spaces they are in, describing what they do. It was very evident however, from research into the writings and evidence of those that worked there, that much of their time was spent trying to keep their spirits up – they told jokes, laughed, fell in love, went to dances in the town where they were billeted, and were in no way separated from the town by their work in the tunnels. The characters and conversations were created to provide this context.

A very powerful effect of this type of audio-tour is that a true soundscape can be created. At the same time that you hear Joyce and Gwen talking about the next dance in the town, you can hear the clatter from the kitchens and trollies rushing to the operating theatre in the distance. This soundscape creates a true sense of depth and space.

The technology for this type of soundscape tour is expensive, but it is also very reliable and, if the system is well designed, allows very fine control over sound levels and locations. All the sounds are stored digitally and computer controlled to replay at the exact times programmed.

A qualitative survey of visitor responses carried out at Dover recently (The Difference Engine, 1995) confirmed that visitors particularly enjoyed the interpretive techniques used and the contribution of the sound system. It was also confirmed that the pilot story had been followed and made the experience 'more personal'. The atmosphere was also reported as 'very effective'.

A system providing the same type of soundscape, but used in a very different way, has been installed at Conisbrough Castle, in South Yorkshire. The reflooring and roofing of the keep of the castle offered improved opportunities for the interpretation of the interiors. However, the development strategy for the castle required more than basic interpretation and demanded the creation of an attraction which would increase visitor numbers.

An audio-tour would have significantly increased visitor satisfaction, but not necessarily numbers. The new 'Keep Experience', as it is marketed, has done both. When ascending the keep, the story progresses through various stages which relate to the functions of the different spaces passed through. When descending the keep, backlit display panels light up, providing further information and full reconstruction drawings. The mix of simple props, soundscape audio and light effects, with a simple storyline reflecting the siege of Conisbrough by Lancaster after the lord of the castle, John de Warenne, had made off with his wife, has a startling effect. Visitor numbers have doubled in the first year and market research by the Ivanhoe Trust, the managers of the castle, shows visitor satisfaction at very high levels. A major drawback here is that, because of safety requirements, visitor numbers in the keep are restricted, and so the tour operates on 'freeflow' on peak days. In this mode, only background sounds and backlit graphic panels are available.

Main points to consider when thinking of audio-tours
The technology
At present (1996), there are three main choices available in audio-tour technology: the personal stereo tape tour, the solid state wand, and the personal stereo CD tour. There is also a wide

supplementary range of other techniques, including infra-red transmission to headphones or wands, radio-operated headphones, and any number of mixes of use. The choice depends on a number of facts:

1. How many users does the site have at peak times?

2. How will the equipment be distributed?

3. Do you have enough staff to manage distribution?

4. Is the user location sensitive? That is, is it historic fabric, an important landscape, recent or new construction?

5. How much will it cost you to produce and operate the system?

The choice of technology is strongly related to the number of potential users. While it is possible to distribute personal stereo tape tours to many thousands of users per day, it is relatively staff and space intensive. We have found that with existing commitments such as customer welcome, ticketing and sales, our staff find they can manage effectively at sites with up to 30,000 visitors per year. Above this, part-time help is required on peak days and, given this, at least one site is operating with 50,000 visitors per year – but with some difficulty due to space restrictions.

Wands are much easier than personal stereo tapes to hand out as there are no headpieces attached and their operation is relatively straightforward. The wands can simply be handed out with the entry ticket, and gathered in on return. Figure 1 summarises some of the considerations that are involved in choosing an audio system.

	Costs		Demands on Staff	Space Requirement	Reliability	Participatory	Easy to Update	Suitability for Visitor numbers	Interpretive Flexibility
	Production/ per user								
Cassette Sterio	Low/Low		High	High	Medium	Low	Low	Low	Low
CD Sterio	High/Medium		High	High	High	High	Low	Medium	High
Interactive Wand	Medium/Low		Low	Low	High	High	High	High	High
Infra-red	High/Low		Low	Low	High	Low	Medium	High	Low

Fig.1. Audio system considerations.

The interpretation

Many early English Heritage audio-tours had long sections of background information, unrelated to what visitors were looking at the time. Not surprisingly, many visitors were bored and needed to use the fast forward button. There was no need for this at all, as there is never a situation when a story cannot be constructed to suit the site.

The development of the site tour route is mainly constrained by the physical layout of the site, but there is a visual hierarchy of attractiveness at most locations, and the tour route should take account of this. It is no use directing attention to the mason's marks on this very interesting wall if the keep towering in the distance hasn't been mentioned – it has to be dealt with first – even if

only to say you'll be going there later. The actual tour around a site is in reality the differing visual views of the site encountered by the visitor – the audio-tour is only commenting on this. In this respect, the visitor always expects to be told where to look first, and then to be given information relating to that view.

Storylines do not need to be chronological, and are often more tedious for being so. Weaving background information into the actual locations visited, and the things seen, is much more effective. This relationship between visual and auditory stimuli is important as most information is coming from what is seen – its significance comes from the audio-commentary.

It is usually the case that sites have so much information potential, visual as well as audio, that you cannot deal with it all with a single tour. You could consider different tours on different topics, but often you will just have to tell people to go and look at a particular part of the site by themselves. This option is actually very useful as it 'breaks' the tour, providing an optional extra. With most audio-tour systems, it is the ability to turn the sound off when you want to and just explore the site that is as valuable as the audio-tour itself.

The tour narrative should generally be provided via a recognisable character – that could be a real person, the archaeologist, the historian or curator, or a character associated with the site in the past or present. Some studies have suggested that a recognisable character behind an exhibit (McManus, 1989) helps to maintain motivation to read, and the same may be the case in relation to the characterisation of audio narratives. Normally, our narratives are broken with character interludes – reconstructed scenes relating to the locations encountered during the tours.

References

Ashworth, F. 1988 *Project for English Heritage.* Unpublished internal document. English Heritage

English Heritage, *The Difference Engine,* August/September 1995, *English Heritage on a 'micro' level – a qualitative research report.* Unpublished internal document

English Heritage, First Report, August 1995, Historic Buildings Visitor Monitor 5 and Visitor Satisfaction 1995. Unpublished internal document

English Heritage, First Report, October 1995, *Stonehenge 1995 A visitor profile.* Unpublished internal document

Franklin, J. 1989 *Interpretation and Visitor Satisfaction – An evaluation of the interpretation and associated levels of visitor satisfaction at 5 English Heritage sites in the North East.* Unpublished internal document. English Heritage

McManus, P.H. 1989 Oh yes they do! How visitors read labels and interact with exhibit texts. *Curator* 32(3): 174–9

Willis, M. 1990 *Audio-communication Study.* Unpublished internal document. English Heritage

A Visitors' Guide to the Contents and Use of Guidebooks

Paulette M. McManus

The perceived status of guidebooks

Guidebooks were once the sole source of interpretation offered at many heritage sites in Britain. In some cases they still hold this position. However, over time, as heritage interpretation has become a more sophisticated and vigorous form of activity, guidebooks have been joined at many sites by other forms of interpretation such as brochures, leaflets, teacher packs, audio-tours, interpretive panels out on the site and displays and audiovisuals at visitor centres near car parks. Increasingly, visitors must pay for entry to sites and this can cause them to be resistant to paying extra for a guidebook when other forms of interpretation appear to be included in the entry fee.

These factors – a professional perception that guidebooks are 'old fashioned', competition from other forms of interpretation and lowered take up due to cost – have conspired to give guidebooks such a low, taken for granted, profile that a recent publication on Heritage Management, in referring to 'the standard guidebook' offered very little advice on their compilation (Riddle, 1994).

It is true that earlier references (for example, Binks, 1986) do give advice, recommending that guidebooks should have short texts linked to vantage points on site and explanatory illustrations all presented in an easily handled format so that the guide becomes 'an impersonal substitute for the personal guided tour'. One rarely comes across helpful accounts of the development of individual guidebooks (but see, Glen, 1993). None of these accounts describe research showing how visitors actually use site guidebooks. This situation is startling when compared to the the amount of research which has gone on in the museum world into the use of exhibits – the staple, original form of interpretation in that context.

A survey of guidebook users

Since guidebooks are an important part of interpretive provision, and, at some sites the only form, it was decided to conduct a survey of guidebook users to discover what they liked to find in a guidebook and the manner in which they used them (McManus, 1995). The hope is that information from this initial survey will help guidebook compilers to place the function of a guidebook in a visitor context which will bring a firmer understanding of the use and place of a guidebook during and after a visit. Such information should help to improve the quality of guidebooks overall.

A postal survey was made of 300 members of English Heritage who lived within reach of six particular English Heritage sites. Fifty members were randomly selected from each locality. English Heritage members pay an annual subscription in return for privileges such as reduced

entry fees and a members' magazine. It was thought that a sample of this type would be bound to contain many experienced guidebook users and this proved to be the case as only 2 per cent reported that they usually did not buy guidebooks. The response rate for the questionnaire was 42 per cent, giving a sample size of 125. This sample size is a little larger than that needed for a similar survey of visitors to a museum. The sample was skewed towards retired people as 63 per cent were over 56 years of age. As older and retired people are making up an increasing segment of the audience for leisure activities this age orientation is not seen as compromising the validity of the survey.

The characteristics of an ideal guidebook

A choice of seven characteristics from which the sample could compile their ideal guidebook was given. Around nine out of ten thought that the following four characteristics were important. They can be regarded by guidebook compilers as essential.

- The story and importance of the site,
- An explanatory tour of the things to see on site,
- The architectural history of the site, and
- A bird's-eye map of the site.

Around eight out of ten included the following two topics. They can be regarded as important inclusions to a guidebook if they are relevant to a site.

- The history of the people who lived at the site, and
- Interesting events from the past.

Only six out of ten people wanted attractive, scenic photographs in their guidebooks. This is understandable when thinking of on-site use of guidebooks when visitors can look about for themselves.

Use of guidebooks on site

Around nine out of ten respondents (87 per cent) indicated that being able to buy and use a guidebook during a visit contributed 'very much' or 'a lot' to their enjoyment of that visit. This is a warm response as many elements, including the interest of a site, being with friends and family and the enjoyment of being on an outing, contribute to the enjoyment of a visit. Around two out of ten of these people who were experienced guidebook users reported that they did not always buy a guidebook because of the expense.

Around seven out of ten people in the sample (68 per cent) reported that they usually used guidebooks when visiting a site. Around three quarters (72 per cent) of these people who usually use a guidebook on site only use the tour part of the book on site. These people who only use the tour part of the guidebook on site represent forty nine per cent of the entire sample. Only 5 per cent of those who use a guidebook on site throw it away after using it.

Around half of the sample had experience of audio-tours and of this group, three quarters thought that audio-tours did not replace the need for guidebooks.

So, nearly everyone who buys a guidebook at some time thinks that they add to the enjoyment of a visit but quite a large minority of these people do not always buy one because of the cost. Amongst those who like guidebooks, audio-tours are not seen as a substitute. The large majority of experienced guidebook users usually buy a guidebook on site and around three quarters of them only use the tour part of the book during the visit.

Use of guidebooks after the visit

More than nine out of ten respondents (93 per cent) kept at least one guidebook bought at a past visit to an English Heritage site at home. This is a very high level of long term retention. More than eight out of ten respondents (84 per cent) indicated that they usually kept the guidebook after their visit so some guidebooks must have more intrinsic keeping value than others. One in five respondents actively collected guidebooks.

Those in the sample indicated an interplay of reasons for keeping their guidebooks. The motivations for keeping a guidebook (in descending order of popularity) included: for re-use during a later visit, as a general home reference, to read conveniently at home as reinforcement of the visit, as a souvenir, to lend to friends, because they were attractive books, as educational reference sources for children, and to add to a collection of guidebooks.

It could easily be assumed that those who take a guidebook away from a site do so primarily in order to read the parts they did not have time to read on site when they get home. Only 6 out of 10 respondents (63 per cent) gave this reason as a motivation for taking the book off-site – the interplay of motivations is genuine.

So, we have nearly all the people in a sample of experienced guidebook users keeping at least one book long term at home and a large majority usually keeping every guidebook they buy for some time after their visit. An interplay of reasons leads to this situation. The reasons include the desire to read the book soon after the visit, the perception that the book could be used or referred to by someone some time in the future and the desire to have a attractive souvenir.

Conclusion

Three quarters of a sample of mainly older users of guidebooks only used the tour part of a guidebook on site and 84 per cent of them make a habit of always taking a guidebook off-site. Nearly all of such users of guidebooks will have a copy of at least one guide book at home. Retention of guidebooks after leaving a site is one of the most remarkable aspects of their use.

Given that surveys of museum visitors constantly find that word of mouth from family or friends is the most common motivation for making a visit to a museum (McManus, 1991), it can readily be appreciated that a guidebook off-site can become the focus of recommendation in conversations with people who have not yet visited a site and a prompt to revisit for those who have. Guidebooks may have as much impact on audience development as they have on site interpretation.

This survey needs to be balanced by on site surveys of ordinary visitors to heritage sites in order to see how guidebooks are used by a general audience. For example, do families use guidebooks in the manner described by this somewhat older sample or is the audience segmented according to an interpretive preference based on age?

There is a long way to go before 'the standard guidebook' can be dismissed as a form of site interpretation.

Acknowledgement

English Heritage is thanked for permission to report the study discussed above.

References

Binks, G. 1986 Interpretation of historic monuments : some critical issues. In Hughes, M., & Rowley, L. (eds) *The Management and Presentation of Field Monuments*. Oxford University, Department for External Studies

Glen, M. 1993 Seeing the wood and the trees. *Interpretation, The Bulletin of the Centre for Environmental Interpretation* 8(2):14–15

McManus, P. M. 1991 Towards understanding the needs of museum visitors. In Lord,G. & Lord, B. (eds) *The Manual of Museum Planning.* London, HMSO

McManus, P.M. 1995 *A survey of English Heritage members concerning English Heritage guidebooks.* Unpublished report, English Heritage

Riddle, G. 1994 Visitor and user service. In: Harrison, R. (ed.) *Manual of Heritage Management.* Oxford, Butterworth Heinemann